HEART OF THE BRUSH

Shambhala Publications, Inc.
4720 Walnut Street
Boulder, Colorado 80301
www.shambhala.com

© 2016 by Kazuaki Tanahashi

9 8 7 6 5 4 3 2 1

First Edition
Printed in the United States of America

♾ This edition is printed on acid-free paper that meets the American National Standards Institute Z39.48 Standard.
♻ Shambhala Publications makes every effort to print on recycled paper. For more information please visit www.shambhala.com.

Distributed in the United States by Penguin Random House LLC and in Canada by Random House of Canada Ltd

Designed by Lance Hidy

Library of Congress Cataloging-in-Publication Data

Tanahashi, Kazuaki, 1933–
Heart of the brush: the splendor of East Asian calligraphy / Kazuaki Tanahashi; Christine Haggarty, Associate Editor.—First Edition.
pages cm
Includes bibliographical references.
ISBN 978-1-61180-134-7 (pbk.: alk. paper)
1. Calligraphy—East Asia. 2. Calligraphy—Technique. I. Title.
NK3632.T36 2015
745.6'1095—dc23
2015007485

To Wouter Schopman,
my soul mate ❧

CONTENTS

PREFACE

Welcome to the wondrous world of brush calligraphy. This three-thousand-year-old art form, which originated in China, has commonly been practiced in most parts of East Asia and appreciated throughout the world. This book offers you its history, techniques, aesthetics, and philosophy, with an in-depth practical guide to understanding and drawing ideographs. You may look at the images of ideographs selected from great classical masterpieces, see how these characters are drawn and pronounced, and learn what they signify. You may also take a brush and try to re-create characters from these examples.

1. Welcome!

Studying East Asian calligraphy is a cross-cultural experience for those from other parts of the world, as the formation of characters is unique and the creative process in calligraphy is quite different from that employed in any other form of art. In following the predetermined stroke orders and re-creating masterworks, you begin to interpret, and then create your own style and work. This gentle progression of creativity allows you to gradually expand your artistic process.

Drawing lines with a brush is a joyous visual and tactile experience. You can enjoy drawing lines on any skill level and continue to learn from calligraphers from the past. Repetitious brush movements improve your relaxation and focus, which in turn nurture your inner path.

At first, all East Asian calligraphic works may look similar to you, and you may have difficulty understanding why some of them are regarded as outstanding pieces while others are not. You will notice little by little, however, the nuances of the lines, spacing, and composition of celebrated pieces. As a way to demonstrate how calligraphic study is done, I show you my own study of ancient samples on a scale suitable for your own drawing, which are presented on right-side pages in part 2, "Master Samples and Study."

The lines you draw may initially look unskilled or clumsy, but soon they will gain adequacy and fluency. Each moment of practice is a moment of learning. Your eyes will see more acutely and your hand will draw more elegantly. The progress,

however, may not be as immediate as you desire. That will allow you all the more opportunity to improve your brush-work and enjoy your experience endlessly. Calligraphy is not a goal-oriented task but, rather, a path for deepening your way of life.

I am delighted to bring you into the heart of this magnificent art form. You may ask me, "How long have you been studying calligraphy?" I answer, "Eighteen . . . hundred years." A good number of calligraphies are in the lineage of this art form that has continued well over a millennium since its classical era.

What you see in this book is what I have come to know as an ideal approach to East Asian calligraphy. That is, to study ancient Chinese masterpieces from the earliest to the most accomplished stage of your learning. Where the models are outstanding, their handwritten reproductions can be adequate and graceful. I hope you will find this approach helpful in your appreciation and practice of calligraphy.

Of course, knowing an East Asian language could be of use in learning calligraphy. But you can also view or learn calligraphy as an art form without it. Increasingly, you will get used to its writing system.

Studying calligraphy is one way to realize how much we have to learn from the wisdom, aesthetics, and depth of our ancestors. In this time of rapid technological advancement, in taking up the brush we become humble and feel privileged to be part of an ancient, creative civilization.

2. Does the brush have a heart?

🖎 Kazuaki Tanahashi

A video tutorial of the author executing samples of the ideograms found in this book can be found at www.shambhala .com/heartofthebrush

Part One

AN INTRODUCTION TO EAST ASIAN CALLIGRAPHY

1 WHAT IS IDEOGRAPHY?

THE COMMON WRITING SYSTEM OF EAST ASIA

East Asian calligraphy is the art of writing characters or ideographs. The abstract noun *ideography* signifies the writing system that uses ideographs. An ideograph (etymologically, "diagram of an idea") is a symbol that represents a word, in contrast to phonetics, where each letter or combination of letters (such as *th*) represents a sound.

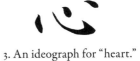

3. An ideograph for "heart."

Phonetic letters are used in the majority of languages, including all European languages, Arabic, Hebrew, and Hindi. Ideography, however, is used by more than one billion people in East Asia.

4. A pictograph for "heart."

The earliest evidence of this writing system goes back to the Yin Period (ca. 1700–110 B.C.E.) in China. After centuries of development, it was then introduced to Korea, Japan, and Vietnam. Although people speak different languages in these regions, ideography has been the common script in large parts of East Asia for many centuries.

As ideography is a character-per-word writing system, thousands of characters have been created. For example, *A Chinese English Dictionary* (compiled by Herbert A. Giles) contains 13,848 characters. *Dai Kan'wa Jiten* (Great Chinese-Japanese Dictionary, compiled by Tetsuji Morohashi) contains more than 50,305 characters.

Children who learn ideographic writing need to learn hundreds and thousands of characters. For example, in Japan children are required to learn more than eighteen hundred characters by the end of their high school education. However, people need to know many more to conduct daily activities such as reading the newspaper.

(In the Chinese language, ideographs have been exclusively used for writing, while no phonetic letters have been developed. Since ancient times, the Chinese have employed methods of transliterating words from foreign languages, such as Sanskrit from India, using ideographs. In such transliterations,

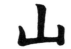

5. An ideograph for "mountain."

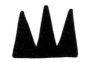

6. A pictograph for "mountain."

7. A pictograph for "water."

8. A pictograph for "tree."

the sounds of ideographs are utilized and their inherent meanings are ignored. In contrast, the Japanese developed phonetics called *kana* in the ninth century. Nowadays it is common to use a mixture of ideographs and kana in Japan. Koreans developed a phonetic system called *hangul* in the fifteenth century. The Vietnamese started using the Western alphabet in the twentieth century.)

THE SYMBOL AS A PICTURE

The ideograph for "mind" in ideography also means "heart" (fig. 3). It originally came from a pictograph of the heart organ (fig. 4).

When people in East Asia see the symbol for "mountain," they recognize it right away as a sign that means "mountain" or "mountains" (fig. 5). Reading a symbol is reading a word. If you compare this symbol with the English word *mountain,* you may notice that the English term has eight characters, while its counterpart ideograph has only one. People in East Asia, when using the ideograph for "mountain," may not think of the original picture of a mountain of three peaks standing on a horizontal ground (fig. 6). But their awareness of the original picture is always somewhere in the back of their mind. Each ideograph has its own unique shape. The number of strokes for each ideograph varies between one and thirty-three. One thousand characters have one thousand shapes. This makes it easy for native readers to recognize words quickly and accurately.

The symbol for "water" originally came from a picture of water drops coming down (fig. 7). The streams are always there. In the symbol "tree" or "wood," a trunk, two branches, and three roots are condensed (fig. 8).

PICTOGRAPHS

In ancient China, people started drawing signs, most likely on soil with a wooden stick, though there is no remaining evidence of this mode of writing. Later they carved signs

with knives on animal bones and stones. Many artifacts from this process remain. Scholars argue that among these carved writings, there are hints of initial sketches done with the use of the brush. Initially, the ancient Chinese took shapes from nature or artificial objects, making them into simple but recognizable pictures.

Here are pictographs for "human" and "deer" (figs. 9, 10). You can observe the process of simplification and standardization. These characters are called pictographs, the earliest and most basic form in ideography.

IDEOGRAPHS

Eventually, people in ancient China started combining pictographs. For example, they put two signs for "tree" side by side to signify "forest" (fig. 11). They then added another tree on top of the two trees to signify "large forest" (fig. 12). They also put two signs for "fire" on top of another to mean "flame" (fig. 13), and there is also an ideograph consisting of three signs for fire. People put "human" next to "tree," creating a symbol for "to rest" (fig. 14). "Sun" and "moon" are put together to mean "bright" or "clarity" (fig. 15).

In early times, there existed a word, *wu,* to signify negation. It means "not," "no," "not possessed," "there is not." Because there is no natural or artificial object to represent such meanings, the ancient Chinese took another word *wu* that meant "dancer" or "dance," slightly altered the shape, and used it to signify negation (figs. 16, 17).

STROKES

It took hundreds of years for ideographs to develop in China. As they were gradually standardized, basic strokes were established. A disk was replaced with a circle, then with a rectangle consisting of four lines to facilitate carving.

In brushwork, calligraphers started using straight or slightly curvy lines that were horizontal, vertical, or diagonal. Sometimes two or more strokes were combined and counted as one

9. A pictograph for "human."

10. A pictograph for "deer."

11. An ideograph for "forest."

12. An ideograph for "large forest."

13. An ideograph for "flame."

14. An ideograph for "to rest."

15. An ideograph for "bright."

16. An ideograph for "dance."

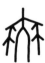

17. An ideograph for "not."

stroke. The directions of the strokes were also determined. For example, horizontal strokes began to be drawn from left to right, and vertical strokes from top down. Each ideograph was assigned a certain number of strokes.

2 THE EVOLUTION OF STYLES

THE PERIODS OF CALLIGRAPHY

The history of East Asian calligraphy can be roughly divided in the following manner:

Carving period	1700–1 B.C.E.
Early brush period	1–200 C.E.
Classical period	200–700 C.E.
Postclassical period	700–1300 C.E.
Modern period	1300–1945 C.E.
Contemporary period	1945–present

STYLES OF WRITING AND TYPES

Carved Script

The earliest unified script in East Asian calligraphy is called seal script, because this style of ideography later came to be used for carving seals for signatures. Here are examples for "mountain," "river," and "tree" (figs. 18, 19, 20).

These forms of ideographs may show some traces of brush movement, such as an initial push or an ending sweep-off. And yet the lines were, in most cases, straight or curved and of even width. Later, brush calligraphy in seal script emerged, where archaic compositions of brush lines were drawn with even width but without dewdrop shapes or sweep-offs (which I explain later).

Clerical Script

The calligraphy brush with a round bristle and a bamboo or wooden handle was invented in China. The ideograph for "brush" was already known in the Zhou Dynasty (ca. 1046–256 B.C.E.). During that time, the writing of documents was carried out by government clerks. That is why the script is called clerical script. Here are examples of

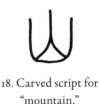

18. Carved script for "mountain."

19. Carved script for "river."

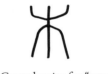

20. Carved script for "tree."

21. Clerical script for "mountain."

22. Clerical script for "river."

23. Clerical script for "tree."

24. Formal script for "mountain."

25. Formal script for "river."

26. Formal script for "tree."

this script: "mountain," "river," and "tree" (figs. 21, 22, 23).

From these examples you can see that the early writers of this script were excited about using the brush as a writing tool. One of the brush's most distinct characteristics is that you can start with a pointed entry, pressing the brush down to create a wide section, then taper off to create a pointed end. The artists held the brush diagonally, with its top leaning toward themselves, to create the maximum width. Some of the lines were drawn with exaggerated brush movements. Eventually, when formal script developed, clerical script became outdated for practical use because it had taken extra effort to keep tilting the brushes.

Formal Script

In the third century C.E., a Chinese calligrapher named Zhong Yao established a new style of brush writing that became the most basic form of calligraphy and was used for formal occasions. This style of writing is called formal script. Following are examples of "mountain" (fig. 24; see also fig. 5), "river" (fig. 25), and "tree" (fig. 26).

The principles of Zhong Yao's calligraphy include demonstrating the moderate brush movement without exaggeration. For example, a horizontal line has a distinct beginning and ending that is unique to brush writing (see fig. 26). Yet the width is even and not so dramatic as in the earlier clerical script. His lines show a 45-degree entry of the brush against the direction of the brush and the same degree of brush ending. (Later I will explain it as forming a dewdrop shape in a 4:30—half past four o'clock—direction.)

Following the style of clerical script, each combination of strokes is independently drawn, instead of a few strokes being drawn continuously as in semicursive and cursive scripts. This separation of strokes keeps the style of writing the ideographs that Zhong Yao established highly legible. This formal script has become the most frequently used script, largely for official occasions and in correspondence as well as in commercial signs and statements. Later it became the basis of East Asian typography.

Semicursive Script

Wang Xizhi of fourth-century China radically expanded the horizon of calligraphy with his tireless exploration of a great variety of forms, especially in semicursive script. That is why he is regarded as the Sage of Calligraphy. Here are examples of his work: "mountain," "river," and "tree" (figs. 27, 28, 29). As you see, his forms are imaginative, gentle, and flexible. The lines are fluid, and strokes are sometimes connected. Some lines are represented by simpler or even abbreviated lines. This script enhances the speed of brush movement, creating a rhythmic flow of lines suited for writing poems as well as personal correspondence.

Cursive Script

Cursive script was developed simultaneously with semicursive script. The Buddhist monk Huaisu of eighth-century China, in particular, is known for a dynamic style of cursive script. If you compare his ideographic expressions with those in formal script, you may not at first recognize that they represent the same characters. But if you see steps of evolution in the styles of these characters, you may see the connection. Here are examples: "mountain," "river," and "tree" (figs. 30, 31 32).

Lines in cursive script are soft, fluid, and often linked with ligatures (thin connecting lines). They are often curved or round, representing abbreviations of multiple lines in formal script. People sometimes use this script in poetic or artistic writings. In the past, educated people could read writings in this script. Nowadays, hardly anyone can.

Types

Printing was invented in China around the tenth century, more than five hundred years before Johannes Gutenberg printed the Bible in Europe. Gutenberg invented independent types that could be reset, but in ancient East Asia a block of wood had to be carved for each page or pair of facing pages. Formal script is the basis of typographical design.

27. Semicursive script by Wang Xizhi for "mountain."

28. Semicursive script by Wang Xizhi for "river."

29. Semicursive script by Wang Xizhi for "tree."

30. Cursive script by Huaisu for "mountain."

31. Cursive script by Emperor Tai for "river."

32. Cursive script by Sun Guoting for "tree."

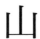

33. Ming dynasty–style type for "mountain."

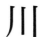

34. Ming dynasty–style type for "river."

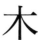

35. Ming dynasty–style type for "tree."

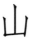

36. Song dynasty–style type for "mountain."

37. Song dynasty–style type for "river."

38. Song dynasty–style type for "tree."

39. Sans-serif type for "mountain."

40. Sans-serif type for "river."

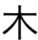

41. Sans-serif type for "tree."

In the Ming Dynasty (1368–1661) a style of types was established that was mechanical yet retained a sense of brush movement. In this style, horizontal lines are narrow, while vertical lines are sometimes wide, and both are geometrically straight. Horizontal lines have an upward-pointing triangular ending called fish scale. Some vertical lines end with a hook. Diagonal lines end with a sweeping brush movement. This style of typography is called Ming Dynasty. It has become the most standard style in East Asian typography, being widely used for books and newspapers. Figures 33–35 show some examples of characters that we have been studying in the Ming Dynasty–style types.

There is also a Song Dynasty (960–1229) style, which is used for elegant, artistic media, including book covers and artists' business cards. It is much less frequently used than the Ming Dynasty style. Examples can be seen in figures 36–38.

Sans-serif style is called *gojikku* in Japanese, after "Gothic style." It employs wide lines with no brush-like endings, including fish scales. It is commonly used for headlines and occasionally in the main text in contemporary designs. Figures 39–41 show some examples.

These are some of the most common fonts in ideography. As there are thousands of characters, it is enormously labor-intensive to create a new font. Nevertheless, there are just as many ideographic fonts as there are alphabetic ones.

Nowadays, on a computer or smartphone keyboard, there is a button to switch language inputs. For example, in the case of Chinese, if you switch to "Pinyin-Traditional" and type the alphabetic spelling of an ideograph such as "dao," multiple ideographs of the same pronunciation appear. Then you choose the one you are looking for. In the case of Japanese, if you switch to "hiragana" (phonetic letter) input, and type the alphabetic spelling of an ideograph such as "michi," then the Japanese phonetic equivalent of the spelling appears. By pushing the space bar, multiple ideographs or sets of ideographs of the same pronunciation appear. Then you choose an ideograph or a set of ideographs you are looking for.

3 SHALL WE BEGIN?

It's perfectly fine to simply read about calligraphy and look at the selected examples presented in part 2, "Master Samples and Study." Alternatively, you can take up a brush and try painting some of the sample pieces yourself. You don't need to have any previous art or calligraphy experience. You don't need to know any East Asian language. And both right-handers and left-handers are equally capable.

I assume many of you would like to try it at least a few times. If so, I suggest that you start with a minimum set of tools and materials: paper, ink, an ink container, a brush, and a paperweight, along with table space and a chair.

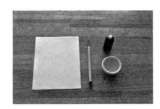

42. Minimal equipment.

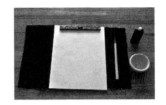

43. Enough to begin.

PAPER

Regular letter-sized paper or a similar size of A5 computer printing paper works very well with brush and ink. You might also like to experiment with *hanshi*—Japanese rice paper used specifically for calligraphy practice. It is absorbent, slightly larger than letter size, and inexpensive. It is available in most art supply stores. (Also see the appendix "Recommended Supplies.")

INK

At the beginning it is most convenient to use liquid calligraphy ink, which can be purchased in most art supply stores. If you add water to thin it down, it will be easier to clean potential spills or stains. Pour the ink into a cup or a small bowl. If you have an East Asian inkstone, put the ink in the hollow area. Black watercolor paint also works well. Keep your leftover ink in a lidded jar for reuse. You can also grind an ink stick with water on an inkstone. I suggest you wait until you get familiar with brushwork before doing this. (I will later explain how to prepare ink in the traditional way.)

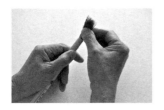

44. Softening the bristle.

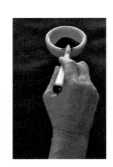

45. Preparing the brush.

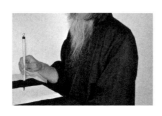

46. Posture.

BRUSH

You might like to acquire a medium-sized East Asian calligraphy brush at an art supply store. I recommend a bristle size of about ⅜ inch (1 cm) in diameter and 1⅞ inch (4.8 cm) long. (See the "Recommended Supplies" appendix.)

Thus, some paper, a brush, ink, and an ink bowl will allow you to get started (fig. 42).

FELT AND WEIGHT

Placing a black piece of felt underneath your paper can be very useful, as it absorbs extra ink and protects the surface underneath. (Felt can be purchased at a fabric store.) A metal weight, stone, or cup is good for holding down the paper. With these supplies, you can enjoy brushwork for some time (fig. 43).

TABLE AND CHAIR

Pick a chair that allows you to have good posture. Your table space should be at least one foot long and three feet wide.

PREPARING THE BRUSH

If the brush is new and the bristle is starched, gently soften the bristle with your fingers (fig. 44). It's good to use a brush with a totally softened bristle. Squeeze the bristle all the way to its base.

Before you start to draw, dip the bristle all the way into the ink. Make sure the base of the bristle is soft and wet. Remove any extra ink by pressing the bristle across the edge of the cup, bowl, or inkstone while pulling the brush toward you or sideways (fig. 45). Rotate the brush and then remove more ink. By repeating this motion about ten times, you get the bristle straight and pointed with the appropriate amount of ink.

Recondition the bristle in the same manner when you notice it is split or splayed. When you are done with your exercise, rinse the bristle with water and keep the bristle straight and pointed for drying.

POSTURE

Sit up straight on a chair, close to the table. Put the paper in front of you at a right angle (fig. 46). If you are left-handed, place the paper several inches (about 10 cm) to the left so that you can see the tip of the brush while drawing.

HOLDING THE BRUSH

Keep the brush fairly straight up. Make an effort to avoid holding it leaning toward you like a pen. When you use a medium-sized brush, hold the shaft between the middle and the ring fingers and place the thumb about one-third of the way from the bottom. Keep the wrist about midway, not too high or too low, so the thumb line is horizontal. Some leaning is all right, but hold the shaft fairly straight. Although there are other traditional ways of holding the brush, this is my personal recommendation for doing so comfortably (fig. 47).

47. Holding the brush.

MOVING THE BRUSH

When using a medium-sized brush, keep your elbow free from the table, a few inches (about 5 cm) away from the torso. Move the brush up and down, side to side, toward and away from your body with your entire arm. Do not manipulate the brush with your fingers or wrist. Do not rotate the brush while drawing.

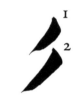

48. Directions of the brush. The numbers show the beginnings of the strokes.

Direction of the Brush Movement

The general direction of the brush movement is predetermined. Horizontal lines are drawn from left to right, while vertical lines are drawn from the top down. Diagonal lines are usually drawn downward, but there are lines that go upward right and sweep off. Dots are drawn, in most cases, diagonally from the top down. Hooks at the end of strokes go diagonally upward (fig. 48).

Stroke Order

The sequence of strokes in each ideograph has been observed ever since the classical period of East Asian calligraphy. Stroke

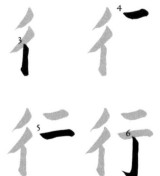

49. A stroke-order sample. Continued from figure 48.

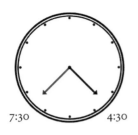

50. Initial directions of the brush.

order is particularly important for semicursive and cursive scripts where strokes are connected by ligatures, as a wrong sequence may represent a wrong ideograph (fig. 49).

There are many artists of ancient times whose works have been regarded as standards of calligraphy. In cases where artists' sequences of strokes do not match each other, two or more "authentic" sequences are recognized.

Pretouchdown

Move the brush in the air before drawing each line. Bring the brush from the direction opposite to the line you are going to draw and be ready for touchdown. The "empty" brush movement in the air affects the shape of the beginning of the stroke as well as the flow of the brush. (In the following chapter, a "0" (zero) in diagrams with a circular line of dots indicates a pretouchdown movement.)

Touchdown

51. Touchdown.

Bring the tip of the brush to slightly touch the paper. The majority of touchdowns are done in the 4:30 (half past four) direction. Some touchdowns are done in the 7:30 direction (fig. 50). They are 45-degree downward directions between the imaginary horizontal and vertical lines (fig. 51). Occasionally touchdown goes in a horizontal (3:00) direction.

The Dewdrop Shape

52. A dewdrop shape.

After touchdown, gently press the brush down in the 4:30 direction, creating a triangular dewdrop shape (fig. 52). All lines in East Asian calligraphy start with this shape going in either the 4:30 or the 7:30 direction or in a rightward horizontal direction. This dewdrop shape can be distinct (see fig. 52) or subtle (see fig. 53). In some cases, the dewdrop shape is implied and not visible. Many strokes end with a dewdrop shape. When two strokes are combined, this shape serves as a joint.

53. A subtle dewdrop shape.

If you have difficulty making a clean dewdrop shape, recondition the brush and make its tip pointed. Draw the shape a number of times until you begin to get it right.

THE THREE ELEMENTS OF A BRUSHSTROKE

All brushstrokes consist of three elements: beginning, middle, and end (fig. 54). The beginning of the horizontal stroke going from left to right constitutes the making of a dewdrop shape. The middle is sliding the brush to another direction. The end of the stroke is accomplished either by making another dewdrop shape by pressing the brush down, or by a sweeping-off, which you create by starting to pull the brush away from the paper, gradually and with focus lifting the brush off. You could count, "One, two, three" while drawing the beginning, middle, and end parts of the stroke (fig. 54).

When two strokes are combined, the ending dewdrop of the first stroke also serves as the beginning dewdrop of the second. In this case, you could count, "One, two; one, two, three." (For a line where three strokes are combined, count, "One, two; one, two; one, two, three.") A line that lacks appropriate beginning, middle, or end looks inadequate.

54. Three elements of a stroke.

THE FOLLOW-THROUGH

When you finish drawing a line, lift the brush off the paper and continue moving the brush in the air to finish the brush movement or to get ready to do the next touchdown (fig. 55). The brush moves through the air, drawing an imaginary arc. An appropriate follow-through not only affects the shape of the end of the stroke but also enables a relaxed sliding of the brush on paper. (In the following chapter, "4" indicates a follow-through brush movement.)

55. Follow-through.

4 THE BASIC STROKES IN FORMAL SCRIPT

HORIZONTAL STROKES

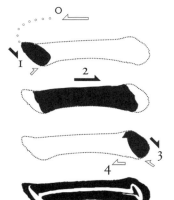

56. Regular horizontal stroke.

Regular Horizontal Stroke (Figure 56)

0. Move the brush counterclockwise leftward through the air before touchdown.
1. Touch down at a 4:30 angle and increase the pressure to make a dewdrop shape. Pause for a moment. Then slightly lift the brush while moving it upward away from you toward the center of the dewdrop.
2. Slide the brush to the right slightly upward, faintly decreasing the pressure and hence the width of the stroke. At midpoint, subtly curve the stroke downward while increasing the pressure so that more of the brush touches the paper to subtly widen the stroke.
3. Bring the tip of the brush away from you against the top contour of the stroke. Press the brush at a 4:30 angle, creating another dewdrop, and let it rest on the paper for a moment. Start releasing pressure while bringing the tip of the brush slightly back to the center of the dewdrop. Then bring the brush leftward lightly over the already drawn line and gradually lift the brush. (The white line inside the bottom image shows the brush movement.)

Gentle Horizontal Stroke (Figure 57)

57. Gentle horizontal stroke.

0. Move the brush counterclockwise leftward through the air before touchdown.
1. Touch down at a 4:30 angle and increase the pressure to make a small dewdrop. (Do not lift the brush.)
2. Slide the brush to the right slightly upward, faintly decreasing the pressure and hence the width of the stroke. At midpoint, subtly curve the stroke downward by increasing the pressure.

3. Bring the tip of the brush away from you against the top contour of the stroke. Press the brush gently at a 4:30 angle, creating another dewdrop, and let it rest on the paper for a moment. Then bring the brush leftward lightly over the already drawn line and gradually lift the brush.

Curved-Up Horizontal Stroke (Figure 58)

0. Move the brush counterclockwise leftward through the air before touchdown.
1. Touch down at a 4:30 angle and increase the pressure to make your small dewdrop. (Do not lift the brush.)
2. Slide the brush to the right, slightly curving upward, faintly increasing the pressure and hence the width of the stroke.
3. Bring the tip of the brush away from you against the top contour of the stroke. Press the brush gently at a 4:30 angle, creating another dewdrop, and let it rest on the paper for a moment. Then bring the brush leftward lightly over the already drawn line and gradually lift the brush.

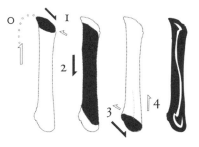

58. Curved-up horizontal stroke.

VERTICAL STROKE (FIGURE 59)

0. Move the brush clockwise upward through the air before touchdown.
1. Touch down at a 4:30 angle and increase the pressure to make your dewdrop. Pause for a moment. Then slightly lift the brush while faintly moving the tip of the brush toward the center of the dewdrop.
2. Think of drawing a very subtle S shape. Slide the brush down toward you, faintly decreasing the pressure to subtly narrow the stroke. At midpoint increase the pressure to subtly widen the stroke.
3. Bring the tip of the brush away from you against the left contour of the stroke. Press the brush at a 4:30 angle, creating another dewdrop, and let it rest on the paper for a moment. Start releasing pressure while bringing the tip of the brush slightly back to the center of the dewdrop. Then bring the brush upward away from you lightly over the already drawn line and gradually lift the brush.

59. Vertical stroke.

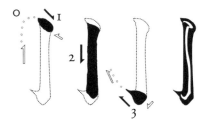

60. Vertical stroke with a hook.

VERTICAL STROKE WITH A HOOK (FIGURE 60)

0. Move the brush clockwise upward through the air before touchdown.
1. Touch down at a 4:30 angle and increase the pressure to make a dewdrop. Pause for a moment. Then slightly lift the brush while faintly moving the tip of the brush toward the center of the dewdrop.
2. Think of drawing a very subtle S shape. Slide the brush down toward you, faintly decreasing the pressure and hence the width of the stroke. At midpoint increase the pressure to subtly widen the stroke.
3. Press the brush leftward down at a 7:30 angle for a very short distance while maintaining the pressure. Change the direction of the brush upward to the left at a 10:30 angle while gently decreasing the pressure and width of the stroke and lift the brush off the paper. This will give your stroke a small diagonal tail.

DIAGONAL STROKE LEFTWARD DOWN (FIGURE 61)

0. Move the brush clockwise up and rightward through the air before touchdown.
1. Touch down at a 4:30 angle and increase the pressure to make your dewdrop. Pause for a moment. Then slightly lift the brush while moving it upward left away from you toward the center of the dewdrop.
2. Slide the brush downward left while slightly curving up, and at the same time faintly decrease the pressure and hence the width of the stroke.
3. Slide the brush off from the paper by lifting it while increasing the clockwise curve.
4. Follow through by moving the brush in the air clockwise.

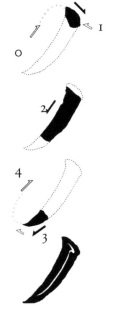

61. Diagonal stroke leftward down.

BENT VERTICAL STROKE (FIGURE 62)

0. Move the brush clockwise upward through the air before touchdown.
1. Touch down at a 4:30 angle and subtly increase the pressure to make your dewdrop, then slightly lift the brush.
2. Slide the brush vertically while slightly bending toward the left, increasing the pressure to widen the stroke.
3. Bring the tip of the brush away from you against the left contour of the stroke. Press the brush at a 4:30 angle, creating another dewdrop, and let it rest on the paper for a moment. Then bring the brush lightly over the already drawn line upward away from you and gradually lift the brush.
4. Follow through by moving the brush in the air clockwise.

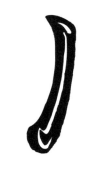

62. Bent vertical stroke.

DIAGONAL STROKE RIGHTWARD DOWN (FIGURE 63)

0. Move the brush upward and then counterclockwise rightward through the air before touchdown.
1. Touch down in a rightward horizontal (3:00) direction and then subtly increase the pressure to make a tiny dewdrop.
2. Slide the brush rightward down at a 4:30 angle, gradually increasing pressure to widen the stroke to the point where about half the bristle is in contact with the paper. Think of the X point in figure 63, which is on an invisible extension of the top contour of the stroke drawn so far.
3. Slowly gather all strands of the bristle to point X while the brush sweeps off while moving in the same (4:30) direction. (Do not change the direction of the brush movement.)
4. Follow through by moving the brush counterclockwise in the air.

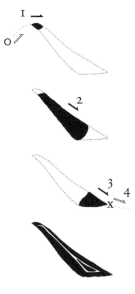

63. Diagonal stroke rightward down

DIAGONAL STROKE RIGHTWARD UP (FIGURE 64)

0. Move the brush counterclockwise rightward down through the air before touchdown.

64. Diagonal stroke
rightward up.

1. Touch down at a 4:30 angle and increase the pressure to make your dewdrop. Pause for a moment. Then slightly lift the brush while moving it upward left toward the center of the dewdrop.
2. Slide the brush upward right, slightly curving up and faintly decreasing the pressure and hence the width of the stroke.
3. Slide the brush off from the paper by lifting it while increasing the counterclockwise curve.
4. Follow through by moving the brush counterclockwise in the air.

DOTS

Each dot is a full short stroke, which consists of the beginning dewdrop, the middle line, and the ending dewdrop, which is at times followed by a tail.

Basic Dot (Figure 65)

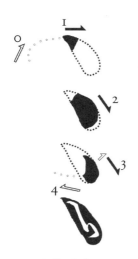

65. Basic dot.

0. Move the brush clockwise upward through the air before touchdown.
1. Touch down in an almost horizontal (3:00) direction and then subtly increase the pressure to make a tiny dewdrop.
2. Slightly slide the brush downward right, increasing the pressure to widen the stroke.
3. Bring the tip of the brush away from you against the top contour of the stroke. Press the brush at a 7:30 angle, creating another dewdrop, and let it rest on the paper for a moment. Start releasing pressure while bringing the tip of the brush slightly upward left and take it off.
4. Follow through by moving the brush clockwise in the air.

Leftward-Down Dot (Figure 66)

66. Leftward-down dot.

0. Move the brush clockwise upward through the air before touchdown.
1. Touch down at a 4:30 angle and then subtly increase the pressure to make a tiny dewdrop.
2. Slightly slide the brush at a 7:30 angle, increasing the pressure to widen the stroke.

3. Bring the tip of the brush away from you against the left contour of the stroke. Press the brush at a 4:30 angle, creating another dewdrop, and let it rest on the paper for a moment. Start releasing pressure while bringing the tip of the brush slightly upward right and take it off.
4. Follow through by moving the brush counterclockwise upward in the air.

Standing Dot (Figure 67)

0. Move the brush clockwise upward through the air before touchdown.
1. Touch down at a 4:30 angle and then subtly increase the pressure to make a tiny dewdrop.
2. Slightly slide the brush vertically down but faintly toward the left, increasing the pressure to widen the stroke.
3. Bring the tip of the brush away from you against the left contour of the stroke. Press the brush at a 4:30 angle, creating another dewdrop, and let it rest on the paper for a moment. Start releasing pressure while bringing the tip of the brush slightly upward right and take it off.
4. Follow through by moving the brush counterclockwise upward in the air.

67. Standing dot.

VERTICAL-TO-HORIZONTAL STROKE WITH A ROUNDED JOINT (FIGURE 68)

0. Move the brush clockwise upward through the air before touchdown.
1. Touch down at a 4:30 angle and then subtly increase the pressure to make a dewdrop. Slightly lift the brush.
2. Slide the brush vertically downward, subtly curving toward the left. Make a gently round turn toward the right and continue the brush movement by drawing horizontally, subtly curving up.
3. Bring the brush upward right for a very short distance while maintaining the pressure and width of the stroke. Change the direction of the brush upward while gently decreasing the pressure and width of the stroke. Then lift the brush off the paper. This will give your stroke a small upward tail.

68. Vertical-to-horizontal stroke with a rounded joint.

4. Follow through by moving the brush in the air counter-clockwise.

COMBINED STROKES (FIGURES 69, 70)

69. Combined strokes, vertical and horizontal.

70. Combined strokes, diagonal rightward up and diagonal leftward down.

Two basic strokes can be combined with a dewdrop as a joint. Three strokes can also be combined with two dewdrops. In that case, count between the strokes. Such lines are counted as one stroke in dictionaries of ideographs. As I suggested earlier, you could count "One, two; one, two, three" or "One, two; one, two; one, two, three." Thus, the ending dewdrop of the first line serves as the beginning of the second line.

5 APPLIED STROKES
IN SEMICURSIVE AND
CURSIVE SCRIPTS

SOFT STROKES

Lines in semicursive and cursive scripts have movements similar to those in formal scripts. Drawn lines, however, are often soft and curvy in these scripts (fig. 71). The transitions from pressing-down points to extending lines, and vice versa, are gentler and more gradual than those in formal script. Some lines in semicursive and cursive scripts are connected by ligatures.

71. "Two" in soft strokes, semicursive script.

CONNECTED STROKES

Forms in semicursive and cursive scripts can be quite complex, as some brush movements combine a number of strokes in one continuous line (fig. 72). There is, however, no need to memorize all movements before you start. You can pause at any joint where a dewdrop-shaped pressure is applied, then observe and see how the next line goes. In fact, feel free to pause in many places for as long as you want. Your lines will still be continuous.

72. "Ten thousand" in soft strokes, semicursive script.

LIGATURES

While all strokes are primary and must be fully drawn in formal script, ligatures—or connecting thread-like lines—can be broken in semicursive and cursive scripts (fig. 73). Nonetheless, these invisible ligatures suggest a continuous movement of the brush in the air.

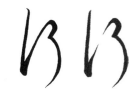

73. "Action" with a continuous ligature (left), and with a broken-off ligature (right), cursive script.

6 ASPECTS OF IDEOGRAPHY

PRONUNCIATION

Although ideography is a common writing system in most parts of East Asia, characters are often pronounced differently, as these regions have different languages. For example, the symbol 山, meaning "mountain," is pronounced "shan" in Chinese. It is pronounced "san" in Korean, and "sơn" (pronounced similarly to "sun" or "son" in English) in Vietnamese. The Sino-Japanese sound of this character is "san." On the other hand, "yama" is its indigenous Japanese sound. In this way, there are usually two or more pronunciations for each ideograph in Japanese.

There are many characters with the same sound in ideography. For example, for the sound "san" ("mountain") in Japanese, there are 202 characters listed in *Shin Jigen,* a medium-sized dictionary of ideographs.

The Chinese language basically has four different tones per vowel, although some of its dialects have more tones. The four tones are: the first or upper even tone (i.e., ā), the second or rising tone (i.e., á) , the third or lower-rising tone (i.e., ǎ), and the fourth or falling tone (i.e., à). There is also the neutral tone, which has no diacritical mark. For "shan" ("mountain"), fourteen characters coexist with the same tone (the first tone); also, forty-six characters with different tones of the same sound are listed in *Mathews' Chinese-English Dictionary.*

RADICALS

There are more than 220 signs that are used in forming all ideographs. They are called radicals, meaning root signs. Many radicals are independent ideographs that are also used as part of another ideograph. Some shapes of radicals are altered—flattened or narrowed—to be part of another character. For example, the ideograph for "water" is the radical for forming ideographs related to water—such as "sea," "lake," and "wave."

In the case of "water," either the original shape or a narrowed shape form part of the ideographs in the "water" category (figs. 74, 75).

In dictionaries, radicals are arranged in order of the number of strokes. Characters in each category are also arranged in order of the number of additional strokes. (See the "List of Radicals" appendix for a list of all radicals in the unabridged system and the simplified Japanese system.)

PARTS OF SPEECH

As I suggested earlier, the ideographs "sun" and "moon" are put together to form the ideograph " bright," also meaning "clear." In this way, two common nouns combine to become an adjective. Further, this ideograph can mean "brightness," "brighten," "light," "clarify," and "knowledge." Thus, one symbol can be used not only as an adjective but also as a verb, a common noun, and an abstract noun according to the context in which it is used.

STANDARD AND VARIED FORMS

Due to the long history of ideography, the ways people wrote individual characters varied in some cases. For example, the ideograph for "soil" (土) was sometimes written with a dot on the right side (fig. 76). It was not uncommon that the ideograph for "not" (無) was written in an alternative way consisting of fewer strokes (无). When we study calligraphy with ancient classical pieces, we often encounter such examples.

Eventually the most commonly used forms have been recognized as the standard forms, and modern dictionaries of ideographs follow this convention. And yet, many dictionaries include some of the varied forms.

SIMPLIFIED FORMS

There was a universal way of writing, which can be called the traditional or unabridged ideographs, in most parts of East Asia until the end of World War II. However, in 1946 the

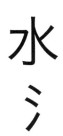

74. Two types of the "water" radical: the full form (top) and the narrow form (bottom).

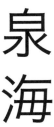

75. The full form of the water radical in "fountain" (top) and the narrow form in "ocean" (bottom).

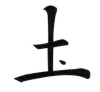

76. A varied form of "soil."

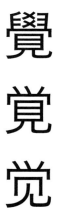

77. Three styles of "awake": unabridged (top), simplified Japanese (middle), and simplified Chinese (bottom).

Japanese government standardized and simplified a number of complex characters, and the government of the People's Republic of China did the same with its own writing system in 1956. These are referred to as simplified Japanese and simplified Chinese, respectively. (Very basic characters as well as infrequently used characters were left unchanged by both the Japanese and the Chinese governments.) In Taiwan, the unabridged way of writing is still used. Thus, there are three versions of ideographs both in writing and in typography (fig. 77).

7 MODES OF STUDY

Beginning a calligraphy practice with the study of ancient master samples, which I am suggesting in this book, is unique. It goes counter to the usual way of initially studying the standard brush movements with a manual written by a contemporary master.

I find it extremely useful, however, that we who study calligraphy, including beginners, become familiar with different ways of drawing lines by emulating great masters from the past. For example, instead of learning a set of conformed horizontal lines in a manual, we observe a great variety of horizontal lines from the celebrated pieces. In this way we become surrounded by amazingly imaginative calligraphic art that helps shape our aesthetics and techniques. There is no better way to study East Asian calligraphy than this.

There are five modes of studying an ancient sample: (1) a close study, (2) an interpretation of the brush flow, (3) an interpretation of the energy behind the brush movement, (4) an expressive work inspired by the sample, and (5) improvisation.

A *close study* means faithfully reproducing a sample. That consists of studying the shape and direction of each line and the composition of lines in each ideograph. The composition has to do with determining the length and positioning of each line and creating a relationship among lines and between lines and space (figs. 78, 79).

In a close study you do not need to try to make a perfect reproduction of the original. The brush is not a camera or a photocopy machine. Thus, no one can make an exact reproduction of even a single line. We are human beings, and each line we draw is slightly or vastly different from another line we draw. Rather, drawing each line in a close study is a process of learning as much as possible from the original. This is the ultimate way of training with calligraphic discipline, in which the process can continue for a lifetime. Each time, we learn something new.

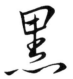

78. "Black," semicursive script by Wang Xizhi.

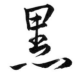

79. A close study of figure 78.

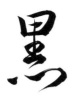

80. An interpretation of the brush flow of figure 78.

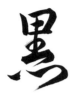

81. An interpretation of the energy of figure 78.

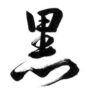

82. An expressive work inspired by figure 78.

83. An improvisation inspired by figure 78.

An *interpretation of the brush flow* focuses on the movement of the brush while not necessarily being concerned with the shapes and directions of the lines. In contrast to a close study that involves study of multiple aspects of each ideograph, the study of the brush flow can be concentrated on the continuous and consistent movement of the brush, which is an important element of calligraphic creativity (fig. 80). Because this is your own interpretation, you can change the speed and pressure of the brush in the way you like and exaggerate one part or another of the ideograph. As in interpretation of music, the original needs to be recognizable. That means you still maintain the form of an ideographic symbol.

An *interpretation of the energy behind the brush movement* focuses on capturing and reproducing the poetry, spirit, and inner quality of the ancient artists through their brush traces. It is perfectly fine that your interpretation is different from others' or from your own interpretation at another time. The integrity of the form as a written character still needs to be maintained (fig. 81).

An *expressive work inspired by the sample* is your own creative work resulting from a close study and interpretation of an original. This is where you freely render your own voice and develop your style of expression. Again, here the form of the written character will be maintained (fig. 82).

An *improvisation* is a brush drawing related to your study of the original sample. You are no longer bound to the written form. You can add or reduce lines to the point where they are nonideographic abstract forms. You have total freedom in your brushwork (fig. 83).

Thus, there is a wide range of calligraphic study you can conduct. You can be highly disciplined at one point and be completely free at another. Your disciplined study can be strengthened by your free exercises and vise versa. Discipline and freedom are the two feet of creativity. The most effective way of developing creativity is to alternate these opposite exercises.

8 THE MENTAL APPROACH

BE DECISIVE

When you draw lines and write a character, you may find some parts unsatisfactory and have an urge to touch up such lines. But it is best to draw all lines decisively without making corrections. You might like to repeat drawing lines on the same sheet of paper in order to try to improve them. Touching up makes your work look better in some cases, but you may become dependent on it. The more you learn to accept unsatisfactory lines as they are, the more your decisiveness will naturally increase.

Your brush's bristle may become split in the course of drawing, but try to keep using the brush as it is without reconditioning it or adding ink until you finish your ideograph. When necessary, recondition the brush before drawing another character.

SLOW IS BEAUTIFUL

Do not draw hastily. Take two or three seconds to draw a line. Move your brush as slowly as you move your hands and legs in the exercise of *taiji* (tai chi). In this way you see each brush movement and learn to enjoy each moment more fully.

BREATHE

It is natural to exhale when you exert force. The initial contact of the brush to the paper is not easy. Therefore, inhale before the contact and exhale when the brush touches down. Changing direction with the brush takes effort. Pause while you inhale, then exhale while moving the brush in another direction. Finishing a stroke also takes attention. Again, pause while you inhale, then exhale while finishing the stroke.

Breathing can be done as "one, two, three" when you move the brush in three parts—beginning, middle, and ending of

each stroke. However, breathing should not be mechanical but mindful and natural.

SMILE

I recommend smiling when you hold the brush. Keep smiling with your whole body and heart as long as you have the brush in your hand. It doesn't have to be a visible smile like "cheese," but just maintain an invisible sense of joy. Smiling relaxes you and makes the brushwork fluid and attentive.

Part Two

MASTER SAMPLES
AND STUDY

In this part I present on the left-hand pages the three basic scripts—formal, semicursive, and cursive—of 150 ideographs that carry significant cultural implications. The formal-script example is shown first, on the top left, the semicursive-script example on the top right, and the cursive-script example on the lower left (fig. 84). The samples are all taken from ancient masterpieces of the classical and postclassical periods.

Sample images. Although most original pieces on paper from the classical period have been lost, many have survived in the form of reproductions carved on stone. Traditionally, calligraphers study rubbings of such works, where characters appear white against black backgrounds (fig. 85). The photographically inverted images of these works have been printed and are available in the public domain (fig. 86). The original size of each character is usually smaller than one square inch (2.5 cm). The images presented hereafter have been enlarged and restored by way of repairing corrupted lines and touching up in order to facilitate your study (fig. 87).

Types. I present the typographical representation of the traditional, unabbreviated form of each sample ideograph. When they differ, I also show the simplified Japanese and simplified Chinese forms.

Meanings. The ideographs are arranged by their representative English meanings in alphabetical order. Alternative meanings are also presented.

Pronunciations. The Chinese sound or pronunciation in the Pinyin transliteration is presented with a diacritical mark to represent one of the four tones. Its Wade-Giles equivalent is shown in parentheses. The two types of Japanese pronunciations are shown—first the Sino-Japanese (followed by a semicolon), then the indigenous Japanese pronunciations. Korean and Vietnamese pronunciations are also presented.

Classification. The radical of each ideograph with its

84. Position of the three scripts in the following left-hand pages: formal script, semicursive script, cursive script.

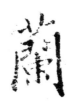

85. The ideograph for "orchid" from a stone rubbing (see fig. 102).

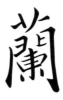

86. An inverted image of fig. 85.

87. A restored version of fig. 85, presented in this book.

number of strokes, as well as additional and total numbers of strokes, are shown.

Artists. The artists' names are shown in Pinyin transliteration. The dates and brief descriptions of the artists are presented in the appendix "List of Ancient Chinese Artists."

Etymology. The etymological explanations of ideographs are based on *Shin Jigen* (a medium-sized Japanese dictionary of ideographs).

Pictographs or seal script. Samples of pictographs or early stone-carved ideographs are presented.

Stroke order. The sequence of brush movements in formal script is presented on the bottom of the page. The numbers are placed at the beginnings of strokes, thus also indicating the directions of the strokes. The stroke order in semicursive or cursive script is explained in an accompanying note only when it differs from that of the formal script. The stroke order of ideographs has been, by and large, uniform in East Asia but has varied in some cases by times and regions.

Study. In order to show how calligraphers re-create brush movements from ancient examples, I show my own handwritten samples on the right-hand pages (fig. 88). These samples are a suitable size for copying. My sample studies consist of the following modes:

88. A sample masterpiece on the left-hand page and the author's close study on the right-hand page.

pp. 37–95	Close reproduction of a shown sample
pp. 97–155	Interpretative reproduction of the brush flow
pp. 157–215	Close reproduction
pp. 217–275	Interpretative reproduction of the energy
pp. 277–315	Expressive work
pp. 317–337	Improvisational work

The mode of study on the right-hand page is indicated on the bottom of the facing page. My groups of brush samples are intended to demonstrate cycles of progressive stages of study and creative work—from close and faithful reproduction to interpretation of the brush flow and energy of the ancient masters, then on to my own creative work inspired by the examples. I recommend that you repeat this cycle in your own study if you wish to deepen your practice.

Suggested way of using this part. You might like to skim through this section and pick some ideographs to view closely, regardless of the sequence of their appearance. Feel free to take a brush and draw whichever ideographs that may appeal to you.

ACTION

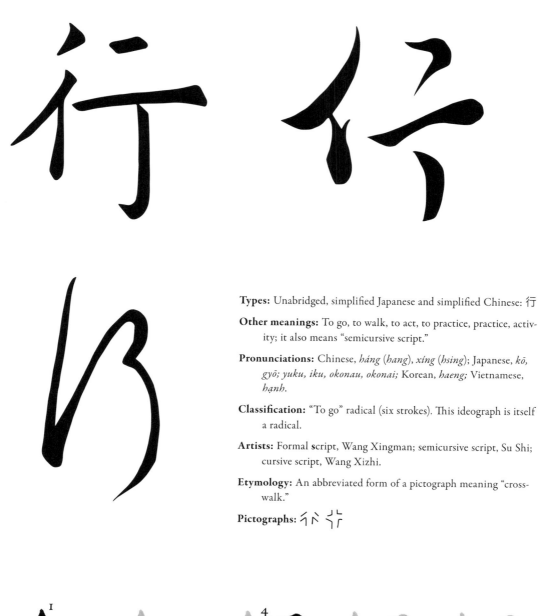

Types: Unabridged, simplified Japanese and simplified Chinese: 行

Other meanings: To go, to walk, to act, to practice, practice, activity; it also means "semicursive script."

Pronunciations: Chinese, *háng (hang)*, *xíng (hsing)*; Japanese, *kō, gyō; yuku, iku, okonau, okonai;* Korean, *haeng;* Vietnamese, *hạnh.*

Classification: "To go" radical (six strokes). This ideograph is itself a radical.

Artists: Formal script, Wang Xingman; semicursive script, Su Shi; cursive script, Wang Xizhi.

Etymology: An abbreviated form of a pictograph meaning "crosswalk."

Pictographs: 彳亍 彳亍

 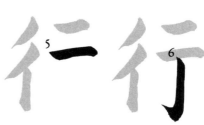

A close study of the formal script ➤

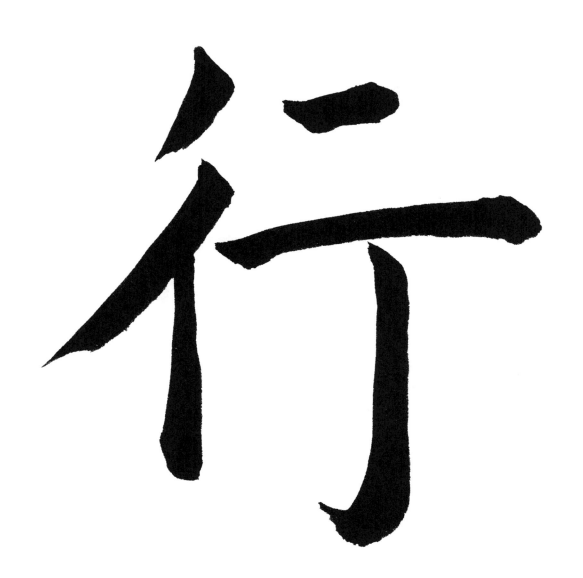

ANCIENT

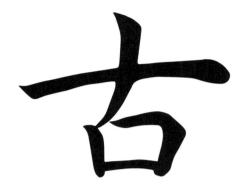

Types: Unabridged, simplified Japanese and Chinese: 古

Other meanings: Old, traditional, authentic.

Pronunciations: Chinese, *gǔ (ku)*; Japanese, *ko; furui, inishie;* Korean, *go;* Vietnamese, *cô.*

Classification: "Mouth" radical (bottom, three strokes) plus "ten" on top (two strokes). Total: five strokes.

Artists: Formal script, Yu Shinan; semicursive script, Wang Xizhi; cursive script, Wang Duo.

Etymology: The "mouths" of speakers in "ten" generations, which means "olden times."

Pictograph: 出 吕

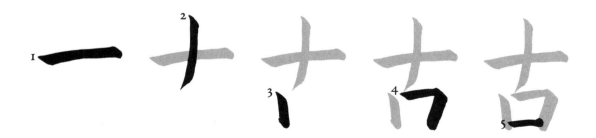

A close study of the formal script ➤

古

AUTUMN

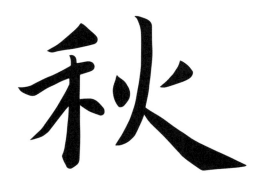
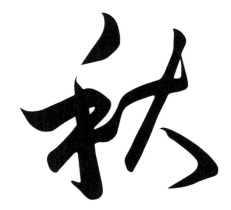

Types: Unabridged, simplified Japanese and Chinese: 秋

Other meanings: (None.)

Pronunciations: Chinese, *qiū* (*ch'iu*); Japanese, *shū; aki;* Korean, *chu;* Vietnamese, *thu.*

Classification: "Rice plant" radical (left, five strokes) plus four strokes. Total: nine strokes.

Artists: Formal script, Yu Shinan; semicursive script, Wang Xizhi; cursive script, Huaisu.

Etymology: "Rice plant" plus the sound indicator 火 (*huo,* which turned into *qiu*), meaning "to assemble."

Seal script: 秌

Note: The common stroke order used today is 1, 3, 2 . . .

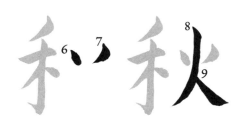

A close study of the formal script ➤

秋

AWAKE

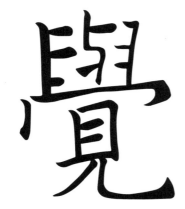

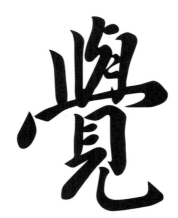

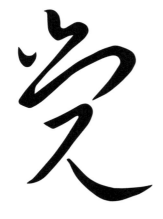

Types: Unabridged: 覺; simplified Japanese: 覚

Other meanings: To wake up, to enlighten, to remember, remembrance.

Pronunciations: Chinese, *jué (chüeh)*, *jiào (chiao)*; Japanese, *kaku; sameru, satoru, oboeru;* Korean, *gyo, gak;* Vietnamese, *giác*.

Classification: "To see" radical (bottom, seven strokes) plus thirteen strokes. Total: twenty strokes.

Artists: Formal script, Chu Suiliang; semicursive script, Dong Qichang; cursive script, Wang Xianzhi.

Etymology: "To see" on the bottom, plus the sound indicator for *jiao,* meaning "clear" or "clearly."

Seal script: 覺

Note: The formal-script sample shows an archaic formation. See the unabridged type and the stroke order for the standard traditional form.

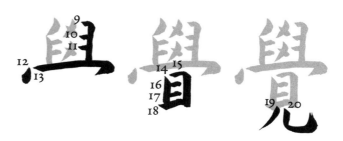

A close study of the formal script ➤

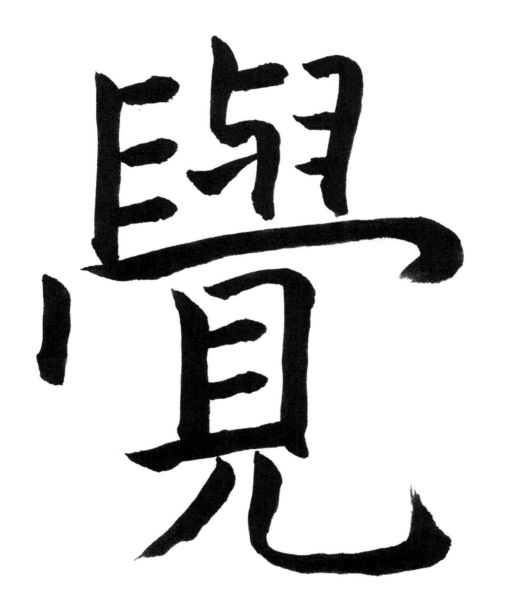

AWAKENED ONE

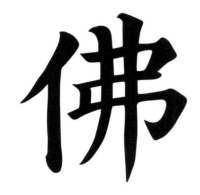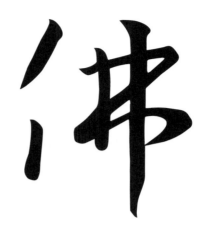

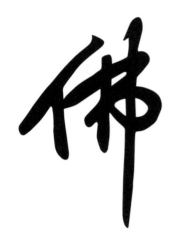

Types: Unabridged, simplified Chinese: 佛; simplified Japanese: 仏

Other meanings: Buddha, a buddha.

Pronunciations: Chinese, *fó* (*fò*); Japanese, *butsu; hotoke;* Korean, *bul;* Vietnamese, *phật.*

Classification: "Human" radical (left, two strokes) plus five strokes. Total: seven strokes.

Artists: Formal script, Yan Zhenqing; semicursive script, Wang Xizhi; cursive script, Huang Tingjian.

Etymology: "Human" on the left, plus "fu" (representing a sound meaning "indistinguishable") on the right. A simplified form for the ideographs 佛陀 (*fótuó* in Chinese and *butsuda* in Japanese—transliterations of the Sanskrit word *Buddha*).

Seal script: 佛

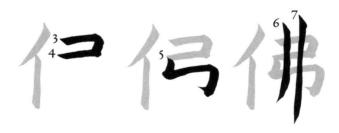

A close study of the formal script ➤

佛

BAMBOO

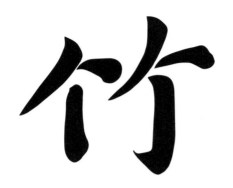 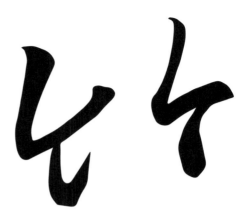

Types: Unabridged, simplified Japanese and Chinese: 竹

Pronunciations: Chinese, *zhú* (*chu*); Japanese, *chiku; take;* Korean, *juk;* Vietnamese, *trúc.*

Classification: "Bamboo" radical (six strokes). This ideograph is itself a radical.

Artists: Formal script, Yan Zhenqing; semicursive script, Wang Xizhi; cursive script, Su Shi.

Etymology: Picture of bamboo trees standing side by side.

Pictographs: ＋＋

A close study of the formal script ➤

竹

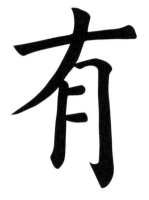

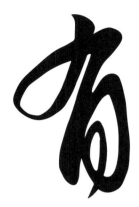

Types: Unabridged, simplified Japanese and Chinese: 有

Other meanings: To exist, to have, existence, possession, some.

Pronunciations: Chinese, *yǒu* (*yu*); Japanese, *u, yū; aru;* Korean, *yu;* Vietnamese, *hŭu.*

Classification: "Moon" radical (bottom, four strokes) plus two strokes. Total: six strokes.

Artists: Formal script, Chu Suiliang; semicursive script, Yan Zhenqing; cursive script, Wang Xizhi.

Etymology: The top two strokes, pronounced *you* in Chinese, meaning "to offer." The bottom four-stroke part is now classified as "moon" but was originally another symbol with the same shape, meaning "meat." This ideograph originally meant, "Here is a feast (for you)."

Seal script: 𣌾𣌾𣌾

Note: The common stroke order used today is 2, 1 . . .

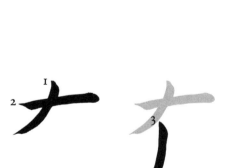

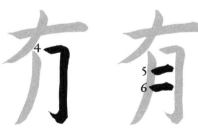

A close study of the formal script ➤

有

BEAUTIFUL

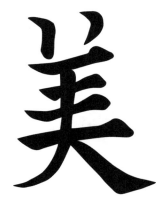

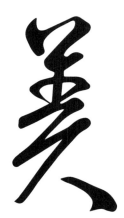

Types: Unabridged, simplified Japanese and Chinese: 美

Other meanings: Good, delicious, beauty, elegant.

Pronunciations: Chinese, *měi* (*mei*); Japanese, *bi; utsukushii, yoi;* Korean, *mi;* Vietnamese, *mỹ.*

Classification: "Sheep" radical (top, six strokes) plus three strokes. Total: nine strokes.

Artists: Formal script, Ouyang Tong; semicursive script, Mi Fu; cursive script, Sun Guoting.

Etymology: A simplified form of "sheep" on top, plus "large" or "fat," meaning "delicious."

Seal script: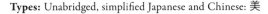

Note: In the formal script and the type samples, the vertical and the leftward-down strokes are connected. But it is usually written as in the stroke order below.

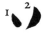

A close study of the formal script ➤

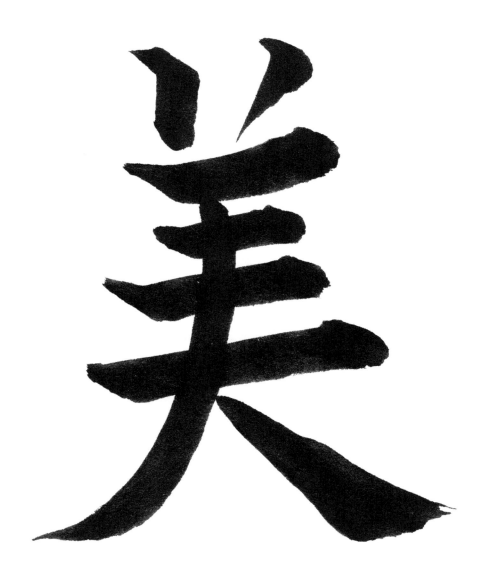

BIG

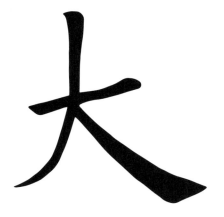

Types: Unabridged, simplified Japanese and Chinese: 大

Other meanings: Great, large.

Pronunciations: Chinese, *dà* (*ta*); Japanese, *dai, tai; ōkii;* Korean, *dae;* Vietnamese, *đại.*

Classification: "Big" radical (three strokes). This ideograph is itself a radical.

Artists: Formal script, Ouyang Xun; semicursive and cursive scripts, Wang Xizhi.

Etymology: Originally a pictograph of a person with spread arms and legs.

Pictograph: 大 大 大

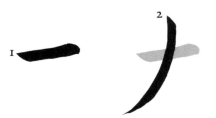

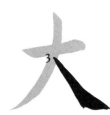

A close study of the formal script ➤

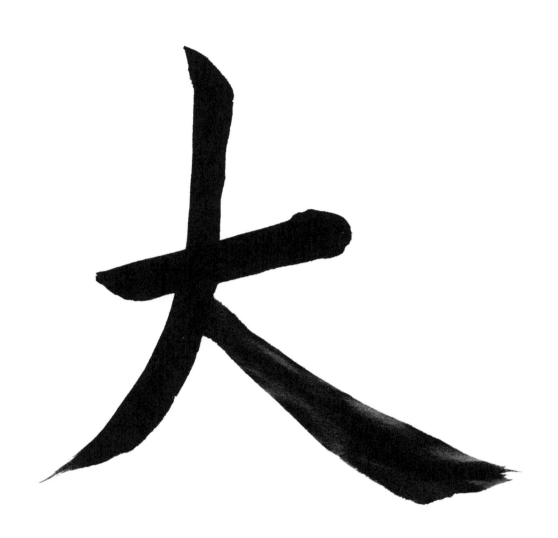

BIRD

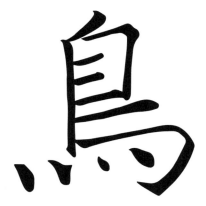 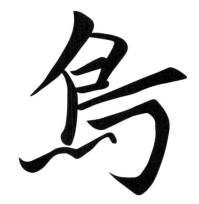

Types: Unabridged, simplified Japanese: 鳥; simplified Chinese: 鸟

Pronunciations: Chinese, *niǎo* (*niao*); Japanese, *chō; tori;* Korean, *jo;* Vietnamese, *điểu.*

Classification: "Bird" radical (eleven strokes). This ideograph is itself a radical.

Artists: Formal script, Chu Suiliang; semicursive script, Zhao Mengtiao; cursive script, Huaisu.

Etymology: A picture of a large bird.

Pictograph:

Note: The formal-script sample shows an archaic formation. See the unabridged type and the stroke order for the standard traditional form.

A close study of the formal script ➤

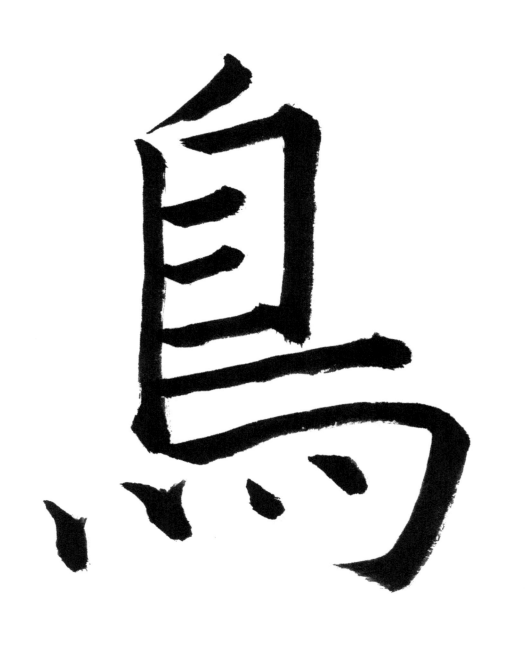

BLACK

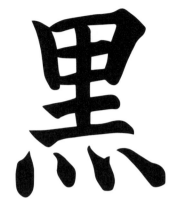

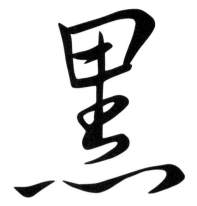

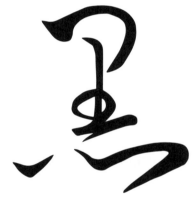

Types: Unabridged, simplified Chinese: 黑; simplified Japanese: 黒

Other meanings: Dark, dusk.

Pronunciations: Chinese, *hēi* (*hei*); Japanese, *koku; kuroi;* Korean, *heuk;* Vietnamese, *hắc.*

Classification: "Black" radical (twelve strokes). This ideograph is itself a radical.

Artists: Formal script, anonymous (*Five Sutras*); semicursive script, Wang Xizhi; cursive script, Wang Duo.

Etymology: A pictograph showing lumps of soot that are stuck (in a chimney)—the first five strokes—and a flame underneath.

Pictograph: 㷠㷠㷠

Note: The formal-script sample shows a simplified formation. See the unabridged type and the stroke order for the standard traditional form.

A close study of the semicursive script ➤

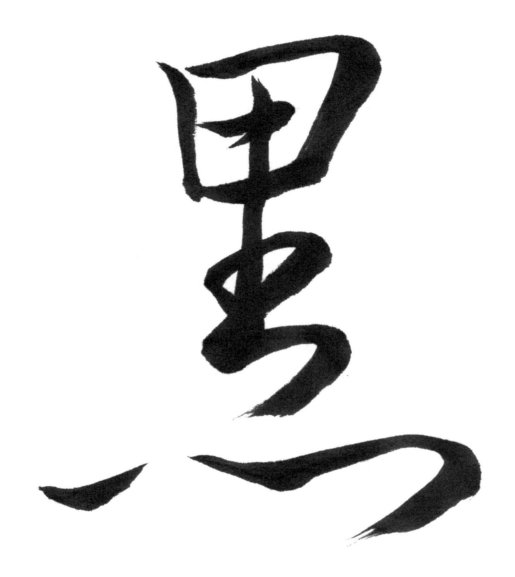

BLUE

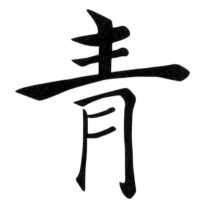

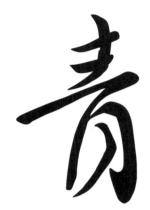

Types: Unabridged: 靑; simplified Japanese and Chinese: 青

Other meanings: Green, young.

Pronunciations: Chinese, *qīng* (*ch'ing*); Japanese, *sei; aoi;* Korean, *cheong;* Vietnamese, *thanh.*

Classification: "Blue" radical (eight strokes). This ideograph is itself a radical.

Artists: Formal script, Chu Suiliang; semicursive script, Yan Zhenqing; cursive script, Sun Guoting.

Etymology: The pictograph "dye taken from a pit" on the bottom, plus a transformed shape of the pictograph *sheng* (生), meaning "sprouting grass." Originally meaning "green dye."

Seal script:

Note: The formal-script sample shows a simplified formation. See the unabridged type and the stroke order for the standard traditional form.

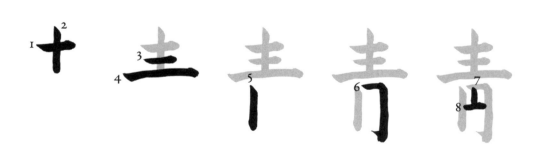

A close study of the semicursive script ➤

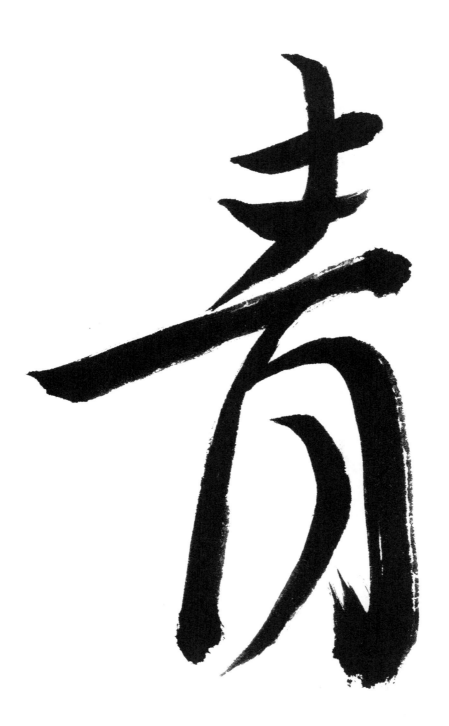

BREAKTHROUGH

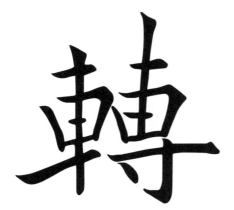

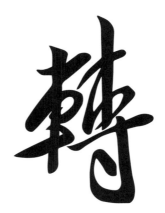

Types: Unabridged: 轉; simplified Japanese: 転; simplified Chinese: 转

Other meanings: To turn, to roll, to rotate, to change, to shift, to tumble.

Pronunciations: Chinese, *zhuǎn, zhuàn (chuan)*; Japanese, *ten; meguru, utsuru, korobu;* Korean, *jeon;* Vietnamese, *chuyên.*

Classification: "Wheel" radical (left, seven strokes) plus eleven strokes. Total: eighteen strokes.

Artists: Formal script, Ouyang Tong; semicursive script, Mi Fu; cursive script, Huaisu.

Etymology: "Wheel," plus the sound indicator *zhuan* (專), meaning "to rotate."

Seal script: 轉 轉

Note: The formal-script sample shows a simplified formation. See the unabridged type and the stroke order for the standard traditional form.

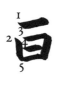 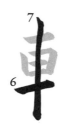 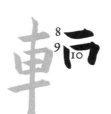 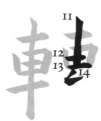 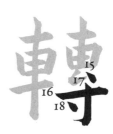

A close study of the semicursive script ➤

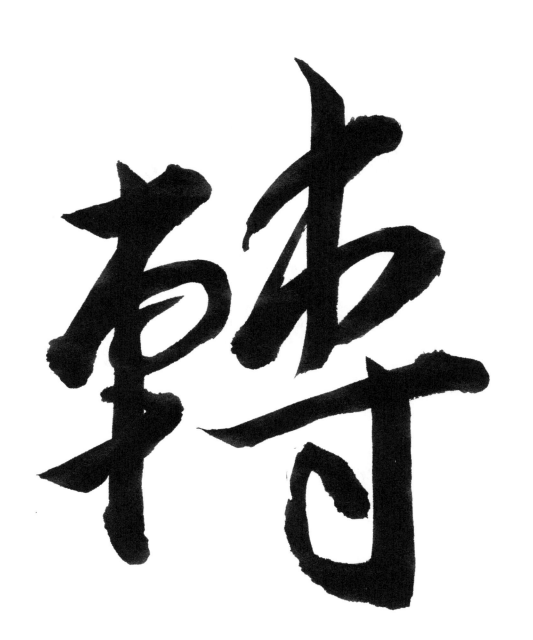

BREATH

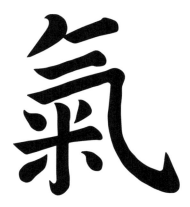
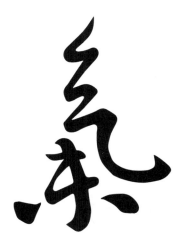

Types: Unabridged: 氣; simplified Japanese: 気; simplified Chinese: 气

Other meanings: Atmosphere, feeling, energy, spirit.

Pronunciations: Chinese, *qi* (*ch'i*); Japanese, *ki; iki;* Korean, *gi;* Vietnamese, *khí.*

Classification: "Breath" radical (top and right, four strokes) plus six strokes. Total: ten strokes.

Artists: Formal script, Yu Shinan; semicursive script, Emperor Tai; cursive script, Wang Xianzhi.

Etymology: The "breath" radical was originally used in this case as a sound indicator for *qian* (遣), meaning "to send." The bottom six strokes mean "rice." This ideograph used to mean "sending food," but later it came to signify "breath."

Seal script: 氣 縈 氋

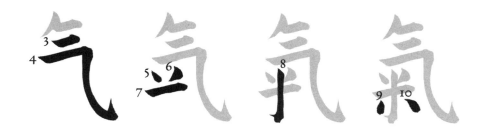

A close study of the semicursive script ➤

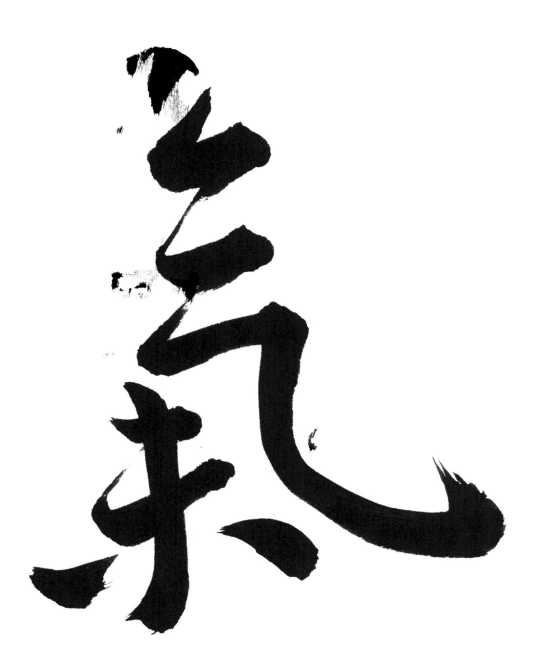

BROAD

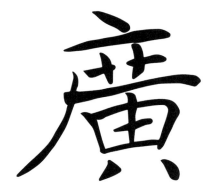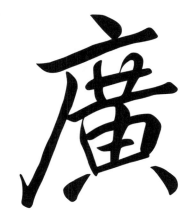

Types: Unabridged: 廣; simplified Japanese: 広; simplified Chinese: 广

Other meanings: Expansive, to expand, to broaden, to spread.

Pronunciations: Chinese, *guǎng* (*kuan*); Japanese, *kō; hiro, hiroi;* Korean, *gwang*; Vietnamese, *quǎng*.

Classification: "Shelter" radical (top and left, three strokes) plus twelve strokes. Total: fifteen strokes.

Artists: Formal script, Chu Suiliang; semicursive script, Li Yong; cursive script, Wang Xizhi.

Etymology: The radical meaning "roof," plus a sound indicator *huang* (黄, yellow), in this case meaning "to spread." This ideograph originally meant an "extended roof."

Seal script: 廣 廣 廣

Note: The formal-script sample shows an archaic formation. See the unabridged type and the stroke order for the standard traditional form.

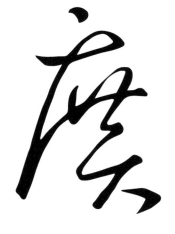

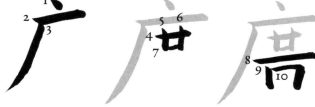

A close study of the semicursive script ➤

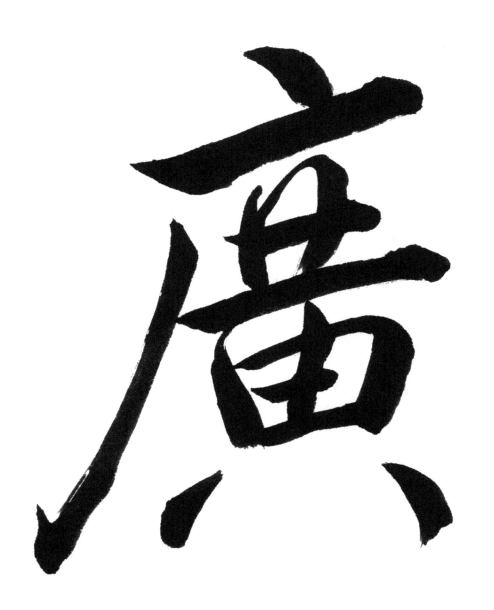

BRUSH

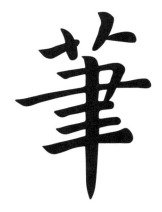

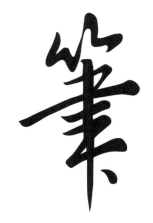

Types: Unabridged; simplified Japanese: 筆; simplified Chinese: 笔

Other meanings: Writing, painting, authorship.

Pronunciations: Chinese, *bǐ (pi)*; Japanese, *hitsu; fude;* Korean, *pil;* Vietnamese, *bút.*

Classification: "Bamboo" radical (top, six strokes) plus six strokes. Total: twelve strokes.

Artists: Formal script, Lady Wei; semicursive script, Mi Fu; cursive script, Sun Guoting.

Etymology: A combination of two ideographs: "bamboo" on top and "brush" on the bottom. The bottom ideograph comes from a pictograph combining a hand and a shaft.

Seal script: 筆

Note: The formal-script sample shows an archaic formation. See the unabridged type and the stroke order for the standard traditional form.

A close study of the semicursive script ➤

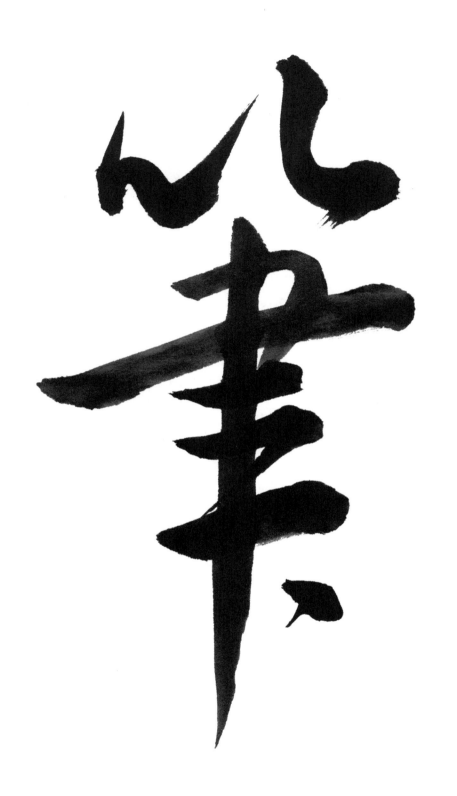

CAPACITY

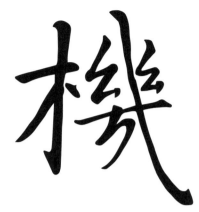

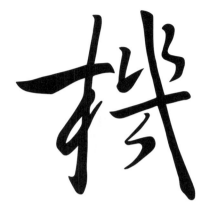

Types: Unabridged, simplified Japanese: 機; simplified Chinese: 机

Other meanings: Occasion, event, timing, talent, person, machine.

Pronunciations: Chinese, *jī* (*chi*); Japanese, *ki; ori;* Korean, *gi;* Vietnamese, *ky, cơ.*

Classification: "Tree" radical (left, four strokes) plus twelve strokes. Total: sixteen strokes.

Artists: Formal script, Zhi Yong; semicursive script, Wang Xizhi; cursive script, Huaisu.

Etymology: "Wood" on the left, plus "weaving device" (*ji*) on the right. The latter consists of two pictographs meaning "thread" on top and "a device for weaving" on the bottom.

Seal script: 機

Note: The formal-script sample shows an archaic formation. See the unabridged type and the stroke order for the standard traditional form.

 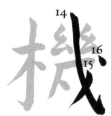

A close study of the semicursive script ➤

揲

CHILD

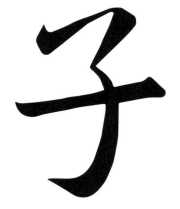
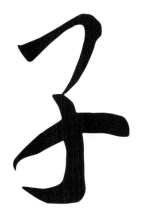

Types: Unabridged, simplified Japanese and Chinese: 子

Other meanings: Man, small, baby.

Pronunciations: Chinese, *zǐ (tzu)*; Japanese, *shi; ko;* Korean, *ja;* Vietnamese, *tǔ.*

Classification: "Child" radical (three strokes). This ideograph is itself a radical.

Artists: Formal script, Ouyang Xun; semicursive script, Wang Xizhi; cursive script, Mi Fu.

Etymology: Originally a pictograph representing a child with a large head and weak limbs.

Pictograph:

A close study of the semicursive script ➤

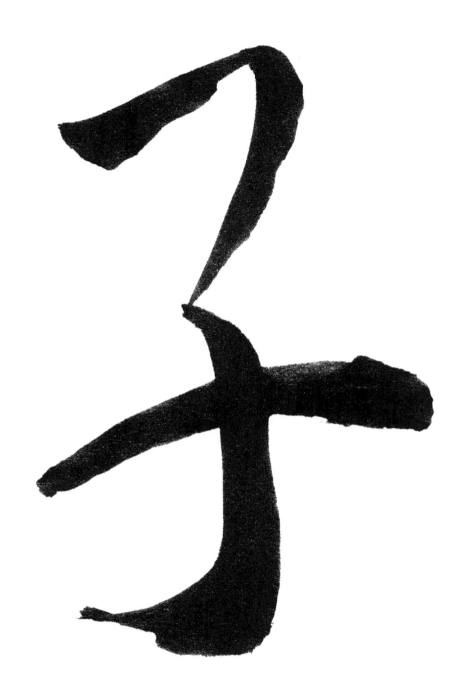

CHRYSANTHEMUM

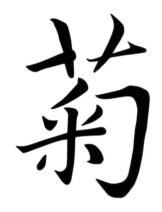

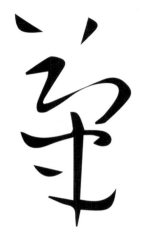

Types: unabridged: 菊; simplified Japanese and Chinese: 菊

Pronunciations: Chinese, *jú (chu)*; Japanese, *kiku;* Korean, *guk;* Vietnamese, *cúc.*

Classification: "Grass" radical (top, four strokes, although classified under 艹—six strokes) plus eight strokes. Total: twelve strokes.

Artists: Formal script, Yu Ji; semicursive script, Zhao Mengtiao; cursive script, Huaisu.

Etymology: "Grass" radical on top, plus *ju* (匊), meaning "cupping with hands" or "a round shape." This ideograph originally means "grass with round flowers."

Seal script: 菊

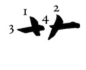 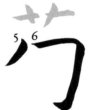

A close study of the semicursive script ➤

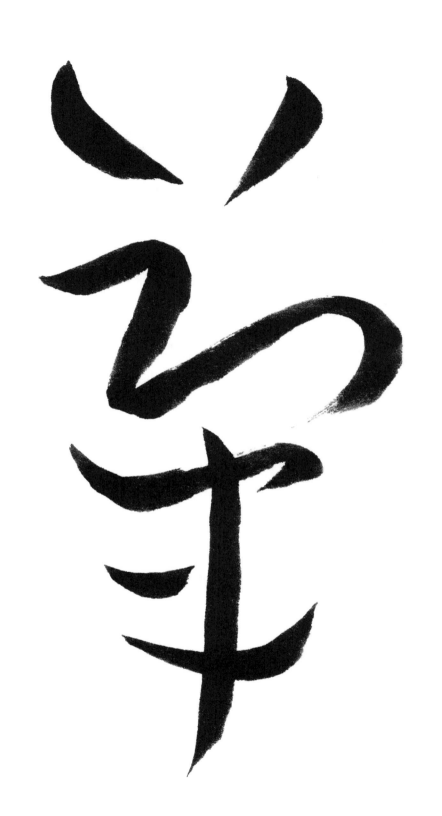

CIRCLE

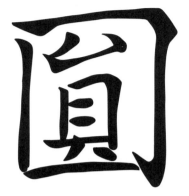 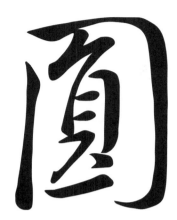

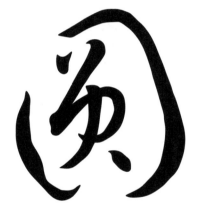

Types: Unabridged: 圓; simplified Japanese: 円; simplified Chinese: 圆

Other meanings: Round, full, complete, coin, money, yen (Japanese currency).

Pronunciations: Chinese, *yuán* (*yuan*); Japanese, *en; marui, madoka;* Korean, *won;* Vietnamese, *viên*.

Classification: "Box" radical (outside, three strokes) plus ten strokes inside. Total: thirteen strokes.

Artists: Formal script, Ouyang Tong; semicursive script, Dong Qichang; cursive script, Sun Guoting.

Etymology: "Enclosure" plus *yuan* inside, meaning "circle" or "to count."

Seal script: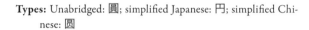

Note: The formal- and semicursive-script samples show an archaic formation. See the unabridged type and the stroke order for the standard traditional form.

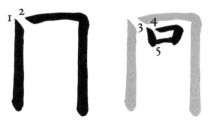 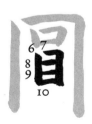 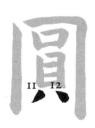 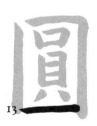

A close study of the semicursive script ➤

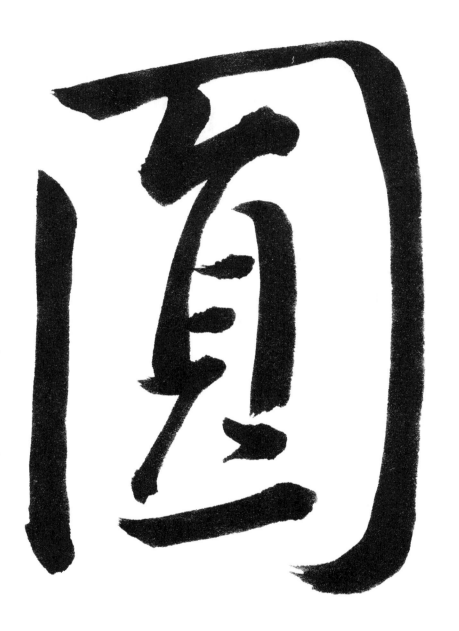

CLARITY

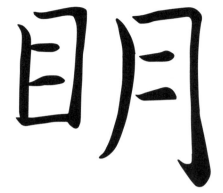
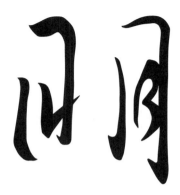

Types: Unabridged, simplified Japanese and Chinese: 明

Other meanings: Clear, bright, brightness, to illuminate, illumination, to clarify, knowledge.

Pronunciations: Chinese, *míng* (ming); Japanese, *mei, myō; akarui, akirameru;* Korean, *myeong;* Vietnamese, *minh.*

Classification: "Sun" radical (left, four strokes) plus four strokes. Total: eight strokes.

Artists: Formal script, Chu Suiliang; semicursive and cursive scripts, Wang Xizhi.

Etymology: The sun (left) and moon (right) together, meaning "a lot of light."

Seal script: ⟨⊕⟩ ⟨◎⟩ ⟨◐⟩

Note: The formal-script sample shows an archaic formation. See the unabridged type and the stroke order for the standard traditional form.

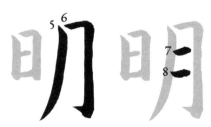

A close study of the cursive script ➤

CLOUD

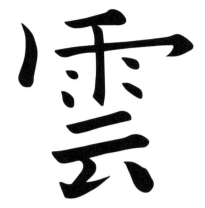
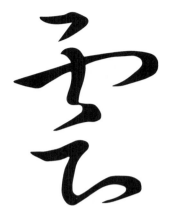

Types: Unabridged, simplified Japanese: 雲; simplified Chinese: 云

Other meanings: To gather.

Pronunciations: Chinese, *yún (yün)*; Japanese, *un; kumo;* Korean, *un;* Vietnamese, *vân.*

Classification: "Rain" radical (top, eight strokes) plus four strokes. Total: twelve strokes.

Artists: Formal script, Chu Suiliang; semicursive script, Wang Xizhi; cursive script, Huaisu.

Etymology: "Rain" on top plus "cloud" (云) on the bottom. The ideograph 云 can also mean "to speak." To avoid confusion, the "rain" ideograph has been added.

Seal script: 雩 雩 ?

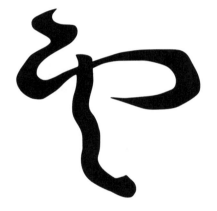

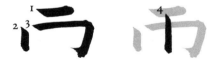

A close study of the cursive script ➤

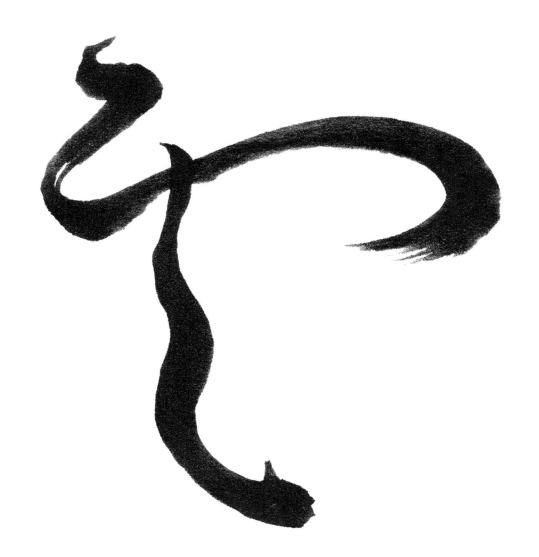

COLOR

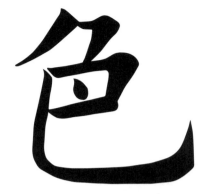
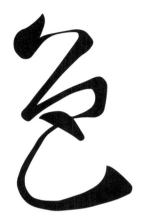
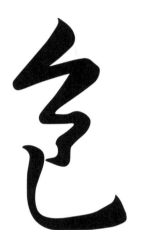

Types: Unabridged, simplified Japanese and Chinese: 色

Other meanings: Form, matter, paint, colorful, attractive, erotic.

Pronunciations: Chinese, *sè* (*se*); Japanese, *shiki; iro;* Korean, *saek;* Vietnamese, *sắc.*

Classification: "Color" radical (six strokes). This ideograph is itself a radical.

Artists: Formal script, Ouyang Xun; semicursive script, Zhi Yong; cursive script, Emperor Tai.

Etymology: Originally a pictograph of a person kneeling down in pursuit of love.

Pictograph: 㞋

A close study of the cursive script ➤

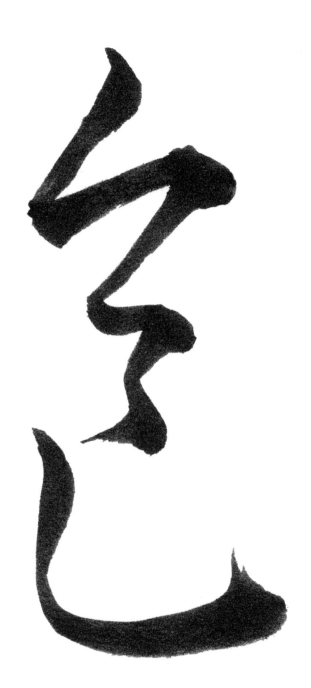

COMPASSION

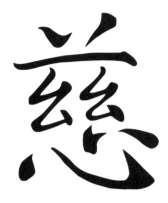

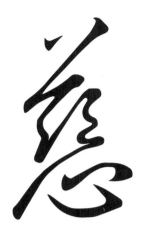

Types: Unabridged, simplified Japanese and Chinese: 慈

Other meanings: To be compassionate.

Pronunciations: Chinese, *cí* (*tz'u*); Japanese, *ji; itsukushimu, itsukushimi;* Korean, *ja;* Vietnamese, *từ.*

Classification: "Heart" radical (bottom, four strokes) plus nine strokes. Total: thirteen strokes.

Artists: Formal script, Zhi Yong; semicursive script, Wang Xizhi; cursive script, Liu Gongquan.

Etymology: "Heart/mind" on the bottom, plus *zi,* meaning "to nurture lovingly" or "to increase family members" on top.

Seal script: 慈慈

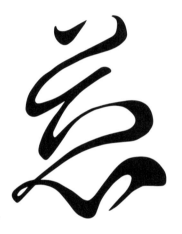

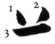
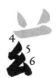
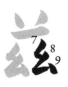
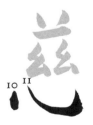
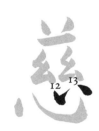

A close study of the cursive script ➤

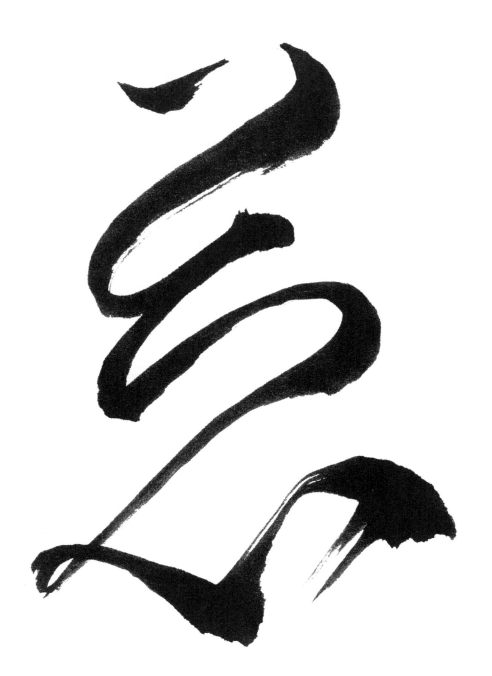

COW

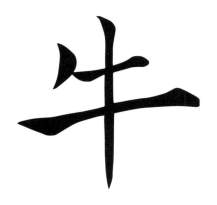

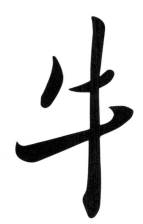

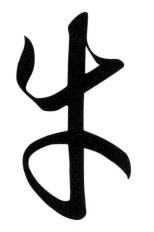

Types: Unabridged, simplified Japanese and Chinese: 牛

Other meanings: Ox, cattle.

Pronunciations: Chinese, *niú* (*niu*); Japanese, *gyū; ushi;* Korean, *u;* Vietnamese, *ngưu*.

Classification: "Cow" radical (four strokes). This ideograph is itself a radical.

Artists: Formal script, Ouyang Xun; semicursive script, Chu Sui-liang; cursive script, Sun Guoting.

Etymology: A picture of a cow's head with horns.

Pictograph:

A close study of the cursive script ➤

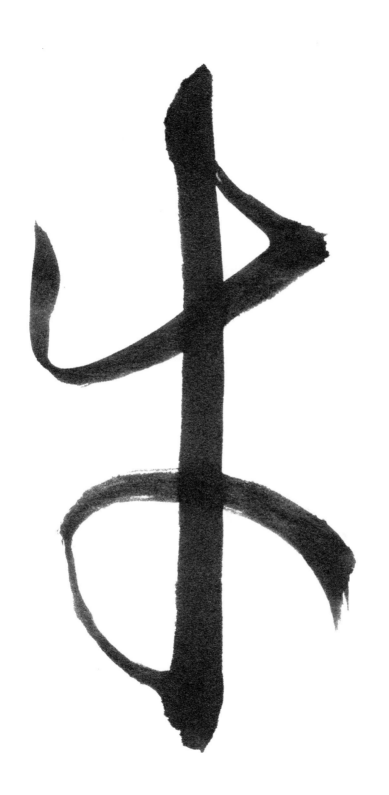

DANCE

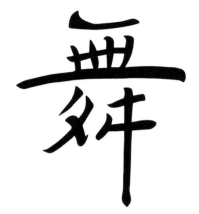

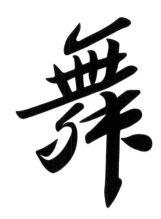

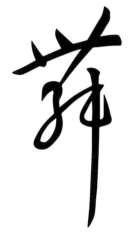

Types: Unabridged, simplified Japanese and Chinese: 舞

Other meanings: To dance.

Pronunciations: Chinese, *wǔ (wu)*; Japanese, *bu; mau, mai;* Korean, *mu;* Vietnamese, *vǔ.*

Classification: "Discord" radical (bottom, classified as six strokes but sometimes written in seven strokes) plus eight strokes. Total: fourteen strokes.

Artists: Formal script, Yu Shinan; semicursive script, Su Shi; cursive script, Sun Guoting.

Etymology: The top part was originally a pictograph of a dancer with long sleeves. Another pictograph of feet facing other directions ("discord") has been added on the bottom.

Pictograph: 𣎴 𣎴 舞

A close study of the cursive script ➤

DELUSION

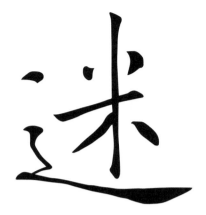
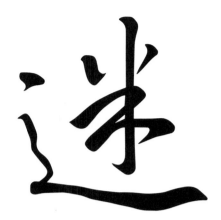

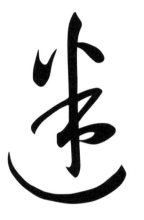

Types: Unabridged, simplified Japanese and Chinese: 迷

Other meanings: To get lost, to be confused.

Pronunciations: Chinese, *mí* (*mi*); Japanese, *mei; mayoi, mayou;* Korean, *mi;* Vietnamese, *tông*.

Classification: "Road" radical (left and bottom, classified as seven strokes but written in three strokes) plus six strokes. Total: nine strokes.

Artists: Formal script, Chu Suiliang; semicursive script, Wang Xizhi; cursive script, Sun Guoting.

Etymology: "Road" on the left and bottom, plus the ideograph "rice," which is used as the sound indicator *mi,* meaning "obscure."

Seal script: 迷

A close study of the cursive script ➤

DHARMA

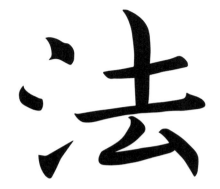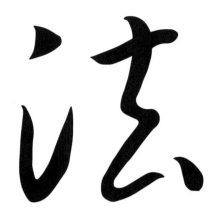

Types: Unabridged, simplified Japanese and Chinese: 法

Other meanings: Truth, law, regulation, method, teaching, phenomenon.

Pronunciations: Chinese, *fǎ* (*fa*); Japanese, *hō; nori;* Korean, *beop;* Vietnamese, *pháp.*

Classification: "Water" radical (left, classified as four strokes but written in three strokes) plus five strokes. Total: eight strokes.

Artists: Formal script, Chu Suiliang; semicursive script, Wang Xizhi; cursive script, Huaisu.

Etymology: "Water," meaning "that which is leveled," plus the ideograph "to take away" or "open the lid." This represents unbiased judgment in court.

Seal script: 灋 灋 法

Note: *Dharma* is originally a Sanskrit word.

A close study of the cursive script ➤

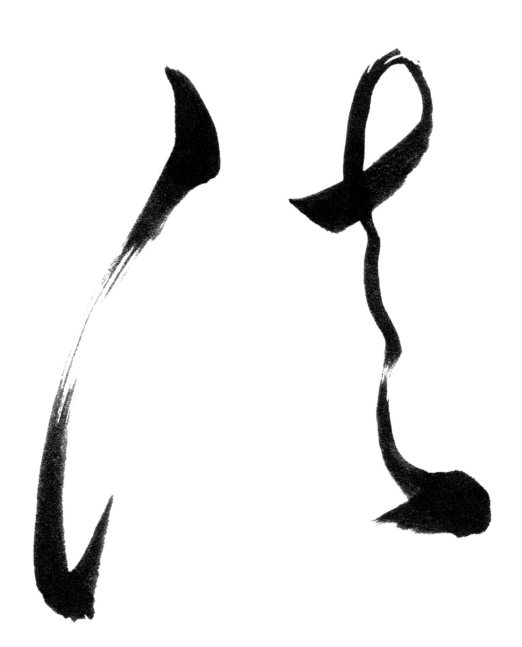

DOWN

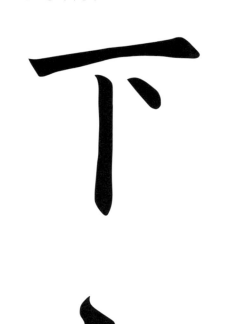

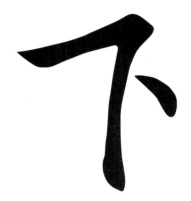

Types: Unabridged, simplified Japanese and Chinese: 下

Other meanings: Low, lowly, bottom, to descend, nearby.

Pronunciations: Chinese, *xià* (*hsia*); Japanese, *ka, ge; shita;* Korean, *ha;* Vietnamese, *hạ.*

Classification: "One" radical (top, one stroke) plus two strokes. Total: three strokes.

Artists: Formal script, Ouyang Xun; semicursive script, Emperor Tai; cursive script, Wang Xizhi.

Etymology: Originally a short horizontal line under the main horizontal line.

Seal script: ⌒ 下 下

Note: The vertical stroke usually touches the horizontal stroke in formal script.

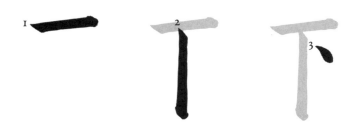

A close study of the cursive script ➤

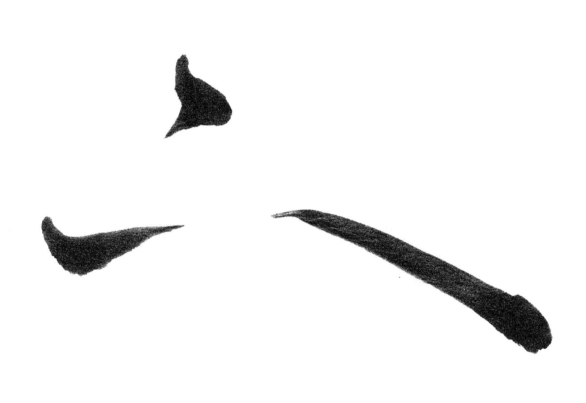

DRAGON

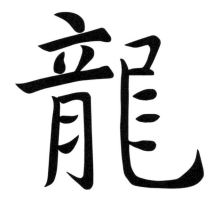
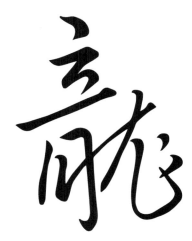
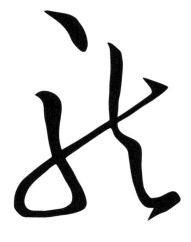

Types: Unabridged: 龍; simplified Japanese: 竜; simplified Chinese: 龙

Other meanings: Excellent person, outstanding practitioner, king.

Pronunciations: Chinese, *lóng* (*lung*); Japanese, *ryū; tatsu;* Korean, *yong, ryong;* Vietnamese, *long.*

Classification: "Dragon" radical (sixteen strokes). This ideograph is itself a radical.

Artists: Formal script, Yu Shinan; semicursive and cursive scripts, Wang Duo.

Etymology: A picture of the mystic serpentine being.

Pictographs:

Note: The formal-script sample shows an archaic formation. See the unabridged type and the stroke order for the standard traditional form.

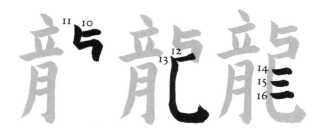

A close study of the cursive script ➤

DREAM

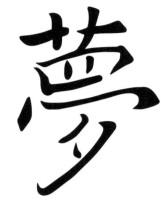 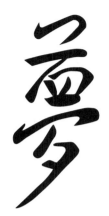

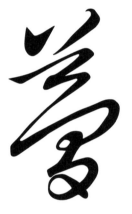

Types: Unabridged: 夢; simplified Japanese: 夢; simplified Chinese: 梦

Other meanings: To dream, fantasy, vision.

Pronunciations: Chinese, *mèng* (*meng*); Japanese, *mu; yume;* Korean, *mong;* Vietnamese, *mộng.*

Classification: "Dusk" radical (bottom, three strokes) plus eleven strokes. Total: fourteen strokes.

Artists: Formal script, Chu Suiliang; semicursive script, Wang Xizhi; cursive script, Zhao Mengtiao.

Etymology: "Dusk" radical on the bottom, plus the sound *meng,* meaning "dark."

Seal script: 夢

An interpretation of the brush flow in the formal script ➤

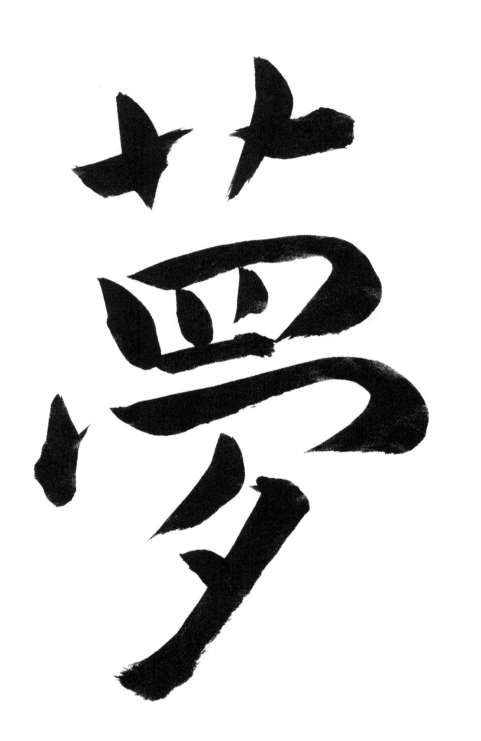

EARTH

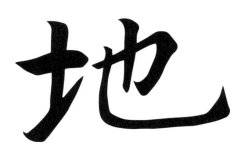

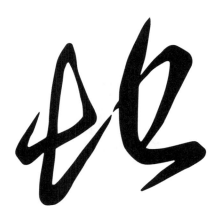

Types: Unabridged, simplified Japanese and Chinese: 地

Other meanings: Ground.

Pronunciations: Chinese, *di* (*ti*); Japanese, *chi; tsuchi;* Korean, *ji;* Vietnamese, *địa.*

Classification: "Soil" radical (left, three strokes) plus three strokes. Total: six strokes.

Artists: Formal script, Zhi Yong; semicursive script, Wang Xizhi; cursive script, Huaisu.

Etymology: "Soil" on the left is originally a pictograph representing a shrine of the earth god. The right ideograph, *di,* is used as a sound indicator meaning "spreading extensively."

Seal script: 墬 坤

An interpretation of the brush flow in the formal script ➤

地

EAST

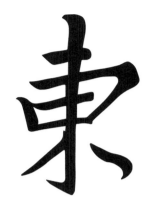

Types: Unabridged, simplified Japanese: 東; simplified Chinese: 东

Other meanings: To go toward the east.

Classification: "Tree" radical 木 (four strokes) plus four strokes. Total: eight strokes.

Pronunciations: Chinese, *dōng* (*tung*); Japanese, *tō; higashi;* Korean, *dong;* Vietnamese, *dông.*

Artists: Formal script, Ouyang Xun; semicursive script, Wang Xizhi; cursive script, Sun Guoting.

Etymology: A picture of the sun rising behind a tree.

Pictograph: ⧫⧫⧫

An interpretation of the brush flow in the formal script ➤

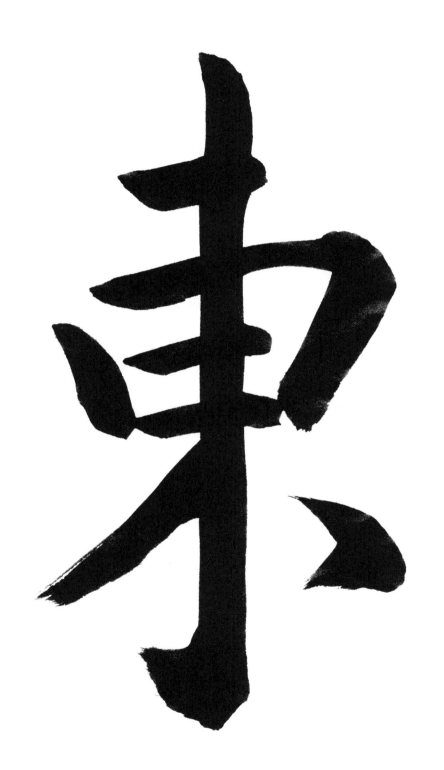

EIGHT

Types: Unabridged, simplified Japanese and Chinese: 八

Pronunciations: Chinese, *bā* (*pa*); Japanese, *hachi; ya, yattsu;* Korean, *pal;* Vietnamese, *bát.*

Classification: "Eight" radical (two strokes). This ideograph is itself a radical.

Artists: Formal script, Yu Shinan; semicursive script, Zhi Yong; cursive script, Wang Xizhi.

Etymology: Originally an ideograph of two lines going down toward opposite directions.

Seal script: 八

An interpretation of the brush flow in the formal script ➤

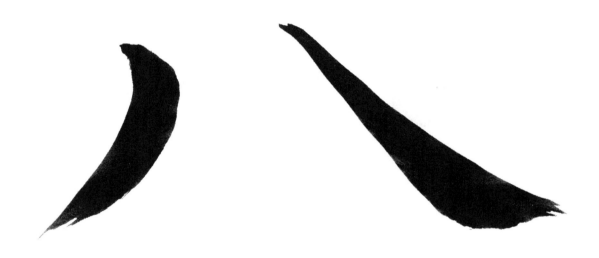

EMPTINESS

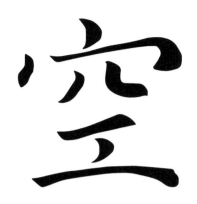

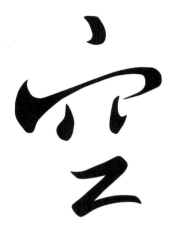

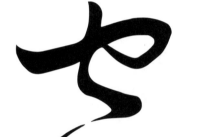

Types: Unabridged, simplified Japanese and Chinese: 空

Other meanings: Empty, vacant, boundless, boundlessness, sky.

Pronunciations: Chinese, *kōng* (*k'ung*); Japanese, *kū; sora, munashii;* Korean, *gong;* Vietnamese, *không.*

Classification: "Cave" radical (top, five strokes) plus three strokes. Total: eight strokes.

Artists: Formal script, Chu Suiliang; semicursive script, Wang Xizhi; cursive script, Zhang Xu.

Etymology: The top part is originally a pictograph representing the entrance of a cave. The bottom ideograph of three strokes is *gong,* meaning "chisel" or "to work with a chisel." Thus, *kong* means "a hole made with a chisel," which is empty.

Seal script: 𤵸 𡧄

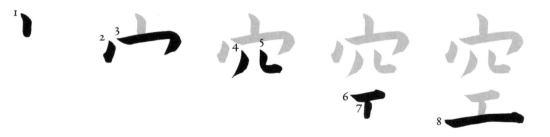

An interpretation of the brush flow in the formal script ➤

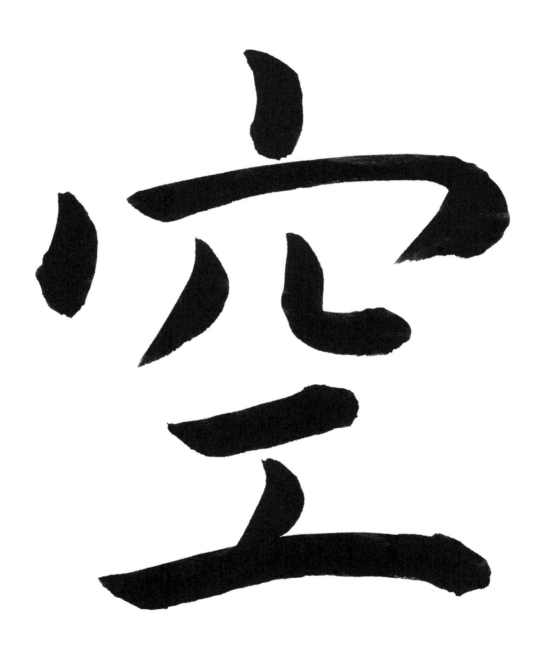

ENJOYMENT

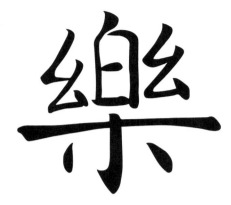
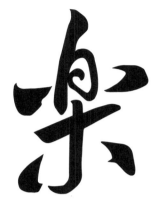

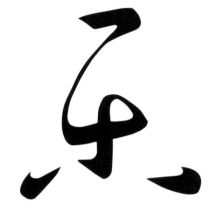

Types: Unabridged: 樂; simplified Japanese: 楽; simplified Chinese: 乐

Other meanings: To enjoy, music, bliss, easy.

Pronunciations: Chinese, *yuè* (*yüeh*), *lè* (*lê*); Japanese, *raku, gaku; tanoshimu, tanoshimi;* Korean, *rak, nak;* Vietnamese, *lạc.*

Classification: "Tree" radical (bottom, four strokes) plus eleven strokes. Total: fifteen strokes.

Artists: Formal script, Chu Suiliang; semicursive script, Mi Fu; cursive script, Sun Guoting.

Etymology: "Wood" on the bottom, plus two pictographs of "string" on both sides of the top. This means a "string instrument." The middle ideograph between the "strings" is *bai,* meaning "to speak."

Seal script: 𡴪 𣱕 樂

An interpretation of the brush flow in the formal script ➤

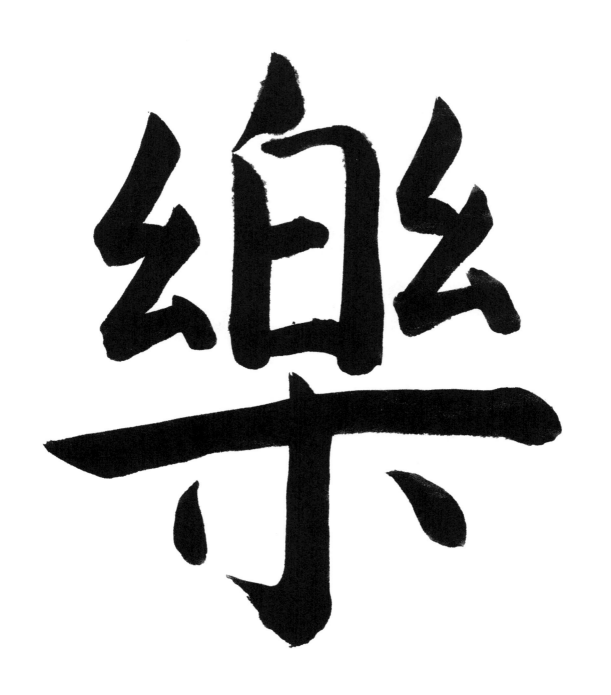

ENLIGHTENMENT

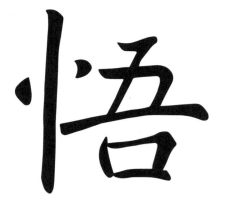 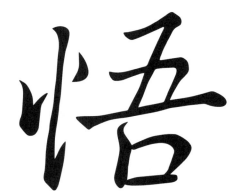

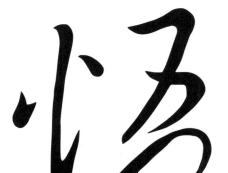

Types: Unabridged, simplified Japanese and Chinese: 悟

Other meanings: To be enlightened, to realize, to be awakened, realization.

Pronunciations: Chinese, *wù (wu)*; Japanese, *go; satori, satoru;* Korean, *o;* Vietnamese, *ngô.*

Classification: "Heart" radical (left, classified as four strokes but often written in three strokes) plus seven strokes. Total: ten strokes.

Artists: Formal script, Chu Suiliang; semicursive and cursive scripts, Wang Xizhi.

Etymology: The left symbol is "heart" or "mind" in a condensed form, plus "self" on the right side.

Seal script:

An interpretation of the brush flow in the formal script ➤

悟

ETERNITY

Types: Unabridged, simplified Japanese and Chinese: 永

Other meanings: Eternal, timeless, timelessness, long time.

Pronunciations: Chinese, *yŏng* (*yung*); Japanese, *ei; nagai;* Korean, *yeong;* Vietnamese, *vĩnh.*

Classification: "Water" radical 水 (bottom, four strokes) plus one stroke. Total: five strokes.

Artists: Formal script, Ouyang Xun; semicursive script, Wang Xizhi; cursive script, Zhi Yong.

Etymology: A river (top) and its tributaries (bottom), meaning "long distance," then "long time." In the pictograph below, a river is represented by the line on the right.

Pictograph: 永 永 永

An interpretation of the brush flow in the formal script ➤

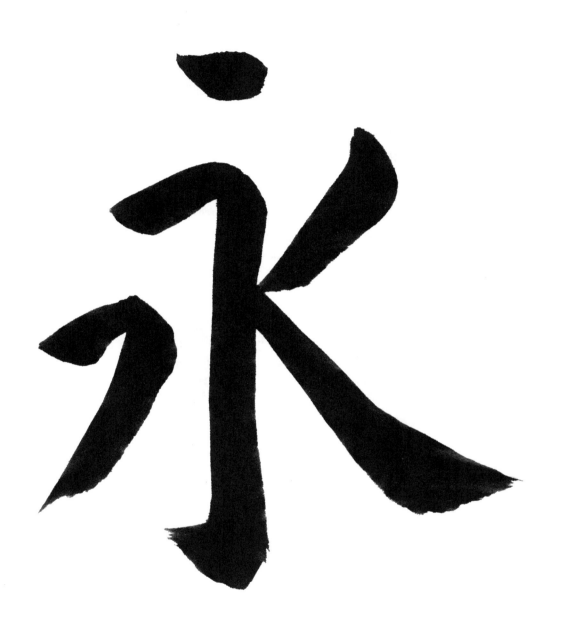

EYE

Types: Unabridged, simplified Japanese and Chinese: 目

Other meanings: Eyeball, to look, to gaze, wood grain.

Pronunciations: Chinese, *mù (mu)*; Japanese, *moku; me;* Korean, *mok;* Vietnamese, *mục*.

Classification: "Eye" radical (five strokes). This ideograph is itself a radical.

Artists: Formal script, Xue Yao; semicursive script, Wang Xianzhi; cursive script, Zhi Yong.

Etymology: Originally a picture of an eye. Later it was rotated.

Pictograph:

An interpretation of the brush flow in the formal script ➤

FACE

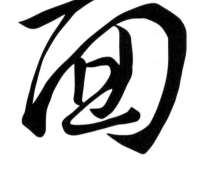

Types: Unabridged, simplified Japanese and Chinese: 面

Other meanings: To face, to meet, surface, outside, front, honor, noodle.

Pronunciations: Chinese, *miàn* (*mieh*); Japanese, *men; omote;* Korean, *myeon;* Vietnamese, *diện.*

Classification: "Face" radical (nine strokes). This ideograph is itself a radical.

Artists: Formal script, Chu Suiliang; semicursive script, Wang Xizhi; cursive script, Yu Shinan.

Etymology: Originally a picture of a neck with a circle around it.

Pictograph:

An interpretation of the brush flow in the formal script ➤

FIRE

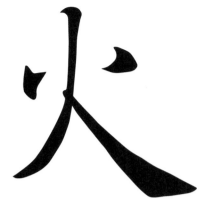
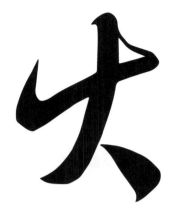

Types: Unabridged, simplified Japanese and Chinese: 火

Other meanings: To light, to burn.

Pronunciations: Chinese, *huǒ* (*huo*); Japanese, *ka; hi;* Korean, *hwa;* Vietnamese, *hỏa.*

Classification: "Fire" radical (four strokes). This ideograph is itself a radical.

Artists: Formal script, Zhi Yong; semicursive script, Wang Shou-ren; cursive script, Sun Guoting.

Etymology: Originally a pictograph representing a flame.

Pictograph: 火

An interpretation of the brush flow in the semicursive script ➤

FISH

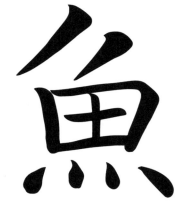

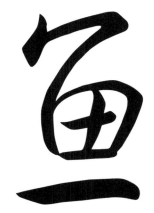

Types: Unabridged, simplified Japanese: 魚; simplified Chinese: 鱼

Other meanings: To fish.

Pronunciations: Chinese, *yú* (*yu*); Japanese, *gyo; uo, sakana;* Korean, *eo;* Vietnamese, *ngư.*

Classification: "Fish" radical (eleven strokes). This ideograph is itself a radical.

Artists: Formal script, Zhi Yong; semicursive script, Wang Xizhi; cursive script, Su Shi.

Etymology: A picture of a fish.

Pictograph:

An interpretation of the brush flow in the semicursive script ➤

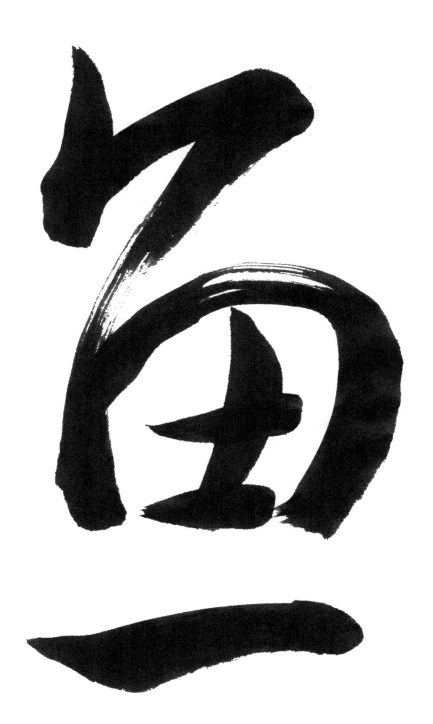

FIVE

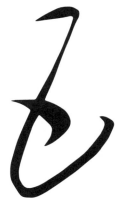

Types: Unabridged, simplified Japanese and Chinese: 五

Other meanings: Fifth.

Pronunciations: Chinese, *wŭ (wu);* Japanese, *go; itsutsu;* Korean, *o;* Vietnamese, *ngŭ.*

Classification: "Two" radical (top and bottom, two strokes) plus two strokes. Total: four strokes.

Artists: Formal and cursive scripts, Yu Shinan; semicursive script, Wang Xizhi.

Etymology: Originally a pictograph of a spool.

Pictograph: ⊠ ⊠ ⊟

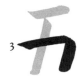

An interpretation of the brush flow in the semicursive script ➤

FLOWER

Types: Unabridged: 花; simplified Japanese and Chinese: 花

Other meanings: Blossom.

Pronunciations: Chinese, *huā* (*hua*); Japanese, *ka; hana;* Korean, *hwa;* Vietnamese, *hoa.*

Classification: "Grass" radical (top, four strokes, although classified under 艸—six strokes) plus four strokes. Total: eight strokes.

Artists: Formal script, Chu Suiliang; semicursive script, Emperor Tai; cursive script, Wang Duo.

Etymology: The top part is originally a pictograph meaning "grass." The bottom character, *hua,* means "transform" or "beautiful."

Seal script: None. This ideograph was formed later than the time of seal script.

An interpretation of the brush flow in the semicursive script ➤

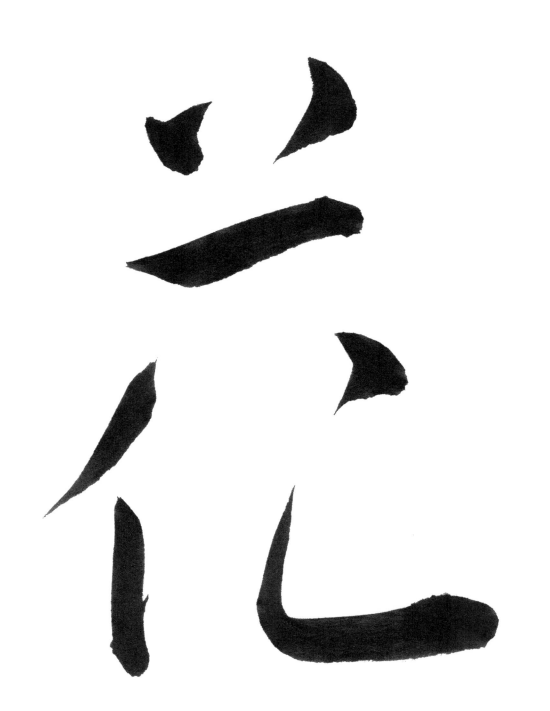

FLY

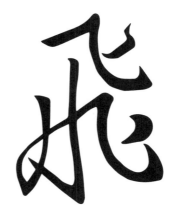

Types: Unabridged, simplified Japanese: 飛; simplified Chinese: 飞

Other meanings: To jump, to run fast, to splash.

Pronunciations: Chinese, *fēi* (*fei*); Japanese, *hi; tobu;* Korean, *bi;* Vietnamese, *phi.*

Classification: "To fly" radical (nine strokes). This ideograph is itself a radical.

Artists: Formal script, Yu Shinan; semicursive script, Wang Xizhi; cursive script, Huaisu.

Etymology: Originally a pictograph of a bird flapping its wings.

Pictograph: 𨾑

Note: The formal-script sample shows an archaic formation. See the unabridged type and the stroke order for the standard traditional form.

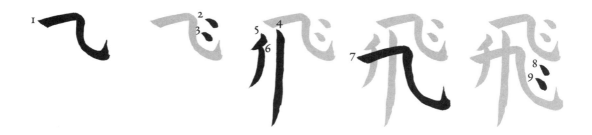

An interpretation of the brush flow in the semicursive script ➤

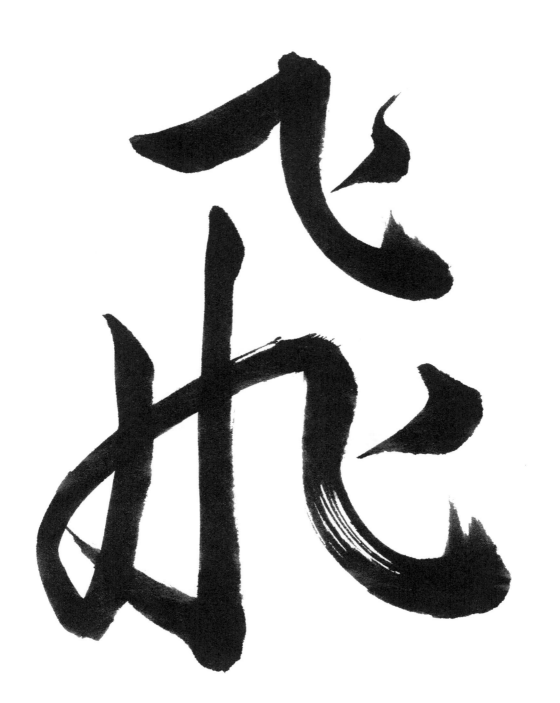

FORM

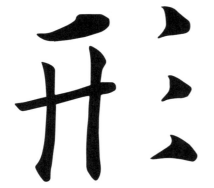
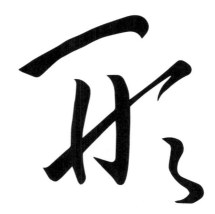

Types: Unabridged, simplified Japanese and Chinese: 形

Other meanings: Shape, contour, design.

Pronunciations: Chinese, *xíng* (*hsing*); Japanese, *kei, gyō; kata, katachi;* Korean, *hyeong;* Vietnamese, *hình.*

Classification: "Streaks" radical (right, three strokes) plus four strokes. Total: seven strokes.

Artists: Formal script, Ouyang Xun; semicursive script, Sun Guoting; cursive script, Huaisu.

Etymology: "Streak" or "ray" radical on the right, plus *jing* (井), meaning "shape," originally a wooden frame of a well. The left part of the present ideograph originally came from *jing.*

Seal script: 形

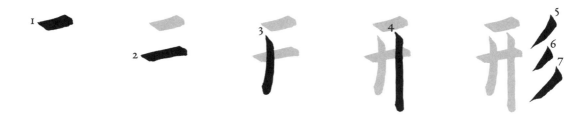

An interpretation of the brush flow in the semicursive script ➤

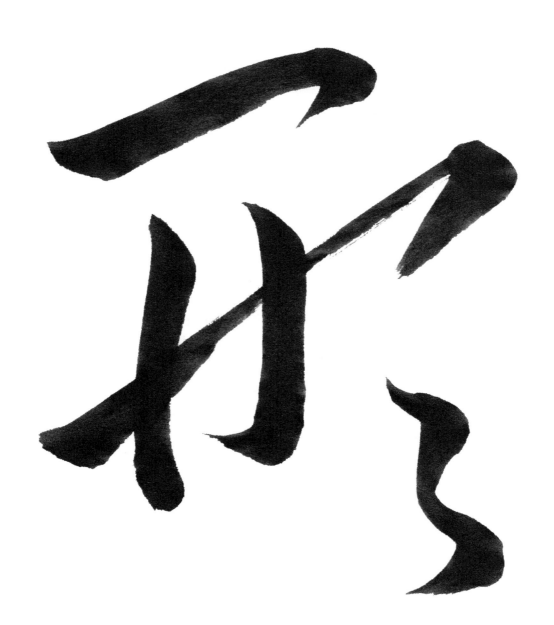

FOUR

Types: Unabridged, simplified Japanese and Chinese: 四

Other meanings: Fourth.

Pronunciations: Chinese, *sì* (*ssu*); Japanese, *shi; yotsu, yottsu;* Korean, *sa;* Vietnamese, *tứ.*

Classification: "Box" radical (outside, three strokes) plus two strokes inside. Total: five strokes.

Artists: Formal script, Yu Shinan; semicursive script, Mi Fu; cursive script, Wang Xun.

Etymology: The original symbol, consisting of four horizontal lines, has been replaced by this symbol, which originally included four vertical lines.

Pictograph: ☰ ⊞ ⊛

An interpretation of the brush flow in the semicursive script ➤

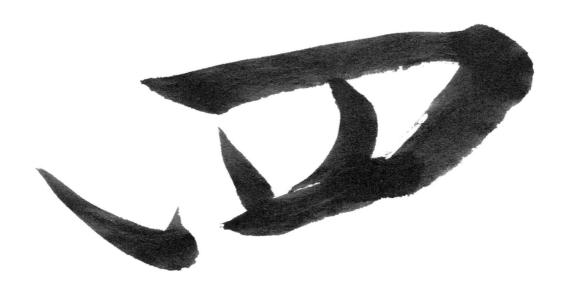

FRAGRANT

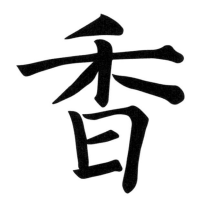

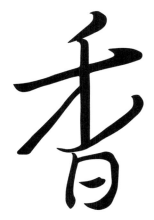

Types: Unabridged, simplified Japanese and Chinese: 香

Other meanings: Smell, odor.

Pronunciations: Chinese, *xiāng* (*hsiang*); Japanese, *kō; kaoru, kaori;* Korean, *hyang;* Vietnamese, *hương*.

Classification: "Fragrant" radical (nine strokes). This ideograph is itself a radical.

Artists: Formal script, Liu Gongquan; semicursive script, Wang Xizhi; cursive script, Wang Duo.

Etymology: A variation of "millet" on top and a variation of "sweet" on the bottom.

Seal script: 香香香

An interpretation of the brush flow in the semicursive script ➤

GRASS

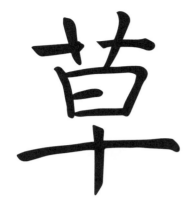
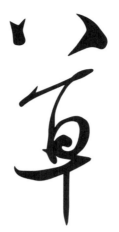

Types: Unabridged: 草; simplified Japanese and Chinese: 草

Other meanings: Weed, cursive script, coarse, to initiate.

Pronunciations: Chinese, *cǎo* (*ts'ao*); Japanese, *sō; kusa;* Korean, *cho;* Vietnamese, *thảo.*

Classification: "Grass" radical (top, four strokes, although classified under 艸—six strokes) plus six strokes. Total: ten strokes.

Artists: Formal script, Zhang Gongli; semicursive script, Mi Fu; cursive script, Huaisu.

Etymology: "Grass," plus the sound indicator *zao* (早), originally meaning "acorn."

Seal script: 艸

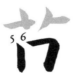

An interpretation of the brush flow in the semicursive script ➤

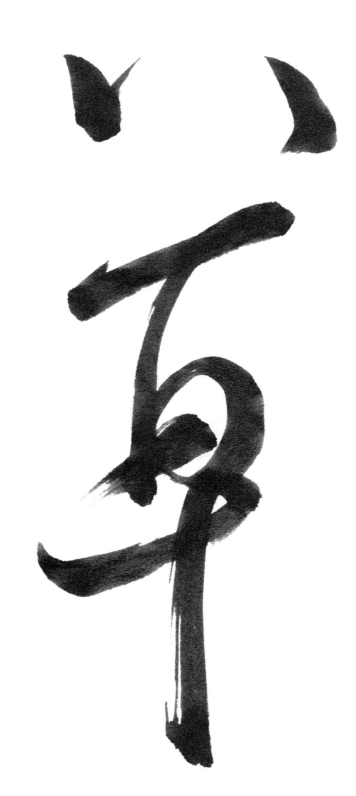

HEALING

 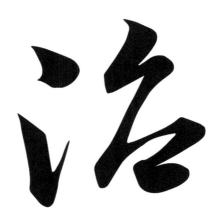

Types: Unabridged, simplified Japanese and Chinese: 治

Other meanings: To fix, to cure, to rule, to govern.

Pronunciations: Chinese, *zhi* (*chih*); Japanese, *ji, chi; osameru, naosu;* Korean, *chi;* Vietnamese, *trị.*

Classification: "Water" radical 水 (left, four strokes but rendered in three strokes) plus five strokes. Total: eight strokes.

Artists: Formal script, Yu Shinan; semicursive script, Mi Fu; cursive script, Wang Xizhi.

Etymology: Water (left), plus the sound indicator *zhi* (right), meaning the river Zhi (Shandong Province).

Seal script: 治

Note: The river Zhi would often cause a flood. To regulate the flow of the river was to govern.

 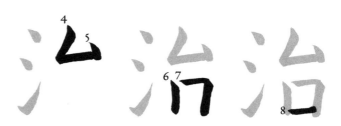

An interpretation of the brush flow in the semicursive script ➤

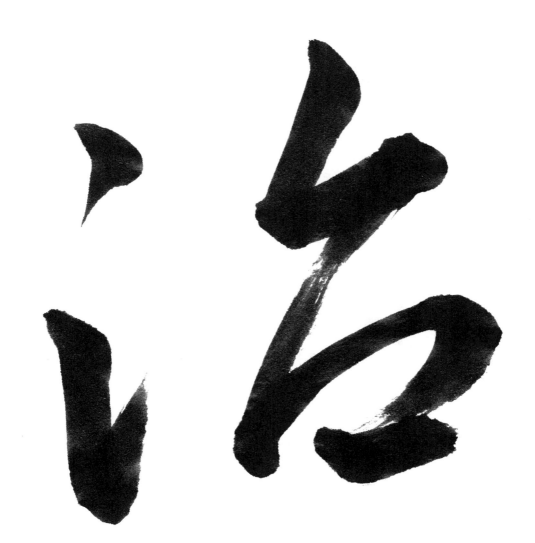

HEART

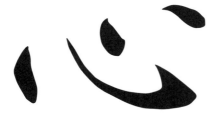 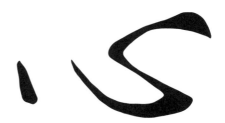

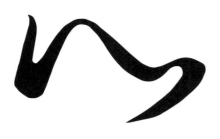

Types: Unabridged, simplified Japanese and Chinese: 心

Other meanings: Mind, feeling, thought, center, essence.

Pronunciations: Chinese, *xīn* (*hsin*); Japanese, *shin; kokoro;* Korean, *sim;* Vietnamese, *tâm*.

Classification: "Heart" radical (four strokes). This ideograph is itself a radical.

Artists: Formal script, Zhi Yong; semicursive script, Wang Xizhi; cursive script, Wang Xianzhi.

Etymology: Derived from the pictograph of a heart with three chambers.

Pictograph:

An interpretation of the brush flow in the cursive script ➤

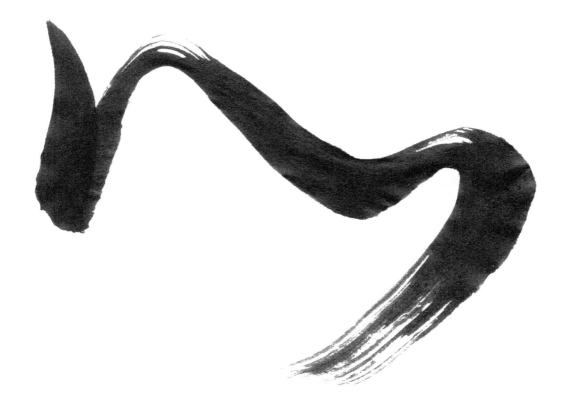

HEAVEN

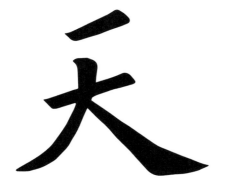

Types: Unabridged, simplified Japanese and Chinese: 天

Other meanings: Sky, top, emperor.

Pronunciations: Chinese, *tiān* (*t'ien*); Japanese, *ten; ame;* Korean, *cheon;* Vietnamese, *thiên.*

Classification: "Big" radical (bottom, three strokes) plus one stroke. Total: four strokes.

Artists: Formal script, Ouyang Xun; semicursive script, Wang Xizhi; cursive script, Wang Duo.

Etymology: Originally the pictograph "big," indicating a person spreading arms and legs, with a large head represented by a disk, meaning "something large above." The disk is now represented by the top horizontal line.

Pictograph: 界 天 大

An interpretation of the brush flow in the cursive script ➤

HOME

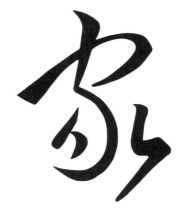

Types: Unabridged, simplified Japanese and Chinese: 家

Other meanings: House, family, clan, community, school, person.

Pronunciations: Chinese, *jiā (chia)*; Japanese, *ka, ke; ie;* Korean, *ga;* Vietnamese, *gia.*

Classification: "Roof" radical (top, three strokes) plus seven strokes. Total: ten strokes.

Artists: Formal script, Zhi Yong; semicursive script, Wang Xizhi; cursive script, Yao Shou.

Etymology: "Roof" radical on top, plus the ideograph *ji,* meaning "to live." (The present form of the seven strokes on the bottom is the same as the symbol *shi,* meaning "boar." However, this is owing to a mistake in the past.)

Seal script: 家家家

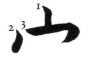 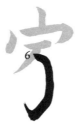

An interpretation of the brush flow in the cursive script ➤

HORSE

Types: Unabridged, simplified Japanese: 馬; simplified Chinese: 马

Other meanings: Stool.

Pronunciations: Chinese, *mǎ* (*ma*); Japanese, *ba, ma, me; uma;* Korean, *ma;* Vietnamese, *mã.*

Classification: "Horse" radical (ten strokes). This ideograph is itself a radical.

Artists: Formal and semicursive scripts, Chu Suiliang; cursive script, Wang Xizhi.

Etymology: A picture of a horse.

Pictograph: 𩡫 𩡨 𩡬

Note: The common stroke order used today is 2, 1, 4, 5, 3 . . .

An interpretation of the brush flow in the cursive script ➤

HUMAN

Types: Unabridged, simplified Japanese and Chinese: 人

Other meanings: Person, humankind.

Pronunciations: Chinese, *rén* (*jen*); Japanese, *jin, nin; hito;* Korean, *in;* Vietnamese, *nhân*.

Classification: "Human" radical (two strokes). This ideograph is itself a radical.

Artists: Formal script, Yu Shinan; semicursive and cursive scripts, Wang Xizhi.

Etymology: Originally a picture of a standing person.

Pictograph: 𝄐 𝄑 𝄒

An interpretation of the brush flow in the cursive script ➤

HUNDRED

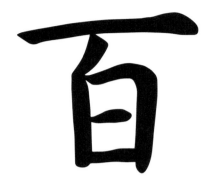

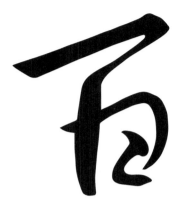

Types: Unabridged, simplified Japanese and Chinese: 百

Other meanings: Hundredth.

Pronunciations: Chinese, *bǎi* (*pai*); Japanese, *hyaku; momo;* Korean, *baek;* Vietnamese, *bách.*

Classification: "White" radical (bottom, five strokes) plus one stroke. Total: six strokes.

Artists: Formal script, Yu Shinan; semicursive script, Wang Xizhi; cursive script, Wang Xianzhi.

Etymology: "One" on top plus the sound indicator *bai,* meaning "many."

Seal script: 百 百 百

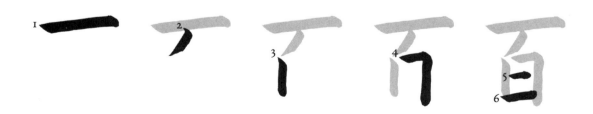

An interpretation of the brush flow in the cursive script ➤

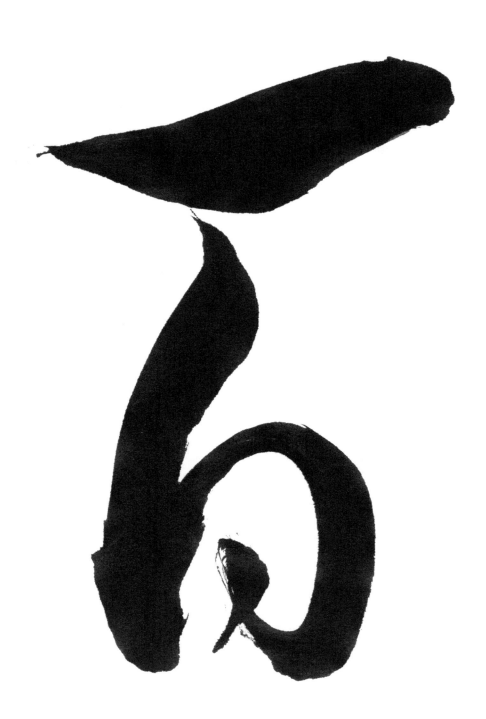

ILLUMINATE

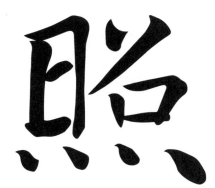
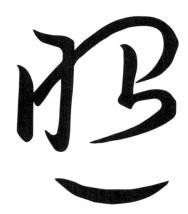

Types: Unabridged, simplified Japanese and Chinese: 照

Other meanings: To shine, illumination.

Pronunciations: Chinese, *zhào* (*chao*); Japanese, *shō; teru, terasu;* Korean, *jo;* Vietnamese, *chiếu.*

Classification: "Fire" radical (bottom, four strokes) plus nine strokes. Total: thirteen strokes.

Artists: Formal script, Yan Zhenqing; semicursive script, Ouyang Xun; cursive script, Sun Guoting.

Etymology: "Fire" on the bottom plus the ideograph *zhao,* meaning "clear." The ideograph on top consists of "sun" on the left and the ideograph *zhao* on the right, which represents a sound that means "clear."

Seal script: 照

Note: The formal script sample shows an archaic formation. See the unabridged type and the stroke order for the standard traditional form.

An interpretation of the brush flow in the cursive script ➤

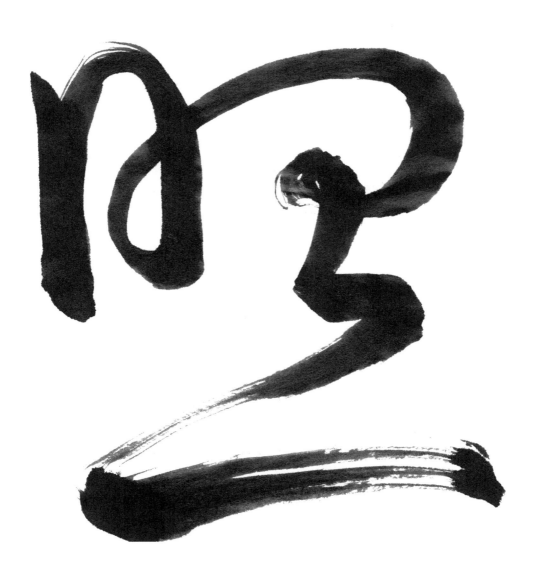

INK

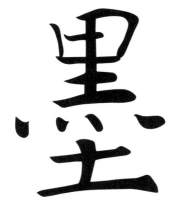

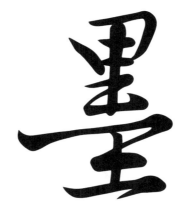

Types: Unabridged: 墨; simplified Japanese and Chinese: 墨

Other meanings: Charcoal, soot, dark.

Pronunciations: Chinese, *mò (mo)*; Japanese, *boku; sumi;* Korean, *muk;* Vietnamese, *mặc.*

Classification: "Soil" radical (bottom, three strokes) plus twelve strokes. Total: fifteen strokes.

Artists: Formal and semicursive scripts, Chu Suiliang; cursive script, Huaisu.

Etymology: "Soot" or "black" on top (eleven strokes), plus "soil" on the bottom. Ancient Chinese ink was a mixture of soot and clay.

Seal script: 墨

Note: The formal-script sample shows a simplified formation. See the unabridged type and the stroke order for the standard traditional form.

 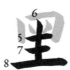 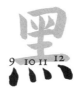 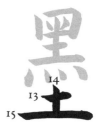

An interpretation of the brush flow in the cursive script ➤

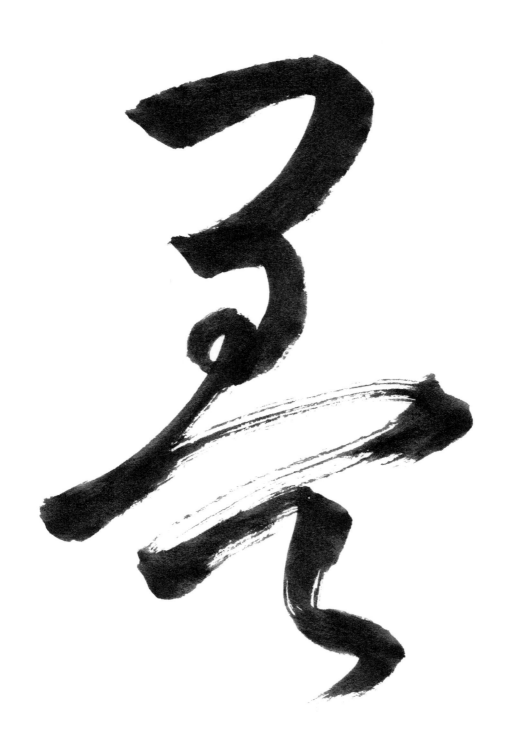

JADE

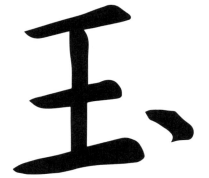

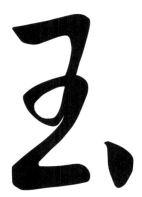

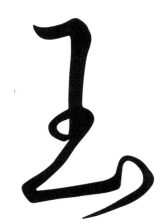

Types: Unabridged, simplified Japanese and Chinese: 玉

Other meanings: Jewel, pearl, precious, beautiful, noble, king, your.

Pronunciations: Chinese, *yù* (*yu*); Japanese, *gyoku; tama;* Korean, *ok;* Vietnamese, *ngọc.*

Classification: "Jade" radical (five strokes). This ideograph is itself a radical.

Artists: Formal script, Yu Shinan; semicursive script, Emperor Tai; cursive script, Huaisu.

Etymology: Originally a pictograph of three tiny balls that are threaded. As this ideograph also meant "king," a dot was added on the right to avoid confusion.

Pictograph: ‡ ‡ 王

An interpretation of the brush flow in the cursive script ➤

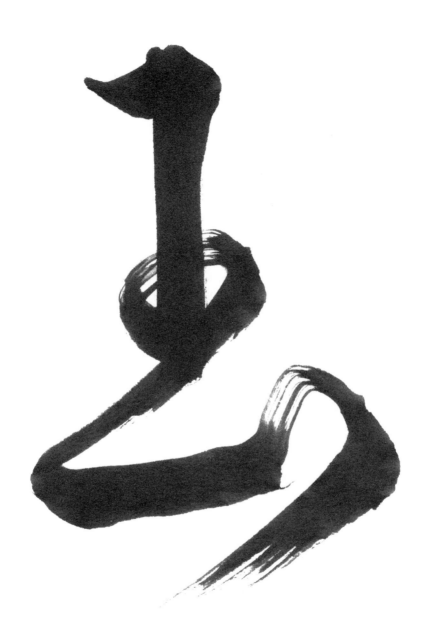

LETTER

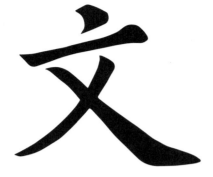 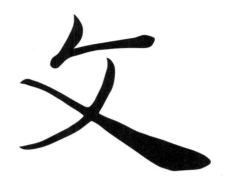

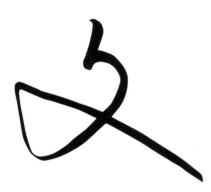

Types: Unabridged, simplified Japanese and Chinese: 文

Other meanings: Literature, civil (as opposed to military).

Pronunciations: Chinese, *wén* (wen); Japanese, *bun, mon; fumi;* Korean, *mun;* Vietnamese, *văn.*

Classification: "Letter" radical (four strokes). This ideograph is itself a radical.

Artists: Formal script, Ouyang Xun; semicursive script, Chu Sui-liang; cursive script, Su Shi.

Etymology: Originally a pictograph of crossed lapels, meaning diagonal cloth, which indicates elegance and formality.

Pictograph: 夰 夽 夽

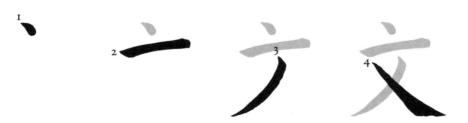

An interpretation of the brush flow in the cursive script ➤

LIFE

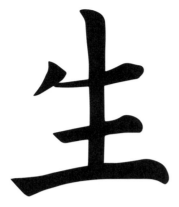

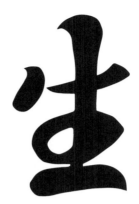

Types: Unabridged, simplified Japanese and Chinese: 生

Other meanings: To live, to be born, birth, to produce.

Pronunciations: Chinese, *shēng* (*sheng*); Japanese, *sei, shō; ikiru, umareru;* Korean, *saeng;* Vietnamese, *sinh.*

Classification: "To produce" radical (five strokes). This ideograph is itself a radical.

Artists: Formal script, Yu Shinan; semicursive script, Wang Xizhi; cursive script, Mi Fu.

Etymology: Originally a pictograph representing a "sprout."

Pictograph:

 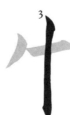 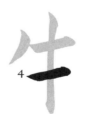

A close study of the formal script ➤

LIGHT

Types: Unabridged, simplified Japanese and Chinese: 光

Other meanings: To shine.

Pronunciations: Chinese, *guāng* (*kuang*); Japanese, *kō; hikaru, hikari;* Korean, *gwang;* Vietnamese, *quang.*

Classification: "Long legs" radical (bottom, two strokes) plus four strokes. Total: six strokes.

Artists: Formal script, Ouyang Xun; semicursive, Zhi Yong; cursive script, Huaisu.

Etymology: A combination of the ideograph "fine" (three strokes on top), and the sound indicator *huang* (two strokes on the bottom), meaning "to shine."

Seal script:

A close study of the formal script ➤

光

LOTUS

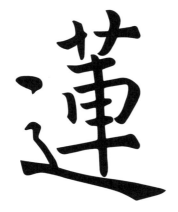

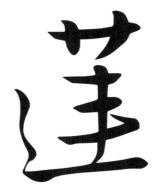

Types: Unabridged: 蓮; simplified Japanese: 蓮; simplified Chinese: 莲

Other meanings: (No other meaning.)

Pronunciations: Chinese, *lián* (*lien*); Japanese, *ren; hasu;* Korean, *ryeon; yeon;* Vietnamese, *liên.*

Classification: "Grass" radical (top, four strokes, although classified under 艸—six strokes) plus ten strokes. Total: fourteen strokes.

Artists: Formal script, Chu Suiliang; semicursive script, Zhang Ruitu; cursive script, Huaisu.

Etymology: "Grass" on top and the sound indicator for *lian* (連).

Seal script: 蕭

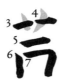

A close study of the formal script ➤

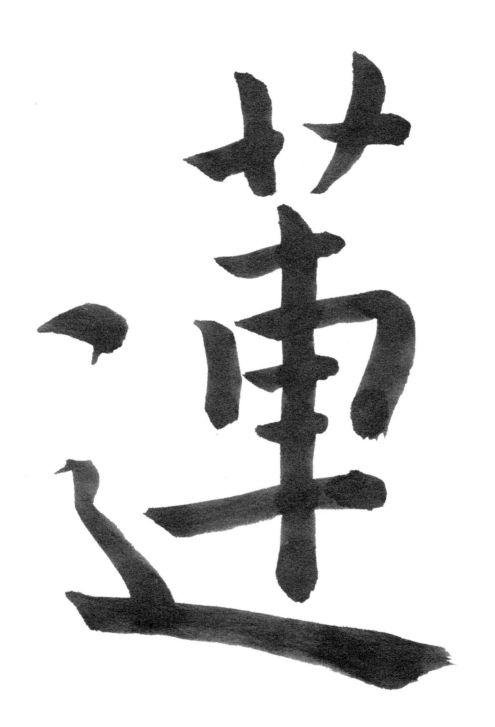

LOVE

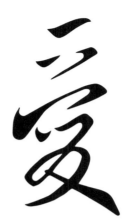

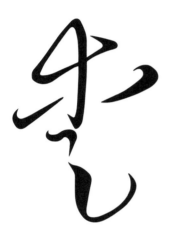

Types: Unabridged, simplified Japanese: 愛; simplified Chinese: 爱

Other meanings: Attachment, to be in love, to be intimate with.

Pronunciations: Chinese, *ài* (ai); Japanese, *ai; itsukushimu, itōshimu;* Korean, *ae;* Vietnamese, *ái.*

Classification: "Heart" radical (under the long horizontal stroke with a hook at the end, four strokes) plus nine strokes. Total: thirteen strokes.

Artists: Formal script, Yin Lingming; semicursive script, Wang Xizhi; cursive script, Wang Duo.

Etymology: The bottom sign in three strokes means "walk slowly." The rest of the sign, on top, originally meant "subtly."

Seal script: 愛 愛

Note: The first strokes in the formal and semicursive script samples are drawn from left to right. See the stroke order for the standard traditional way of drawing the first stroke.

A close study of the formal script ➤

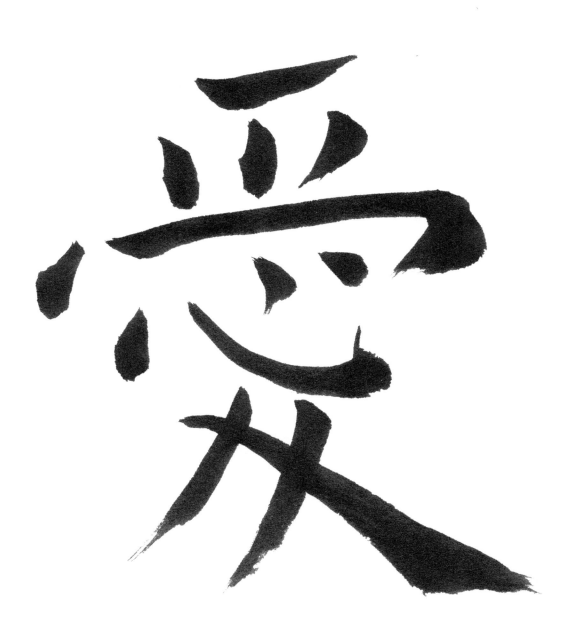

MAN

Types: Unabridged, simplified Japanese and Chinese: 男

Other meanings: Men, male, masculine, boy.

Pronunciations: Chinese, *nán* (*nan*); Japanese, *dan, nan; otoko, onoko;* Korean, *nam;* Vietnamese, *nam.*

Classification: "Rice field" radical (top, five strokes) plus two strokes. Total: seven strokes.

Artists: Formal and cursive scripts, Zhi Yong; semicursive script, Zhao Mengtiao.

Etymology: The pictograph "rice field" on top, plus the pictograph of arm muscle, meaning "strength."

Seal script:

Note: The formal-script sample shows an archaic formation. See the unabridged type and the stroke order for the standard traditional form.

A close study of the formal script ➤

男

MEAL

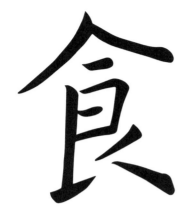

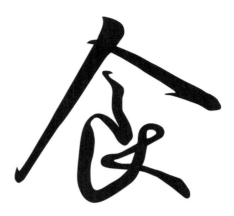

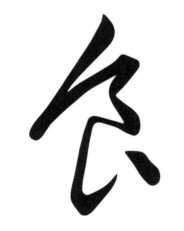

Types: Unabridged, simplified Japanese and Chinese: 食

Other meanings: To eat, food.

Pronunciations: Chinese, *shí* (*shih*); Japanese, *shoku, jiki; taberu;* Korean, *sik;* Vietnamese, *thực.*

Classification: "To eat" radical (nine strokes). This ideograph is itself a radical.

Artists: Formal script, Ouyang Xun; semicursive script, Mi Fu; cursive script, Dong Qichang.

Etymology: A picture of a lid covering food in a bowl.

Pictograph: 食 食 食

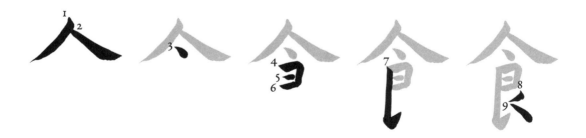

A close study of the formal script ➤

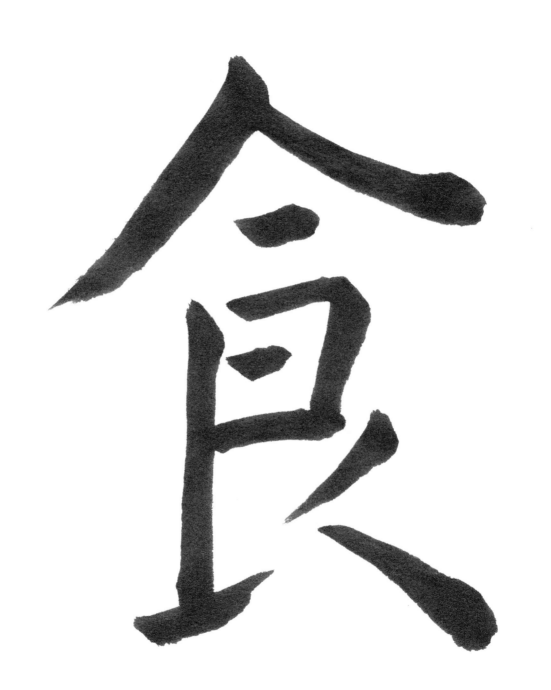

MERGE

Types: Unabridged: 會; simplified Japanese and Chinese: 会

Other meanings: To meet, to encounter, to assemble, assembly, to understand, understanding.

Pronunciations: Chinese, *huì* (*huì*); Japanese, *kai, e; au, ai*; Korean, *hoe;* Vietnamese, *hội.*

Classification: "Human" radical (top, two strokes) plus eleven strokes. Total: thirteen strokes.

Artists: Formal script, Zhi Yong; semicursive script, Mi Fu; cursive script, Sun Guoting.

Etymology: Originally a combination of two pictographs: a "lid" (three strokes) on top of a "steamer," meaning "come together" or "merge."

Seal script:

Note: The formal- and semicursive-script samples show an abridged formation. See the unabridged type and the stroke order for the standard traditional form.

A close study of the formal script ➤

MERIT

 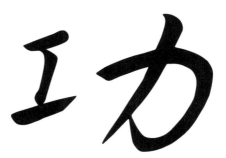

Types: Unabridged, simplified Japanese and Chinese: 功

Other meanings: Function, craft, work, skillful, meritorious, effect, sign.

Pronunciations: Chinese, *gōng* (*kung*); Japanese, *kō, ku; isao;* Korean, *gong;* Vietnamese, *công.*

Classification: "Strength" radical (right, two strokes) plus three strokes. Total: five strokes.

Artists: Formal script, Yu Shinan; semicursive script, Yan Zhenqing; cursive script, Sun Guoting.

Etymology: A combination of "strength" on the right and "to make" on the left.

Seal script: 工𠂆

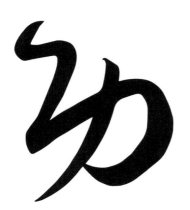

 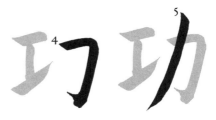

A close study of the formal script ➤

エカ

METAL

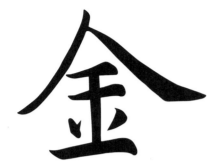

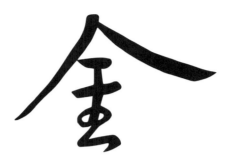

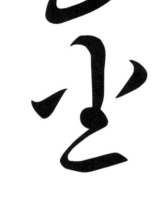

Types: Unabridged, simplified Japanese and Chinese: 金

Other meanings: Gold, money.

Pronunciations: Chinese, *jīn* (*chin*); Japanese, *kin, kon; kane;* Korean, *geum;* Vietnamese, *kim*.

Classification: "Metal" radical (eight strokes). This ideograph is itself a radical.

Artists: Formal script, Yu Shinan; semicursive script, Yan Zhenqing; cursive script, Zhi Yong.

Etymology: A combination of the ideograph *tu* (土), meaning "soil," and the sound indicator, *jin* (今), meaning "contain." It originally meant metal contained in the soil.

Seal script: 金 余 金

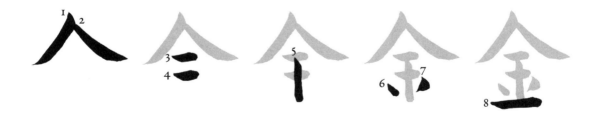

A close study of the formal script ➤

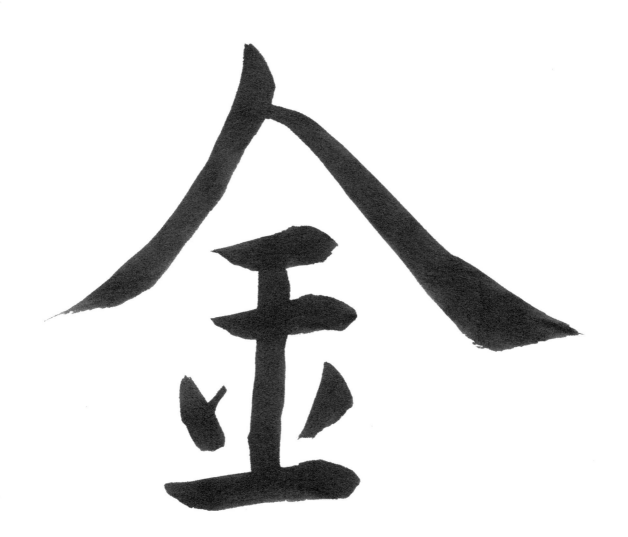

MIDDLE

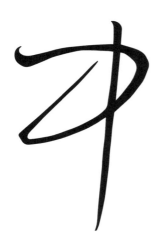

Types: Unabridged, simplified Japanese and Chinese: 中

Other meanings: Center, inside, to hit the mark, China.

Pronunciations: Chinese, *zhōng* (*chung*); Japanese, *chū; naka;* Korean, *jung;* Vietnamese, *trung.*

Classification: "Rod" radical (in the middle, one stroke) plus "mouth" (three strokes). Total: four strokes.

Artists: Formal script, Ouyang Xun; semicursive script, Wang Xizhi; cursive script, Huaisu.

Etymology: A "thing" (box) is penetrated in the middle, meaning "inside."

Pictograph:

A close study of the formal script ➤

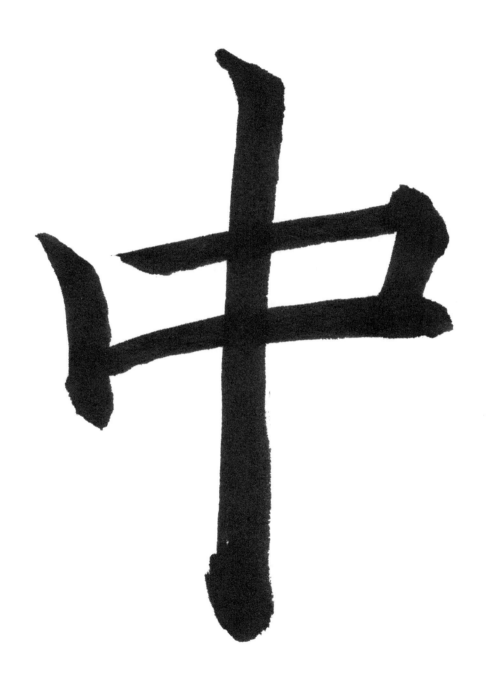

MINDFULNESS

Types: Unabridged, simplified Japanese and Chinese: 念

Other meanings: Thought, moment.

Pronunciations: Chinese, *niàn* (*nien*); Japanese, *nen; nenzuru, omou;* Korean, *nyeom;* Vietnamese, *niệm.*

Classification: "Heart" radical (bottom, four strokes) plus four strokes. Total: eight strokes.

Artists: Formal script, Ouyang Xun; semicursive script, Wang Xizhi; cursive script, Emperor Tai.

Etymology: The ideograph meaning "now" on top, plus "heart/mind" on the bottom.

Seal script: 念 念 念

Note: The formal-script sample shows an archaic formation. See the unabridged type and the stroke order for the standard traditional form.

A close study of the semicursive script ➤

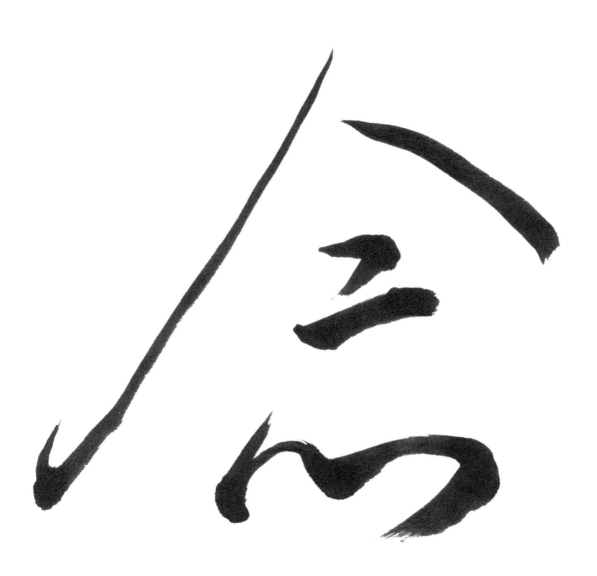

MOON

Types: Unabridged, simplified Japanese and Chinese: 月

Other meanings: Month, Monday, lack.

Pronunciations: Chinese, *yuè* (*yueh*); Japanese, *getsu, gatsu; tsuki;* Korean, *wol;* Vietnamese, *nguyệt.*

Classification: "Moon" radical (four strokes). This ideograph is itself a radical.

Artists: Formal script, Ouyang Xun; semicursive script, Wang Xianzhi; cursive script, Wang Xizhi.

Etymology: Originally a pictograph of a crescent moon.

Pictograph: 𝌆 𝌆 𝌆

A close study of the semicursive script ➤

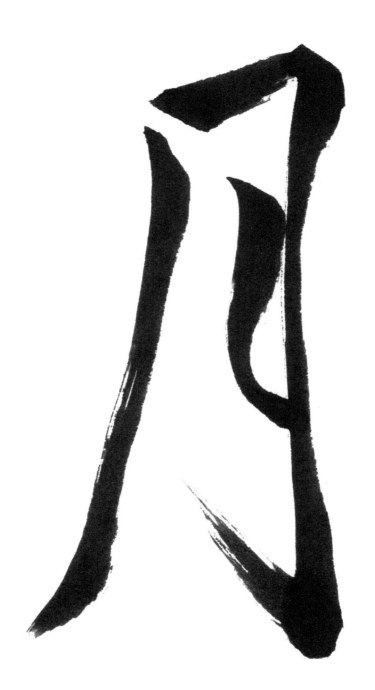

MOUNTAIN

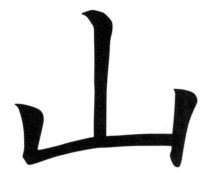
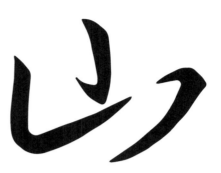

Types: Unabridged, simplified Japanese and Chinese: 山

Other meanings: Hill, monastery, temple.

Pronunciations: Chinese, *shān* (shan); Japanese, *san; yama;* Korean, *san;* Vietnamese, *sơn.*

Classification: "Mountain" radical (three strokes). This ideograph is itself a radical.

Artists: Formal script, Ouyang Xun; semicursive script, Wang Xizhi; cursive script, Huaisu.

Etymology: Originally a pictograph of a mountain with three peaks.

Pictograph: ᚻᚻᚻ ᚼ ᨠᨠ

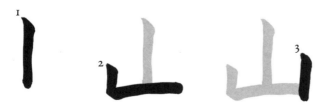

A close study of the semicursive script ➤

MOUTH

Types: Unabridged, simplified Japanese and Chinese: 口

Other meanings: Entrance, exit, mouth of a river.

Pronunciations: Chinese, *kŏu* (*k'ou*); Japanese, *kō; kuchi;* Korean, *gu;* Vietnamese, *khẩu.*

Classification: "Mouth" radical (three strokes). This ideograph is itself a radical.

Artists: Formal and semicursive scripts, Zhi Yong; cursive script, Mi Fu.

Etymology: Originally a pictograph of a mouth.

Pictograph: 凵 凵 凵

A close study of the semicursive script ➤

NIGHT

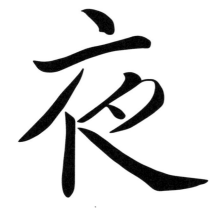
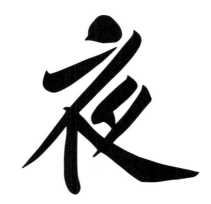

Types: Unabridged, simplified Japanese and Chinese: 夜

Other meanings: Dark.

Pronunciations: Chinese, *yè* (*yeh*); Japanese, *ya, yo; yoru;* Korean, *ya;* Vietnamese, *dạ.*

Classification: "Dusk" radical 夕 (right, three strokes) plus five strokes. Total: eight strokes.

Artists: Formal script, Chu Suiliang; semicursive script, Huang Tingjian; cursive script, Wang Xizhi.

Etymology: Originally the ideograph "moon" (transformed as the four strokes on the lower right side), plus the sound indicator *yi* (亦), meaning "bright."

Seal script: 夜 亦 夾

A close study of the semicursive script ➤

NINE

 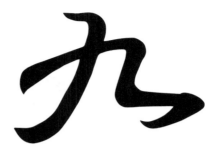

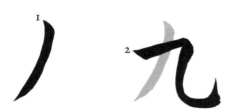

Types: Unabridged, simplified Japanese and Chinese: 九

Other meanings: Ninth.

Pronunciations: Chinese, *jiŭ* (*chiu*); Japanese, *kyū, ku; kokonotsu;* Korean, *gu;* Vietnamese, *cửu.*

Classification: "Carving knife" radical (one stroke, starting horizontally) plus a diagonally sweeping-off stroke. Total: two strokes.

Artists: Formal script, Yu Shinan; semicursive script, Wang Xizhi; cursive script, Huaisu.

Etymology: A pictograph showing a bent arm, later indicating the numeric symbol "nine."

Pictograph: 九己九

A close study of the semicursive script ➤

九

NORTH

Types: Unabridged, simplified Japanese and Chinese: 北

Other meanings: Go against each other, run away.

Pronunciations: Chinese, *běi (pei);* Japanese, *hoku; kita;* Korean, *buk;* Vietnamese, *bắc.*

Classification: "Ladle" radical (right, two strokes) plus three strokes. Total: five strokes.

Artists: Formal script, Ouyang Xun; semicursive script, Emperor Tai; cursive script, Wang Xizhi.

Etymology: Two people sitting back-to-back, meaning "being against each other"; later meaning "sitting against the sun."

Seal script: 北 北 川

Note: The fourth stroke in the formal-script sample is written horizontally, but it is a diagonal leftward-down stroke, as shown in the stroke order, in the standard traditional form.

A close study of the semicursive script ➤

NOT

Types: Unabridged, simplified Japanese: 無; simplified Chinese: 无

Other meanings: There is not, to have not, nothing, beyond.

Pronunciations: Chinese, *wú (wu)*; Japanese, *mu, bu; nai, nashi;* Korean, *mu;* Vietnamese, *vô.*

Classification: "Fire" radical (bottom, four strokes) plus eight strokes. Total: twelve strokes.

Artists: Formal script, Zhong Yao; semicursive and cursive scripts, Wang Xizhi.

Etymology: The shape of this ideograph was borrowed from the ideograph meaning "dance," in the shape of a decorated dancer, pronounced *wu.*

Seal script:

 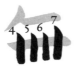 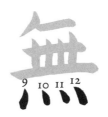

A close study of the semicursive script ➤

NOW

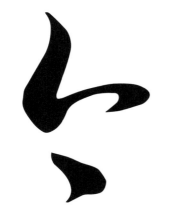

Types: Unabridged, simplified Japanese and Chinese: 今

Other meanings: Present, present moment, this (day, month).

Pronunciations: Chinese, *jīn (chin)*; Japanese, *kin, kon; ima;* Korean, *geum;* Vietnamese, *kim*.

Classification: "Human" radical (top, two strokes) plus two strokes. Total: four strokes.

Artists: Formal and semicursive scripts, Wang Xianzhi; cursive script, Wang Xizhi.

Etymology: The top two strokes here represent a roof. The bottom three strokes represent (all) things. That which covers all things is the present moment.

Seal script: 亼 月 仐

A close study of the semicursive script ➤

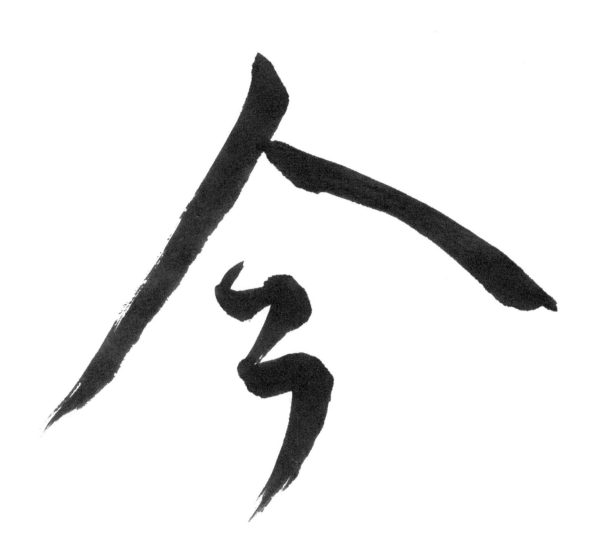

NURTURE

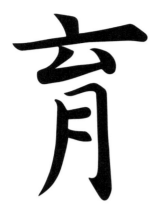
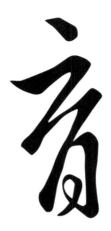

Types: Unabridged, simplified Japanese and Chinese: 育

Other meanings: To bring up, to grow up.

Pronunciations: Chinese, *yù* (*yü*); Japanese, *iku; sodatsu;* Korean, *yuk;* Vietnamese, *dục.*

Classification: "Flesh" radical (bottom, a six-stroke radical sometimes written in four strokes) plus four strokes. Total: eight strokes.

Artists: Formal script, Yu Shinan; semicursive script, Wang Xianzhi; cursive script, Huaisu.

Etymology: Originally the pictograph of a baby coming out of the womb facing down (on top), plus a pictograph meaning "flesh."

Seal script:

A close study of the semicursive script ➤

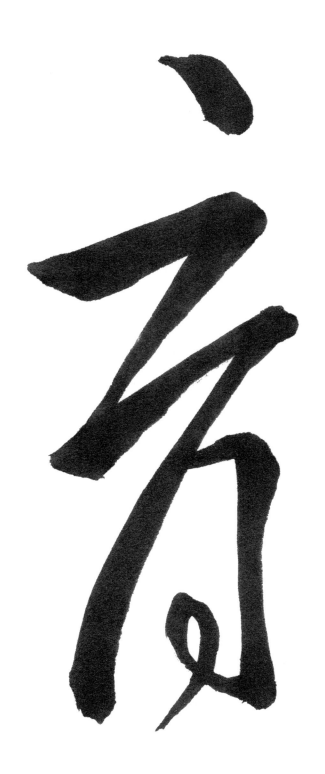

OBSERVE

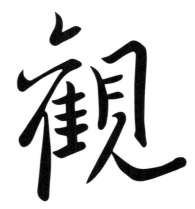

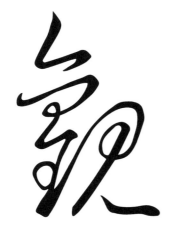

Types: Unabridged: 觀; simplified Japanese: 観; simplified Chinese: 观

Other meanings: To see, to look, to intuit.

Pronunciations: Chinese, *guān* (*kuan*); Japanese, *kan; miru;* Korean, *gwan;* Vietnamese, *quán.*

Classification: "To see" radical (right, seven strokes) plus eighteen strokes. Total: twenty-five strokes.

Artists: Formal script, Yu Shinan; semicursive script, Ouyang Xun; cursive script, Wang Xizhi.

Etymology: An ideograph meaning "to see" on the right, plus the sound indicator *guan,* meaning "around" on the left. The combination of these symbols means "to look around."

Seal script: 觀

 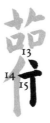 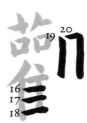 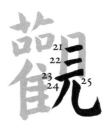

A close study of the cursive script ➤

氣親

OCEAN

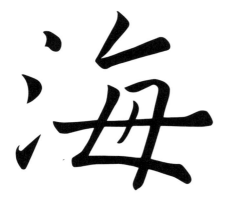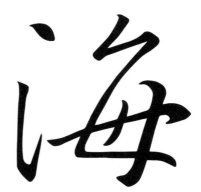

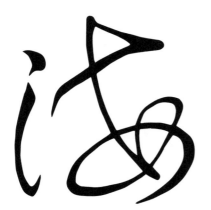

Types: Unabridged, simplified Chinese: 海, simplified Japanese: 海

Other meaning: Sea.

Pronunciations: Chinese, *hǎi* (*hai*); Japanese, *kai; umi;* Korean, *hae;* Vietnamese, *hâi.*

Classification: "Water" radical (left, classified as four strokes but often written in three strokes) plus seven strokes. Total: ten strokes.

Artists: Formal script, Ouyang Xun; semicursive script, Wang Xizhi; cursive script, Wang Duo.

Etymology: The left symbol "water" plus the right symbol *mei,* meaning "dark."

Seal script: 海博海

Note: The formal- and semicursive-script samples show a simplified formation. See the unabridged type and the stroke order for the standard traditional form.

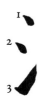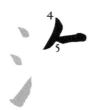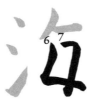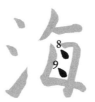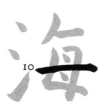

A close study of the cursive script ➤

海

OLD

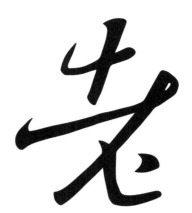

Types: Unabridged, simplified Japanese and Chinese: 老

Other meanings: Aged, to age, the first character of the name "Laozi."

Pronunciations: Chinese, *lăo (lao)*; Japanese, *rō; oiru, fukeru;* Korean, *ro; no;* Vietnamese, *lāo.*

Classification: "Old" radical (six strokes). This ideograph is itself a radical.

Artists: Formal script, Ouyang Tong; semicursive script, Wang Xizhi; cursive script, Sun Guoting.

Etymology: Originally a pictograph of a person with a bent body and long hair holding a stick.

Pictograph: 🏃 老 老

Note: The stroke order in the cursive-script sample is 1, 2, 3, 4, 6, 5.

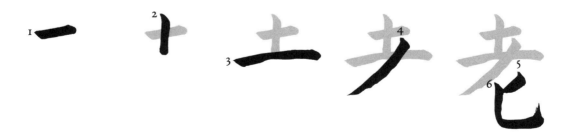

A close study of the cursive script ➤

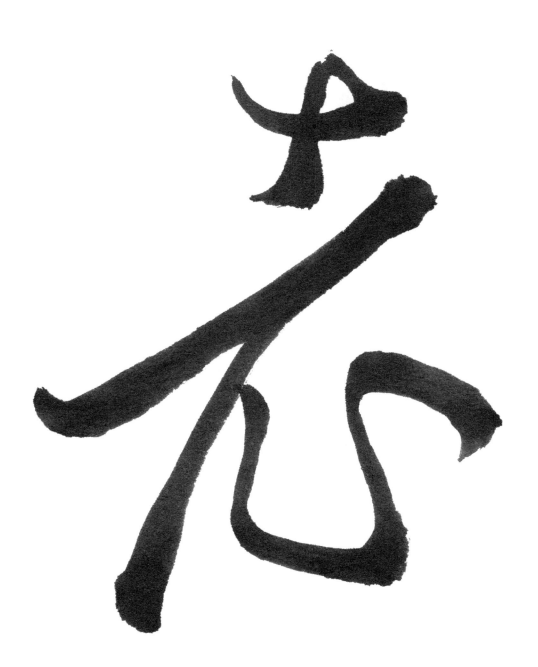

ONE

Types: Unabridged, simplified Japanese and Chinese: 一

Other meanings: First, beginning, supreme, together, all.

Pronunciations: Chinese, *yī* (*i*); Japanese, *ichi; hitotsu;* Korean, *il;* Vietnamese, *nhất.*

Classification: "One" radical (one stroke). This ideograph is itself a radical.

Artists: Formal script, Yan Zhenqing; semicursive and cursive scripts, Wang Xizhi.

Etymology: A horizontal line indicates the first number.

Seal script:

A close study of the cursive script ➤

ORCHID

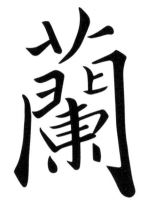

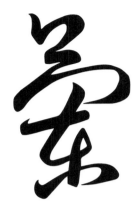

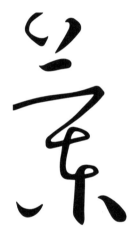

Types: Unabridged: 蘭; simplified Japanese: 蘭; simplified Chinese: 兰

Other meanings: (No other meaning.)

Pronunciations: Chinese, *lán* (*lan*); Japanese, *ran;* Korean, *ran, nan;* Vietnamese, *lan*.

Classification: "Grass" radical (top, four strokes, although classified under 艸—six strokes) plus sixteen strokes. Total: twenty strokes.

Artists: Formal script, Wang Xizhi; semicursive script, Wang Xianzhi; cursive script, Huaisu.

Etymology: "Grass" radical plus the sound indicator, *lan* (闌), meaning "scattered."

Seal script: 蘭

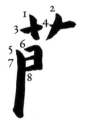

A close study of the cursive script ➤

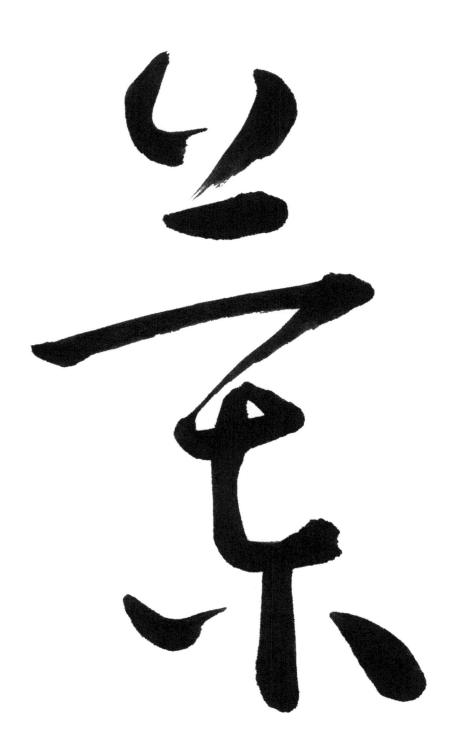

PAPER

 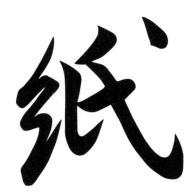

Types: Unabridged, simplified Japanese: 紙; simplified Chinese: 纸

Other meanings: Newspaper.

Pronunciations: Chinese, *zhǐ* (*chih*); Japanese, *shi; kami;* Korean, *ji;* Vietnamese, *chi.*

Classification: "Thread" radical (left, six strokes) plus four strokes. Total: ten strokes.

Artists: Formal script, Zhi Yong; semicursive script, Mi Fu; cursive script, Sun Guoting.

Etymology: The pictograph of a thread, meaning "fiber," on the left, plus the sound indicator *zhi,* meaning "flat," on the right.

Seal script: 紙

Note: The formal- and semicursive-script samples show an archaic formation. See the stroke order for the standard traditional form.

 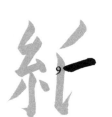 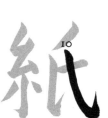

A close study of the cursive script ➤

如

PEACE

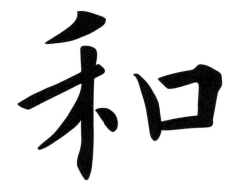
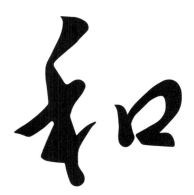

Types: Unabridged, simplified Japanese and Chinese: 和

Other meanings: Harmony, to harmonize, to pacify, reconciliation, mixture.

Pronunciations: Chinese, *hé (ho);* Japanese, *wa; yawaragu, nagomu;* Korean, *hwa;* Vietnamese, *hòa.*

Classification: "Mouth" radical (right, three strokes) plus five strokes. Total: eight strokes.

Artists: Formal script, Ouyang Xun; semicursive script, Emperor Tai; cursive script, Wang Xizhi.

Etymology: The pictograph "mouth" on the right, plus the sound indicator *he,* meaning "to add," on the left. The original meaning of this ideograph is "to respond to and join other people's voices."

Seal script: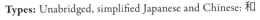

Note: The common stroke order used today is 1, 3, 2 . . .

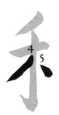

A close study of the cursive script ➤

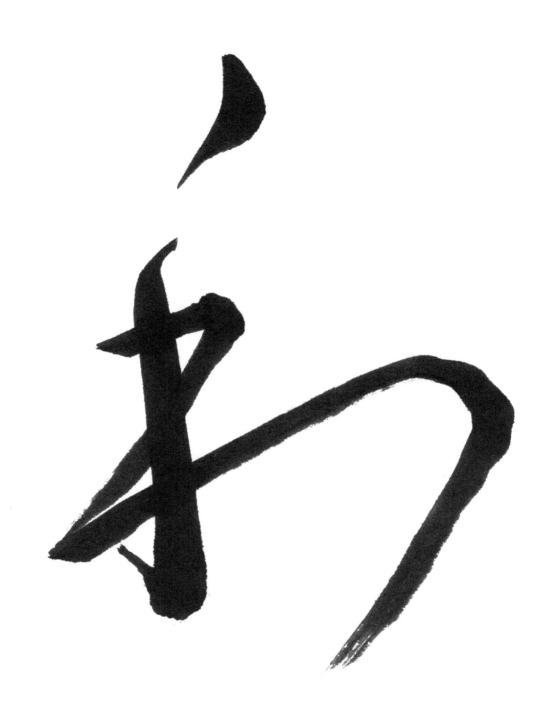

PLUM

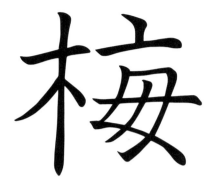 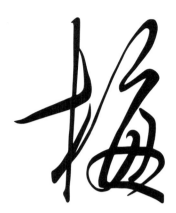

Types: Unabridged, simplified Chinese: 梅; simplified Japanese: 梅

Other meanings: Rainy season.

Pronunciations: Chinese, *méi (mei)*; Japanese, *bai; ume;* Korean, *mae;* Vietnamese, *mai.*

Classification: "Tree" radical (left, four strokes) plus seven strokes. Total: eleven strokes.

Artists: Formal script, Chu Suiliang; semicursive script, Mi Fu; cursive script, Du Yan.

Etymology: "Tree" on the left plus the sound indicator *mei* (每) on the right.

Seal script: 棶 棶

Note: The formal-script sample shows an archaic formation. See the unabridged type and the stroke order for the standard traditional form.

 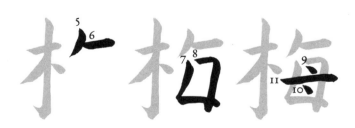

A close study of the cursive script ➤

梅

POEM

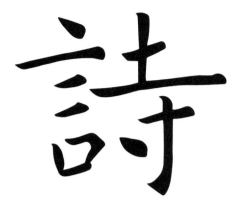
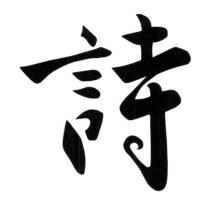

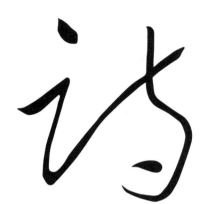

Types: Unabridged, simplified Japanese: 詩; simplified Chinese: 诗

Other meanings: Lyric, song.

Pronunciations: Chinese, *shi* (*shih*); Japanese, *shi; uta;* Korean, *si;* Vietnamese, *thi.*

Classification: "Speech" radical (left, seven strokes) plus six strokes. Total: thirteen strokes.

Artists: Formal script, Yu Shinan; semicursive and cursive scripts, Huaisu.

Etymology: The ideograph meaning "speech" or "word" on the left, plus *shi,* meaning "remain in the heart," on the right.

Seal script:

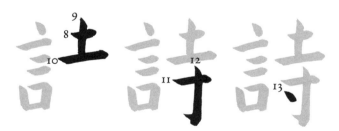

A close study of the cursive script ➤

汤

PRACTICE

 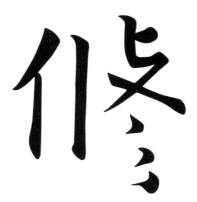

Types: Unabridged, simplified Japanese and Chinese: 修

Other meanings: To learn, to master, to prepare, to repair, to purify.

Pronunciations: Chinese, *xiū* (*hsiu*); Japanese, *shū; osameru;* Korean, *su;* Vietnamese, *tu.*

Classification: "Streaks" radical (bottom right, three strokes) plus seven strokes. Total: ten strokes.

Artists: Formal script, Chu Suiliang; semicursive script, Yan Zhenqing; cursive script, Mi Fu.

Etymology: "Streaks" (narrow bands of light) radical, also meaning "to decorate," on the bottom right, plus the symbol *you,* meaning "to cleanse."

Seal script: 修

Note: The formal-script sample shows an archaic formation. See the unabridged type and the stroke order for the standard traditional form.

 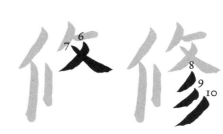

A close study of the cursive script ➤

PRECEPT

Types: Unabridged, simplified Japanese and Chinese: 戒

Other meanings: To caution, to warn, to restrain.

Pronunciations: Chinese, *jiè* (*chieh*); Japanese, *kai; imashimeru, imashime;* Korean, *gye;* Vietnamese, *giới*.

Classification: "Halberd" radical (top and right, four strokes) plus three strokes. Total: seven strokes.

Artists: Formal and semicursive scripts, Zao Mengtiao; cursive script, Deng Wenyuan.

Etymology: A combination of two hands and a halberd, meaning "to hold a halberd."

Seal script:

An interpretation of the energy in the formal script ➤

PROFOUND

Types: Unabridged, simplified Japanese and Chinese: 玄

Other meanings: Dark, black, subtle.

Pronunciations: Chinese, *xuán* (*hsuan*); Japanese, *gen; kuro;* Korean, *hyeon;* Vietnamese, *huyên.*

Classification: "Dark" radical (five strokes). This ideograph is itself a radical.

Artists: Formal script, Yan Zhenqing; semicursive script, Chu Suiliang; cursive script, Huaisu.

Etymology: Originally a pictograph meaning "black thread."

Pictograph: ⧠ ⧠

An interpretation of the energy in the formal script ➤

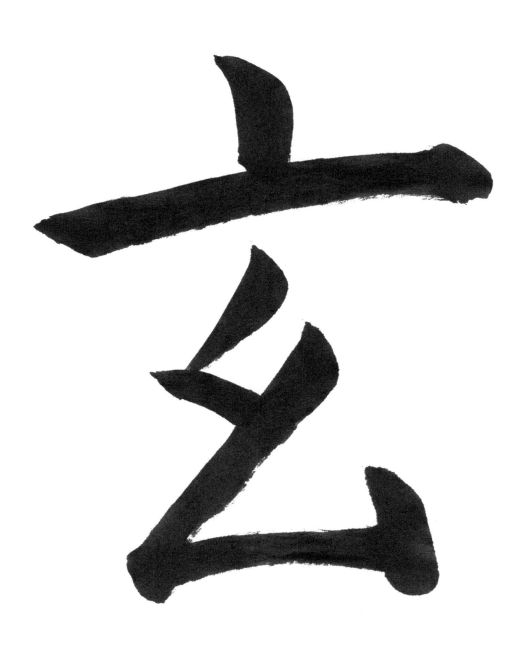

PURE

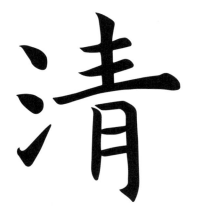

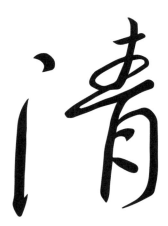

Types: Unabridged: 清; simplified Japanese and Chinese: 清

Other meanings: To purify, clear, to clean, cool.

Pronunciations: Chinese, *qīng* (*ch'ing*); Japanese, *sei; kiyoi, kiyo-meru;* Korean, *cheong;* Vietnamese, *thanh.*

Classification: "Water" radical (left, three strokes—the simplified form of the four-stroke radical) plus eight strokes. Total: eleven strokes.

Artists: Formal script, Yu Shinan; semicursive script, Yan Zhen-qing; cursive script, Wang Xizhi.

Etymology: "Water" on the left, plus the ideograph meaning "blue" or "green."

Seal script: 清

Note: The formal- and semicursive-script samples show a simplified formation. See the unabridged type and the stroke order for the standard traditional form.

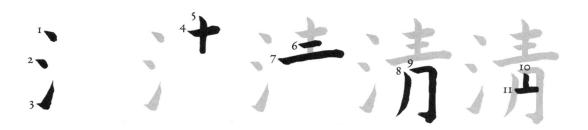

An interpretation of the energy in the formal script ➤

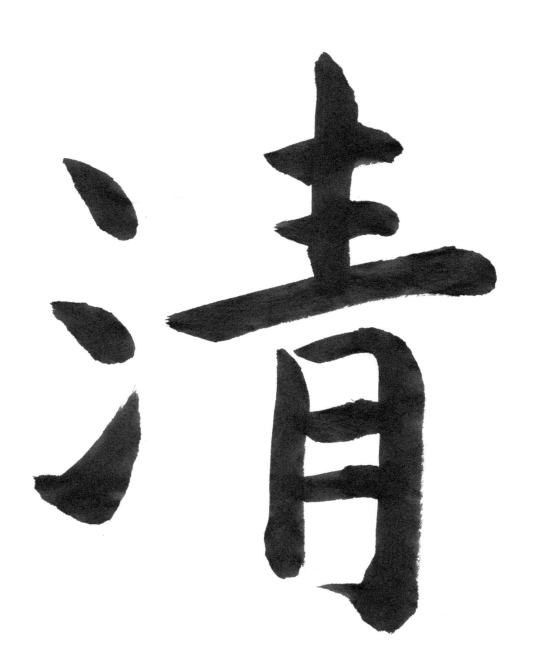

RAIN

Types: Unabridged, simplified Japanese and Chinese: 雨

Other meanings: To rain, to rain down.

Pronunciations: Chinese, *yǔ* (*yu*); Japanese, *u; ame;* Korean, *u;* Vietnamese, *vũ*.

Classification: "Rain" radical (eight strokes). This ideograph is itself a radical.

Artists: Formal script, Yu Shinan; semicursive script, Wang Xizhi; cursive script, Wang Duo.

Etymology: A combination of a shape indicating the sky or heaven and raindrops.

Seal script: 帀 𩆝 雨

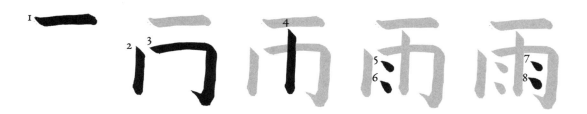

An interpretation of the energy in the formal script ➤

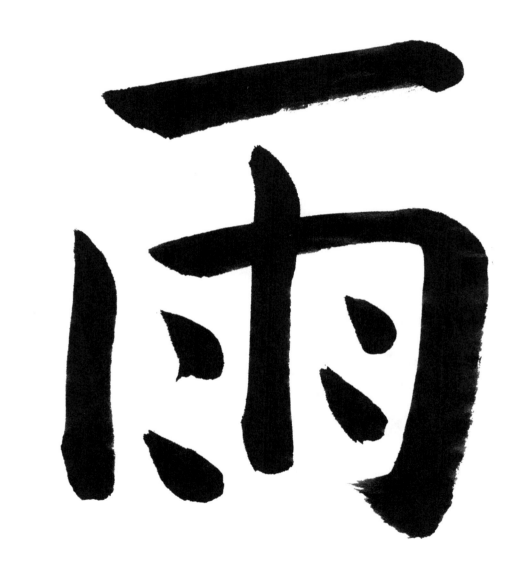

RED

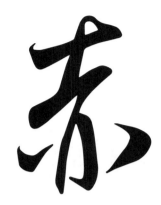

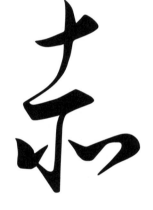

Types: Unabridged, simplified Japanese and Chinese: 赤

Other meanings: Bare, sincere.

Pronunciations: Chinese, *chì* (*ch'ih*); Japanese, *seki; aka;* Korean, *jeok;* Vietnamese, *xích.*

Classification: "Red" radical (seven strokes). This ideograph is itself a radical.

Artists: Formal script, Ouyang Tong; semicursive script, Mi Fu; cursive script, Dong Qichang.

Etymology: Originally a combination of pictographs, "large" on top and "fire" on the bottom.

Seal script: 赤 赤 赤

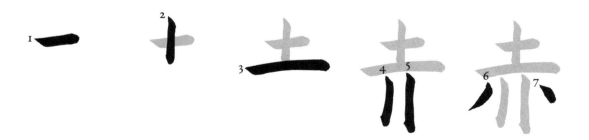

An interpretation of the energy in the formal script ➤

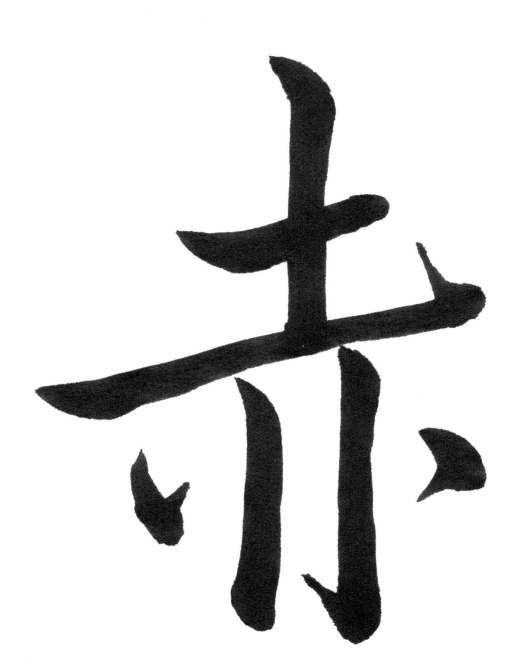

RESPECT

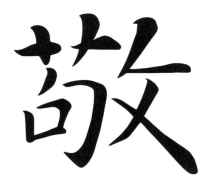
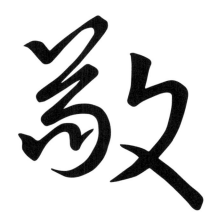

Types: Unabridged: 敬; simplified Japanese and Chinese: 敬

Other meanings: To admonish, to alert.

Pronunciations: Chinese, *jing* (*ching*); Japanese, *kei; uyamau;* Korean, *gyeong;* Vietnamese, *kính.*

Classification: "To knock" radical (right, four strokes) plus nine strokes. Total: thirteen strokes.

Artists: Formal script, Zhi Yong; semicursive and cursive scripts, Wang Xizhi.

Etymology: A pictograph of a hand holding a wooden whip on the right, plus the sound indicator *jing,* meaning "to refrain," on the left.

Seal script: 𤷙𤷙𤷙

An interpretation of the energy in the formal script ➤

敬

RIVER

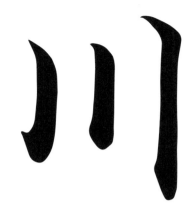

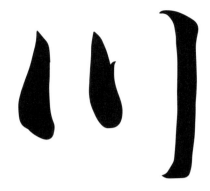

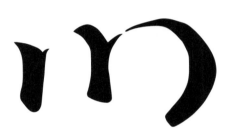

Types: Unabridged, simplified Japanese and Chinese: 川

Other meanings: Creek, brook.

Pronunciations: Chinese, *chuān* (*ch'uan*); Japanese, *sen; kawa;* Korean, *cheon;* Vietnamese, *xuyên*.

Classification: "River" radical (three strokes). This ideograph is itself a radical.

Artists: Formal and semicursive scripts, Zhi Yong; cursive script, Emperor Tai.

Etymology: Originally a pictograph showing streams of water.

Pictograph:

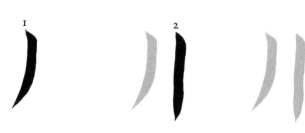

An interpretation of the energy in the formal script ➤

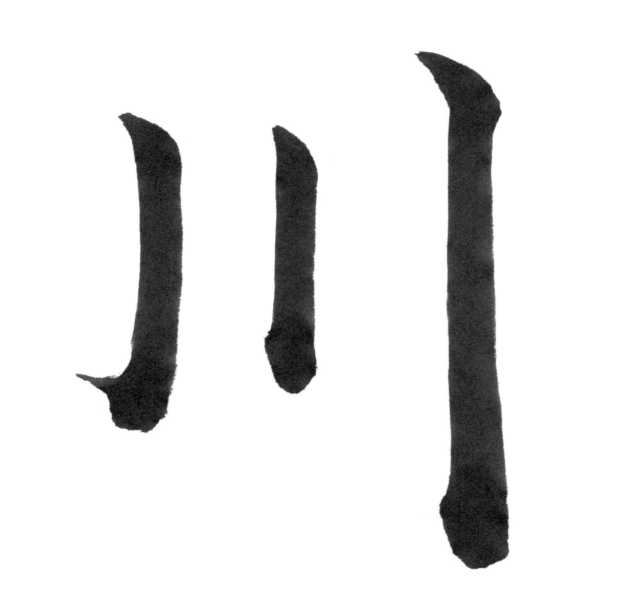

SAMADHI

Types: Unabridged, simplified Japanese and Chinese: 定

Other meanings: To determine, determined, to settle, stable, stability, regulation, law.

Pronunciations: Chinese, *dìng (tìng)*; Japanese, *tei, jō; sadameru, sadame;* Korean, *jeong;* Vietnamese, *định.*

Classification: "Roof" radical (top, three strokes) plus five strokes. Total: eight strokes.

Artists: Formal script, Chu Suiliang; semicursive script, Wang Xizhi; cursive script, Emperor Tai.

Etymology: The pictograph meaning "roof" or "house" on top, plus the sound *zheng,* meaning "correct" or "good order." The original meaning of this ideograph is "to put things in good order" or "settling."

Seal script:

Note: *Samādhi* is a Sanskrit word meaning "concentrated state of body and mind in meditation." *Ding* is its Chinese translation. *Sanmei* (三昧) is its Chinese transliteration.

An interpretation of the energy in the formal script ➤

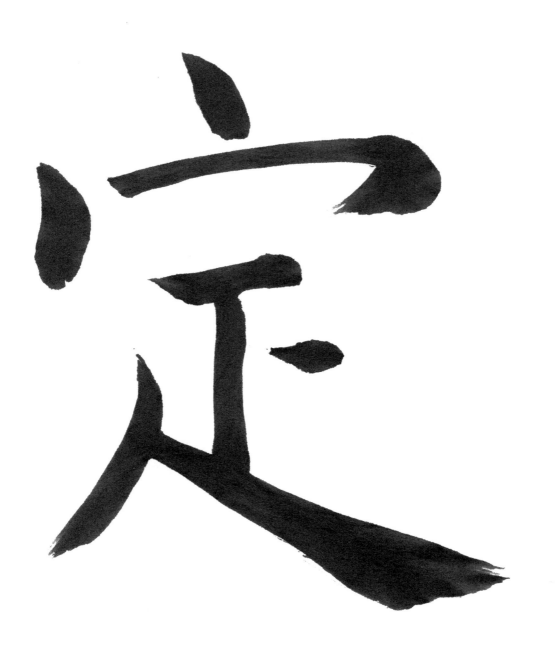

SAND

Types: Unabridged, simplified Japanese and Chinese: 砂

Other meanings: (No other meaning.)

Pronunciations: Chinese, *shā* (*sha*); Japanese, *sa; suna;* Korean, *sa;* Vietnamese, *sa.*

Classification: "Stone" radical (left, five strokes) plus four strokes. Total: nine strokes.

Artists: Formal script, Chu Suiliang; semicursive script, Wang Xizhi; cursive script, Mi Fu.

Etymology: "Stone," plus a simplification of the ideograph *sha* (沙), meaning "small grains."

Seal script:

An interpretation of the energy in the formal script ➤

石砂

SEAL

 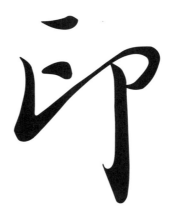

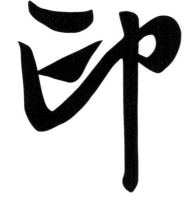

Types: Unabridged, simplified Japanese and Chinese: 印

Other meanings: Sign, form, to print, to seal, proof, India.

Pronunciations: Chinese, *yin* (*yìn*); Japanese, *in; shirusu, shirushi;* Korean, *in;* Vietnamese, *ấn.*

Classification: "Seal" radical (right, two strokes) plus four strokes. Total: six strokes.

Artists: Formal script, Yan Zhenqing; semicursive script, Dong Qichang; cursive script, Mi Fu.

Etymology: A picture of a hand (on top) pressing against a person kneeling down, meaning "to press down."

Seal script:

Note: The formal-script sample shows an archaic formation. See the stroke order for the standard traditional form.

 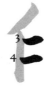

An interpretation of the energy in the formal script ➤

卯

SERENITY

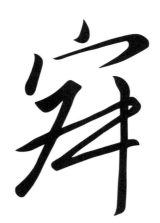

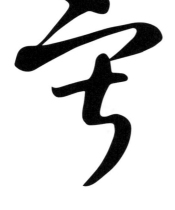

Types: Unabridged, simplified Japanese and Chinese: 寂

Other meanings: Quiet, nirvana, lonely.

Pronunciations: Chinese, *jì (chi)*; Japanese, *jaku, seki; sabi, sabishi;* Korean, *jeok;* Vietnamese, *tịch.*

Classification: "Roof" radical (top, three strokes) plus eight strokes. Total: eleven strokes.

Artists: Formal script, Huang Tingjian; semicursive script, Wang Xizhi; cursive script, Zhi Yong.

Etymology: A "roof" on top means "indoors." The bottom ideograph, *shu,* is related to another ideograph, *su,* which means "solemn" or "respectful."

Seal script: 床

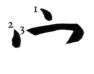
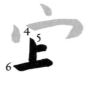

An interpretation of the energy in the semicursive script ➤

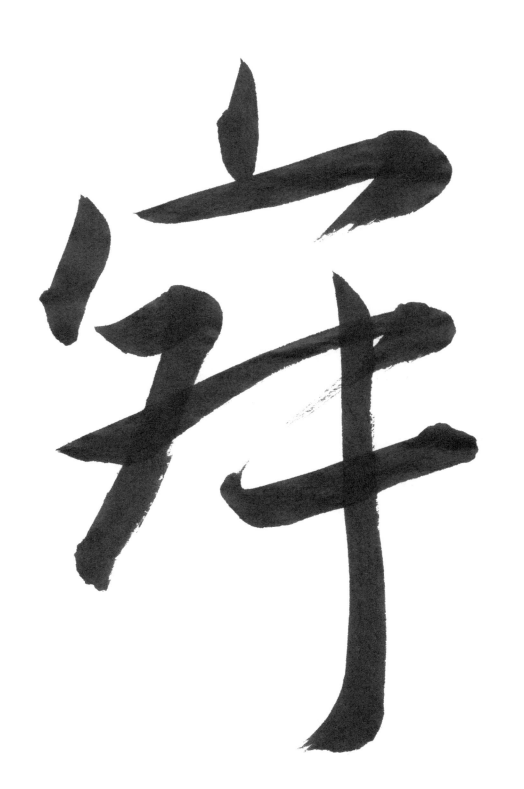

SEVEN

Types: Unabridged, simplified Japanese and Chinese: 七

Other meanings: Seventh.

Pronunciations: Chinese, *qī* (*ch'i*); Japanese, *shichi; nana, nanatsu;* Korean, *chil;* Vietnamese, *thất.*

Classification: "One" radical (in the middle, one stroke) plus one vertical and bent stroke. Total: two strokes.

Artists: Formal script, Yu Shinan; semicursive and cursive scripts, Wang Xizhi.

Etymology: Originally a pictograph meaning "cutting a horizontal line apart." As a sound indicator, it is used to represent "seven."

Seal script: 𠃉 七

An interpretation of the energy in the semicursive script ➤

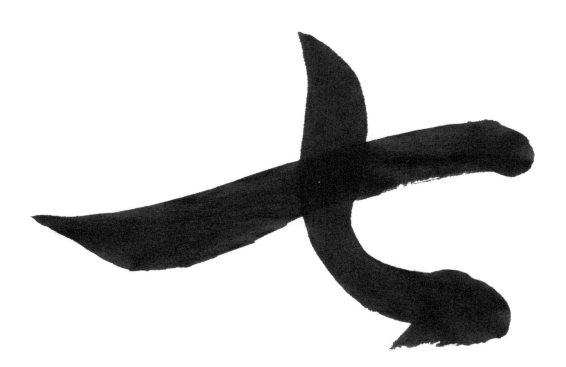

SHADOW

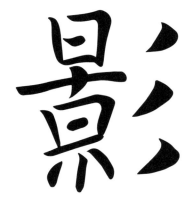
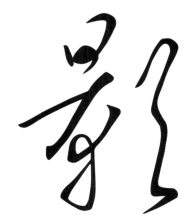

Types: Unabridged, simplified Japanese and Chinese: 影

Other meanings: Shade, sunlight, moonlight, image.

Pronunciations: Chinese, *yǐng* (*ying*); Japanese, *ei; kage;* Korean, *yeong;* Vietnamese, *ảnh.*

Classification: "Streaks" radical (right, three strokes) plus twelve strokes. Total: fifteen strokes.

Artists: Formal script, Ouyang Xun; semicursive script, Wang Xizhi; cursive script, Su Shi.

Etymology: The three lines on the right represent layers of colors. The ideograph on the left consists of "sun" or "sunlight" (three strokes on top) and the ideograph *jing*, meaning "to block" or to "frame."

Seal script: None. This ideograph was created after the time of seal script.

Note: The formal-script sample shows an archaic formation. See the unabridged type and the stroke order for the standard traditional form.

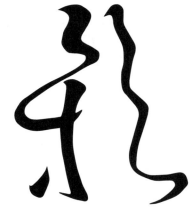

 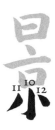 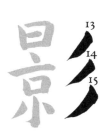

An interpretation of the energy in the semicursive script ➤

観

SHIBUI

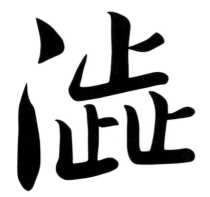
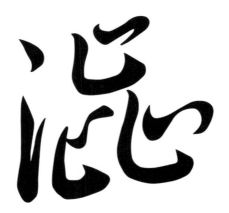

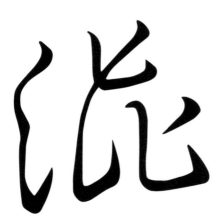

Types: Unabridged, simplified Chinese: 澁; simplified Japanese: 渋

Other meanings: Astringent, tan, stagnant.

Pronunciations: Chinese, *sè;* Japanese, *jū; shibu, shibui;* Korean, *sap;* Vietnamese, *sáp.*

Classification: "Water" radical (left, three strokes, although classified as four strokes—水) plus twelve strokes. Total: fifteen strokes.

Artists: Formal script, Zhi Guo; semicursive script, Xue Yao; cursive script, Sun Guoting.

Etymology: "Water," plus three ideographs meaning "to stop," indicating "stagnancy."

Seal script: None. This ideograph was created after the time of seal script.

Note: *Shibui* is a Japanese word based on the astringency of persimmons, indicating a quiet, subdued, and refined taste. The formal-script sample shows an archaic formation. See the unabridged type and the stroke order for the standard traditional form.

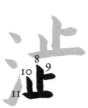
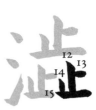

An interpretation of the energy in the semicursive script ➤

滥

SING

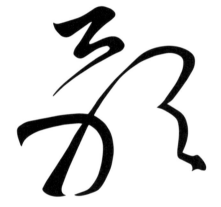

Types: Unabridged, simplified Japanese and Chinese: 歌

Other meanings: Song.

Pronunciations: Chinese, *gē* (*ke*); Japanese, *ka; utau, uta;* Korean, *ga;* Vietnamese, *ca.*

Classification: "To yawn" radical (right, four strokes) plus ten strokes. Total: fourteen strokes.

Artists: Formal script, Zhi Yong; semicursive script, Chu Suiliang; cursive script, Huaisu.

Etymology: A pictograph of an open mouth on the right, plus the sound indicator *ge,* meaning "to sing," on the left.

Seal script: 哥 哥 歌

 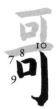 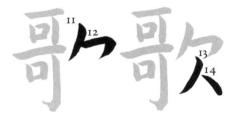

An interpretation of the energy in the semicursive script ➤

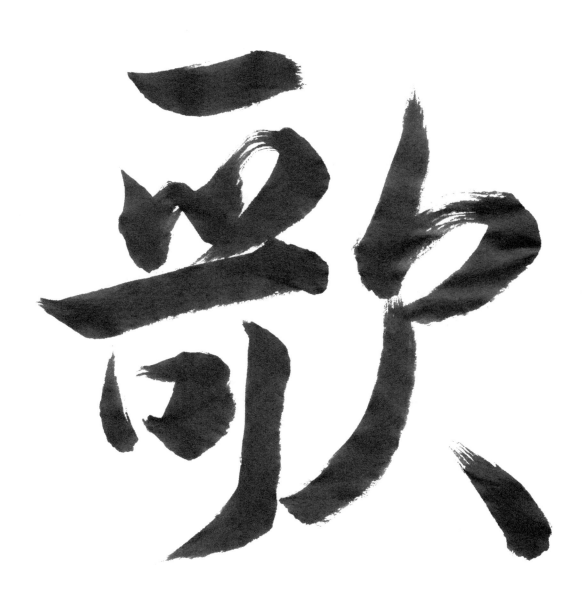

SIX

Types: Unabridged, simplified Japanese and Chinese: 六

Other meanings: Sixth.

Pronunciations: Chinese, *liù* (*liu*); Japanese, *roku; mutsu, muttsu;* Korean, *yuk;* Vietnamese, *lục.*

Classification: "Eight" radical (bottom, two strokes) plus two strokes. Total: four strokes.

Artists: Formal script, Yu Shinan; semicursive and cursive scripts, Wang Xizhi.

Etymology: Originally a pictograph of a house, borrowed to represent "six."

Seal script: 𠔼 𠔽 𠔾

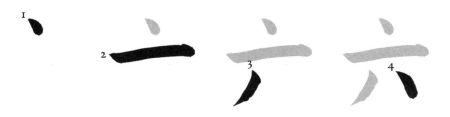

An interpretation of the energy in the semicursive script ➤

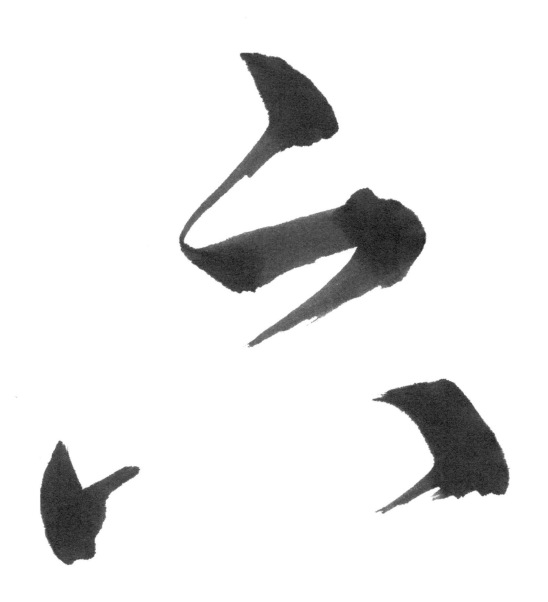

SNOW

Types: Unabridged: 雪; simplified Japanese and Chinese: 雪

Other meanings: To snow, to cleanse.

Pronunciations: Chinese, *xuě* (*hsueh*); Japanese, *setsu; yuki;* Korean, *seol;* Vietnamese, *tuyết.*

Classification: "Rain" radical (top, eight strokes) plus three strokes. Total: eleven strokes.

Artists: Formal script, Chu Suiliang; semicursive script, Wang Xizhi; cursive script, Yan Zhenqing.

Etymology: "Rain," plus a simplified form of the sound indicator *hui* (彗), meaning "broom."

Seal script: 雪

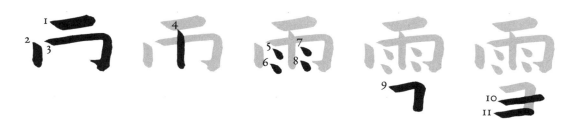

An interpretation of the energy in the semicursive script ➤

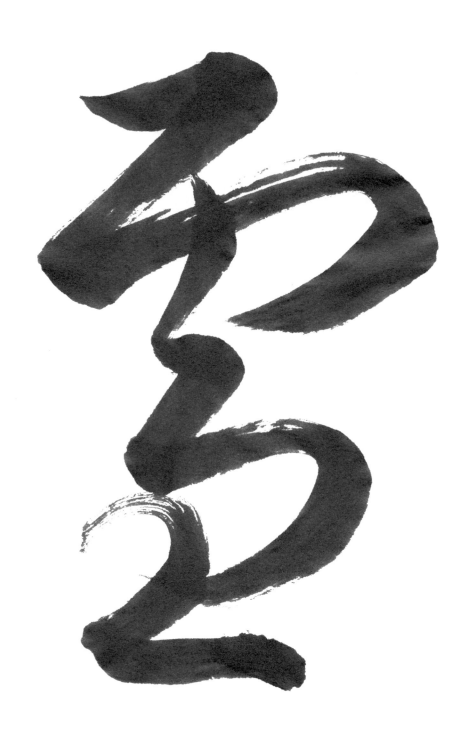

SOIL

Types: Unabridged, simplified Japanese and Chinese: 土

Other meanings: Mud, dirt, land, earth.

Pronunciations: Chinese, *tŭ* (*t'u*); Japanese, *do; tsuchi;* Korean, *to;* Vietnamese, *thổ*.

Classification: "Earth" radical (three strokes). This ideograph is itself a radical.

Artists: Formal script, Ouyang Xun; semicursive and cursive scripts, Wang Xizhi.

Etymology: A pictograph representing a mound of soil that enshrines the deity of the land.

Pictograph:

Note: The formal-script sample shows an archaic formation. See the unabridged type and the stroke order for the standard traditional form.

The cursive script sample has an extra dot at the end.

An interpretation of the energy in the semicursive script ➤

SOUND

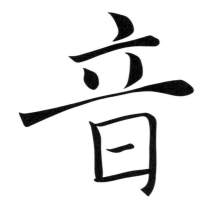 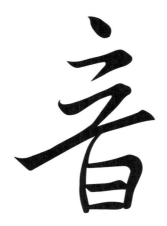

Types: Unabridged, simplified Japanese and Chinese: 音

Other meanings: Voice, tune, tone, music.

Pronunciations: Chinese, *yīn* (*yin*); Japanese, *on, in; oto;* Korean, *eum;* Vietnamese, *âm.*

Classification: "Sound" radical (nine strokes). This ideograph is itself a radical.

Artists: Formal script, Chu Suiliang; semicursive script, Wang Xizhi; cursive script, Huaisu.

Etymology: Originally an ideograph meaning "speech": a combination of the pictograph "mouth" on the bottom and "heart" on top. A horizontal line has been added inside the "mouth," indicating tuned sound.

Seal script:

An interpretation of the energy in the semicursive script ➤

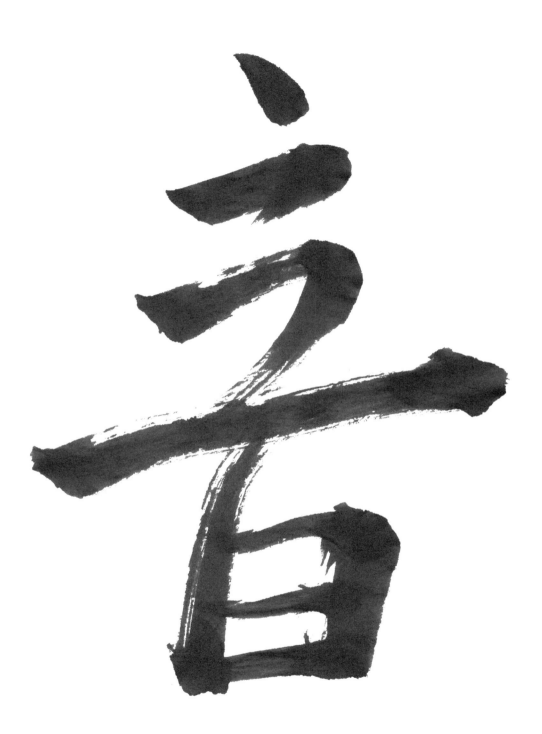

SOUTH

Types: Unabridged, simplified Japanese and Chinese: 南

Other meanings: Southern.

Pronunciations: Chinese, *nán (nan)*; Japanese, *nan; minami;* Korean, *nam;* Vietnamese, *nam.*

Classification: "Cross" radical (top, two strokes) plus seven strokes. Total: nine strokes.

Artists: Formal script, Yu Shinan; semicursive script, Chu Sui-liang; cursive script, Ouyang Xun.

Etymology: Originally a "tent" on top, plus the sound indicator *dan* (丹), meaning warm inside the house.

Seal script: 凸 南 南

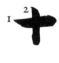 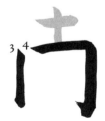 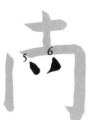 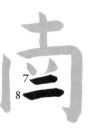

An interpretation of the energy in the semicursive script ➤

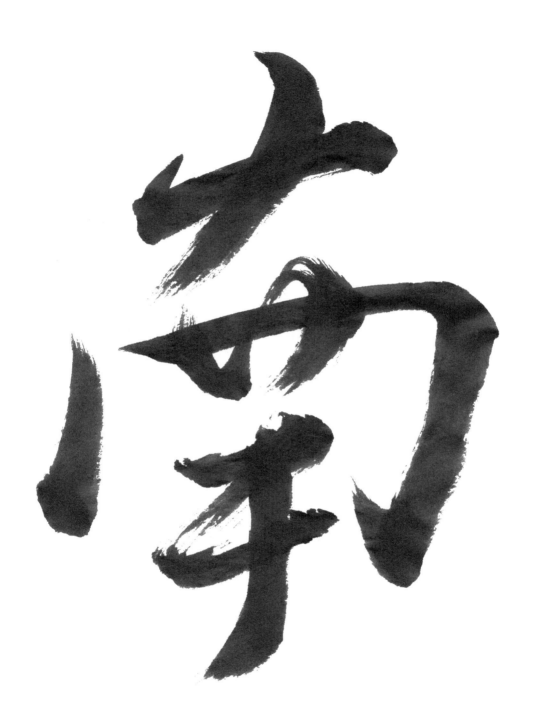

SPACE

Types: Unabridged, simplified Japanese: 間; simplified Chinese: 间

Other meanings: Crack, gap, leisure, to ignore, room, relationship.

Pronunciations: Chinese, *jiān (chien), xián (hsien)*; Japanese, *kan, ken; aida, ma*; Korean, *gan*; Vietnamese, *gian*.

Classification: "Gate" radical (eight strokes) surrounding four strokes on the inside. Total: twelve strokes.

Artists: Formal script, Ouyang Tong; semicursive and cursive scripts, Wang Xizhi.

Etymology: Originally *yue* (月), meaning "lack," between the gate doors.

Seal script: 間 関 閒

Note: The formal- and semicursive-script samples show an archaic formation. See the unabridged type and the stroke order for the standard traditional form.

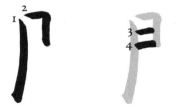

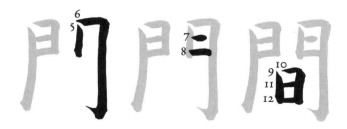

An interpretation of the energy in the cursive script ➤

SPRING

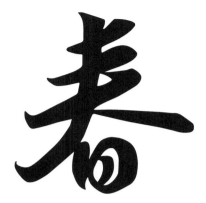

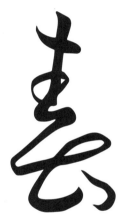

Types: Unabridged, simplified Japanese and Chinese: 春

Other meanings: Adolescence.

Pronunciations: Chinese, *chūn* (*ch'un*); Japanese, *shun; haru;* Korean, *chun;* Vietnamese, *xuân.*

Classification: "Sun" radical (bottom center, four strokes) plus five strokes. Total: nine strokes.

Artists: Formal script, Chu Suiliang; semicursive script, Su Shi; cursive script, Sun Guoting.

Etymology: "Sun" radical on the bottom, plus the sound *chun,* meaning "grass is sprouting," on top.

Seal script: 𡳉 𦰩 𦱮

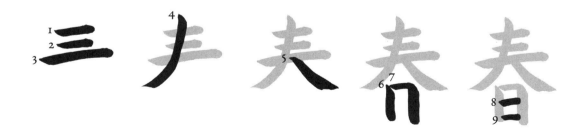

An interpretation of the energy in the cursive script ➤

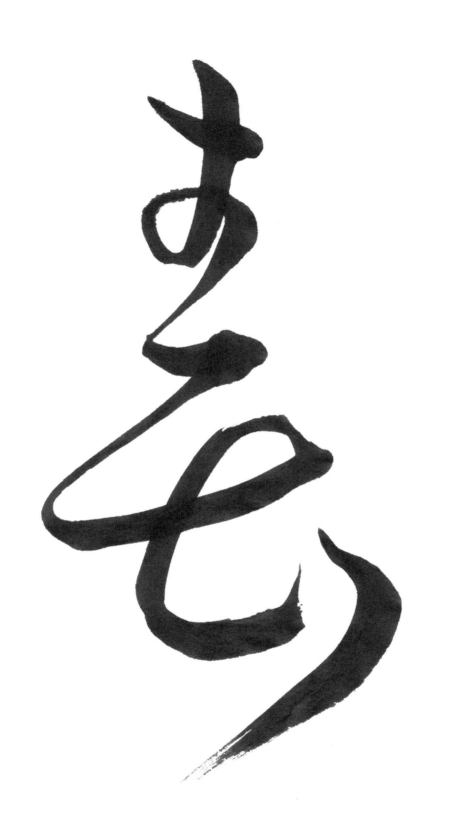

STONE

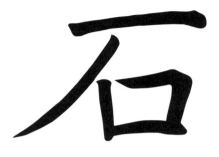 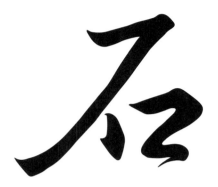

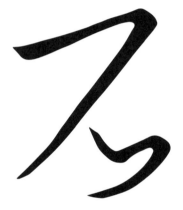

Types: Unabridged, simplified Japanese and Chinese: 石

Other meanings: Rock, hard, mineral.

Pronunciations: Chinese, *shí (shih)*; Japanese, *seki, koku; ishi,* Korean, *seok;* Vietnamese, *thạch.*

Classification: "Stone" radical (five strokes). This ideograph is itself a radical.

Artists: Formal script, Chu Suiliang; semicursive and cursive scripts, Wang Xizhi.

Etymology: A combination of the top stroke and the stroke going downward diagonally left means "cliff." The bottom rectangle represents a small piece of solid substance.

Pictograph: 石 石 石

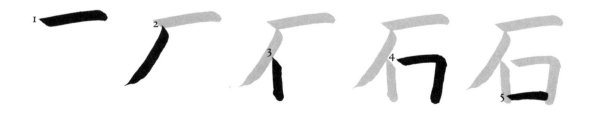

An interpretation of the energy in the cursive script ➤

SUMMER

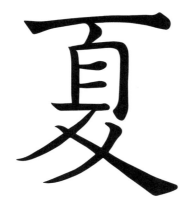

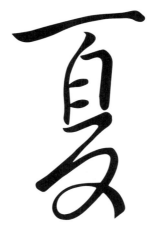

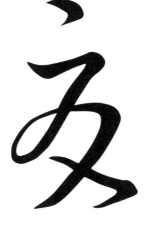

Types: Unabridged, simplified Japanese and Chinese: 夏

Pronunciations: Chinese, *xià (hsia)*; Japanese, *ka; natsu;* Korean, *ha;* Vietnamese, *hạ.*

Classification: "Slow" radical (bottom, three strokes) plus seven strokes. Total: ten strokes.

Artists: Formal script, Chu Suiliang; semicursive script, Emperor Tai; cursive script, Wang Xizhi.

Etymology: Originally a pictograph showing a dancing person wearing a big mask (a summer dance).

Seal script: 夓 夏

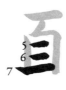

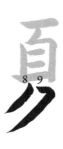

An interpretation of the energy in the cursive script ➤

SUN

Types: Unabridged, simplified Japanese and Chinese: 日

Other meanings: Day, Sunday, Japan.

Pronunciations: Chinese, *rì* (*jih*); Japanese, *nichi, jitsu; hi;* Korean, *il;* Vietnamese, *nhật.*

Classification: "Sun" radical (four strokes). This ideograph is itself a radical.

Artists: Formal script, Yu Shinan; semicursive and cursive scripts, Wang Xizhi.

Etymology: Originally a pictograph with a disk in the center and a circle indicating the sunlight around it.

Pictograph:

An interpretation of the energy in the cursive script ➤

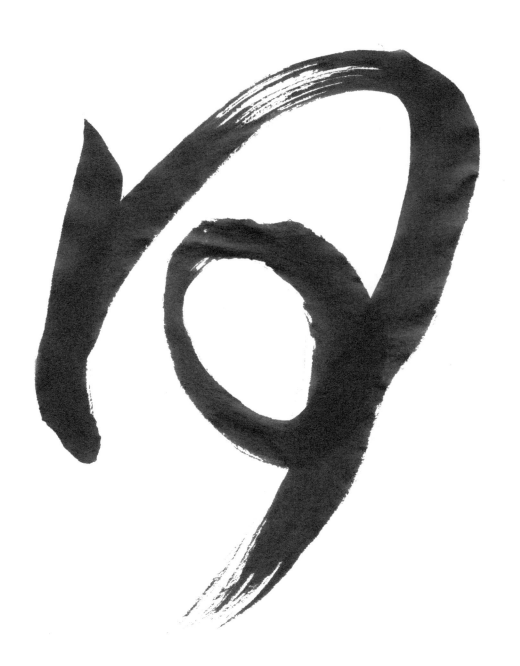

SUTRA

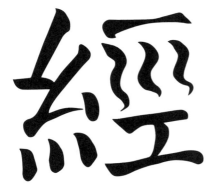 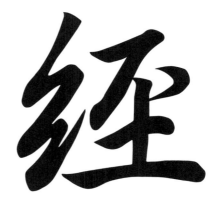

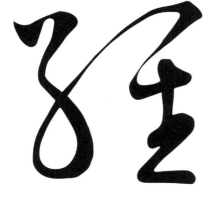

Types: Unabridged: 經; simplified Japanese, 経; simplified Chinese: 经

Other meanings: Scripture, passage, warp.

Pronunciations: Chinese, *jīng* (*ching*); Japanese, *kyō; tateito, tsune, nori, furu, heru;* Korean, *gyeong;* Vietnamese, *kinh*.

Classification: "Thread" radical (left, six strokes) plus seven strokes. Total: thirteen strokes.

Artists: Formal script, Yan Zhenqing; semicursive script, Zhao Mengtiao; cursive script, Wang Xizhi.

Etymology: "Thread" on the left, plus the ideograph *jing,* meaning "stretched warp in the loom," on the right.

Seal script: 經 経

Note: This ideograph was used in pre-Buddhist China to mean "scripture," as in *Daode Jing* (Tao-te Ching) by Laozi. Later in Buddhism, it was used as a translation of the Sanskrit word *sūtra*. The formal-script sample shows an archaic formation. See the traditional unabridged type and the stroke order for the standard traditional form.

 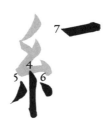 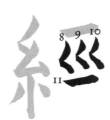 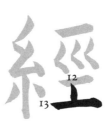

An interpretation of the energy in the cursive script ➤

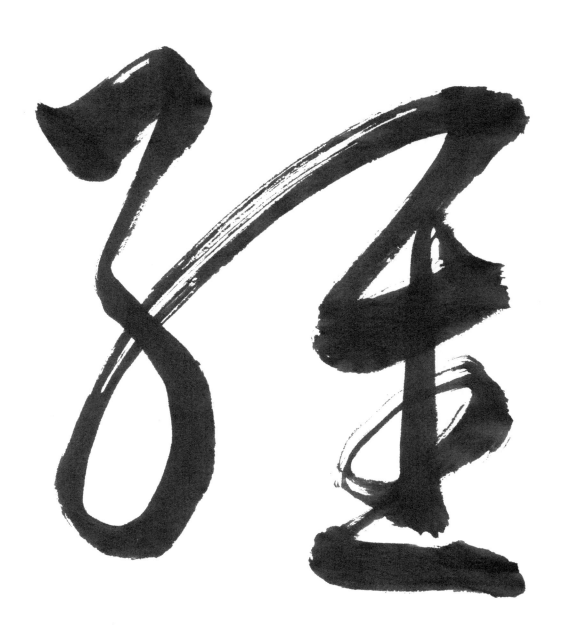

TEA

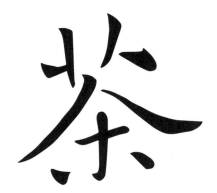

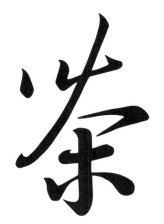

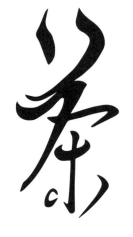

Types: Unabridged: 茶, simplified Japanese and Chinese: 茶

Other meanings: Tea tree, brown.

Pronunciations: Chinese, *chá (ch'a);* Japanese, *cha; sa;* Korean, *da;* Vietnamese, *trà.*

Classification: "Grass" radical (top, four strokes, although classified under 艸—six strokes) plus six strokes. Total: ten strokes.

Artists: Formal script, Wang Meng; semicursive script, Cai Xiang; cursive script, Xu Youzhen.

Etymology: Originally "grass" on top, plus the sound indicator 余, originally pronounced *xie,* meaning "to stimulate." Later the bottom part was replaced by the present symbol.

Seal script: 茶

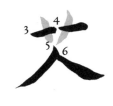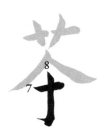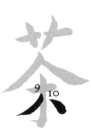

An interpretation of the energy in the cursive script ➤

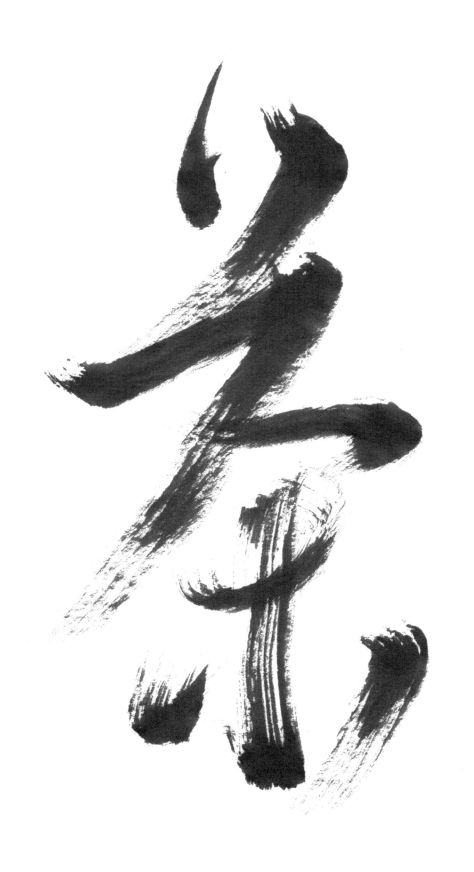

TEACH

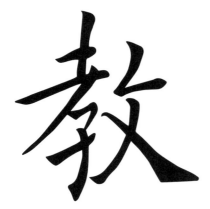

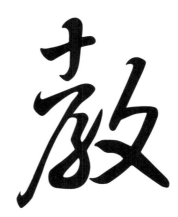

Types: Unabridged, 敎; simplified Japanese and Chinese: 教

Other meanings: Teaching, education, religion.

Pronunciations: Chinese, *jiāo, jiào* (*chiao*); Japanese, *kyō; oshieru, oshie;* Korean, *gyo;* Vietnamese, *giáo.*

Classification: "To knock" radical (right, four strokes) plus seven strokes. Total: eleven strokes.

Artists: Formal script, Ouyang Xun; semicursive script, Mi Fu; cursive script, Wang Duo.

Etymology: A pictograph of a hand holding a wooden whip on the right, plus the sound indicator *jiao,* meaning "to learn," on the left.

Seal script: 敎 敎 敎

Note: The formal-script sample shows a simplified formation. See the unabridged type and the stroke order for the standard traditional form.

An interpretation of the energy in the cursive script ➤

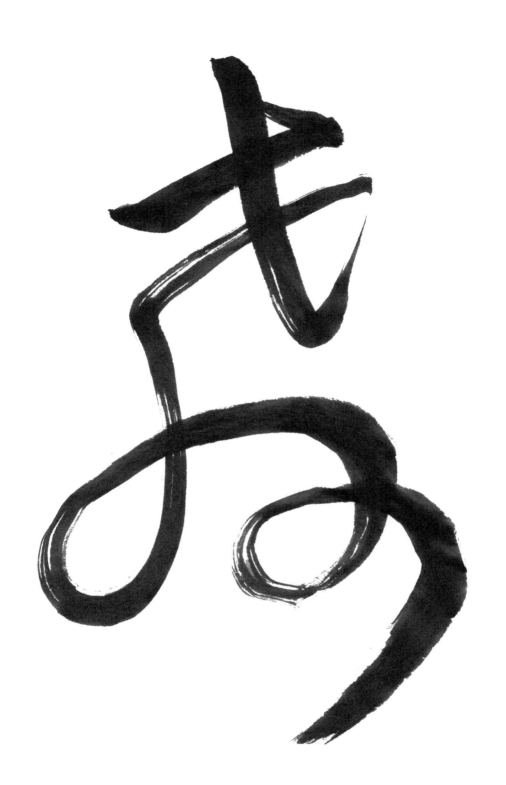

TEN

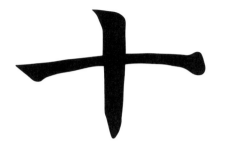

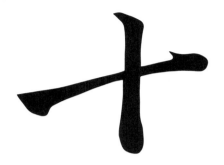

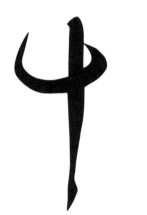

Types: Unabridged, simplified Japanese and Chinese: 十

Other meanings: Tenth, complete, all.

Pronunciations: Chinese, *shí* (*shih*); Japanese, *jū; tō;* Korean, *sip;* Vietnamese, *thập.*

Classification: "Cross" radical (two strokes). This ideograph is itself a radical.

Artists: Formal script, Chu Suiliang; semicursive script, Wang Xizhi; cursive script, Sun Guoting.

Etymology: Originally a pictograph of a needle, which has been borrowed to mean "ten."

Pictograph:

An interpretation of the energy in the cursive script ➤

TEN THOUSAND

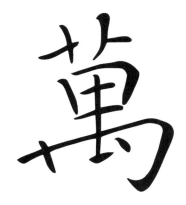

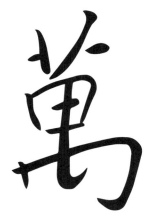

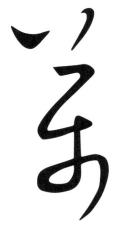

Types: Unabridged: 萬; simplified Japanese and Chinese: 万

Other meanings: Many, innumerable.

Pronunciations: Chinese, *wàn* (*wan*); Japanese, *man, ban; yorozu;* Korean, *man;* Vietnamese, *vạn.*

Classification: "Grass" radical (top, four strokes, although classified under 艸—six strokes) plus nine strokes. Total: thirteen strokes.

Artists: Formal script, Chu Suiliang; semicursive script, Wang Xizhi; cursive script, Huaisu.

Etymology: Originally a pictograph of a scorpion, which has been borrowed to mean "ten thousand."

Pictograph:

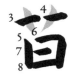 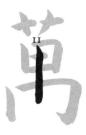 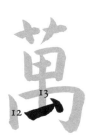

An interpretation of the energy in the cursive script ➤

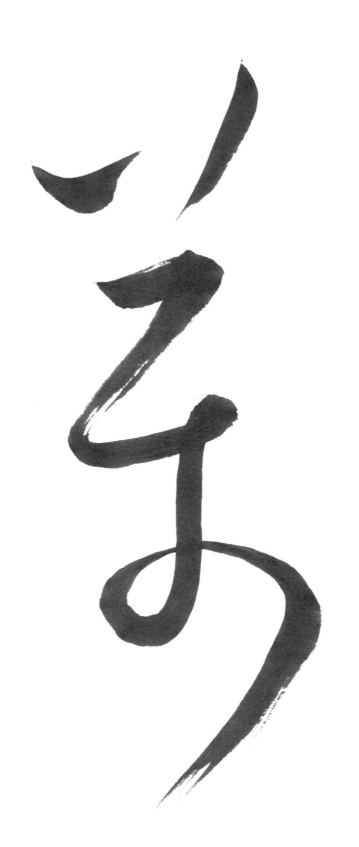

THOUSAND

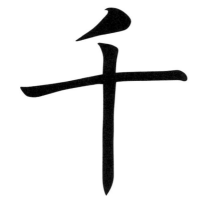

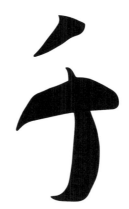

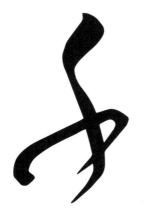

Types: Unabridged, simplified Japanese and Chinese: 千

Other meanings: Many, innumerable.

Pronunciations: Chinese, *qiān* (*ch'ien*); Japanese, *sen; chi;* Korean, *cheon;* Vietnamese, *thiên.*

Classification: "Cross" radical (center, two strokes) plus one stroke. Total: three strokes.

Artists: Formal script, Chu Suiliang; semicursive script, Zhi Yong; cursive script, Huaisu.

Etymology: The ideograph "one" (the horizontal stroke), plus the sound indicator *ren*, meaning "person(s)," to represent "one thousand."

Seal script: 夲 千 千

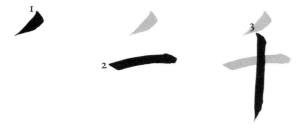

An expressive work inspired by the cursive script ➤

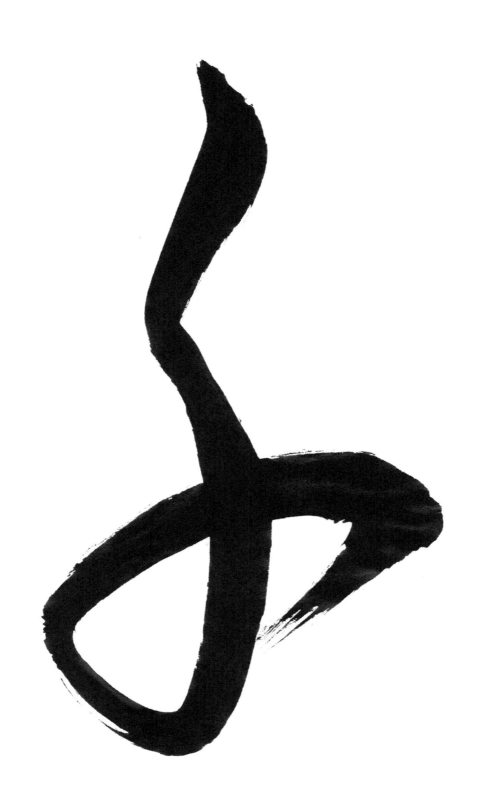

THREE

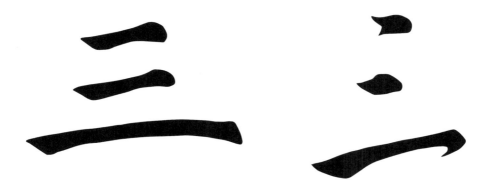

Types: Unabridged, simplified Japanese and Chinese: 三

Other meanings: Third, many.

Pronunciations: Chinese, *sān (san)*; Japanese, *san; mi, mittsu*; Korean, *sam*; Vietnamese, *tam.*

Classification: "One" radical (bottom) plus two strokes. Total: three strokes.

Artists: Formal script, Yu Shinan; semicursive script, Wang Xizhi; cursive script, Huaisu.

Etymology: An ideograph consisting of three lines to signify the number.

Seal script:

An expressive work inspired by the semicursive script ➤

TIGER

Types: Unabridged, simplified Japanese: 虎; simplified Chinese: 虎

Other meanings: Drunkard.

Pronunciations: Chinese, *hŭ* (*hu*); Japanese, *ko; tora;* Korean, *ho;* Vietnamese, *hổ.*

Classification: "Tiger" radical (top and center, six strokes) plus two strokes on the bottom. Total: eight strokes.

Artists: Formal and cursive scripts, Wang Xizhi; semicursive script, Zhao Mengtiao.

Etymology: Originally a picture of a tiger. The first six strokes became a radical forming the "tiger" category of ideographs.

Pictograph: 𩆜𧆜𧆜

Note: The formal- and semicursive-script samples show an archaic formation. See the unabridged type and the stroke order for the standard traditional form.

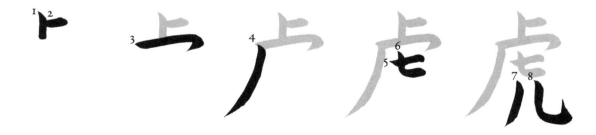

An expressive work inspired by the formal script ➤

TIME

Types: Unabridged, simplified Japanese: 時; simplified Chinese: 时

Other meanings: Hour, moment, season, occasion.

Pronunciations: Chinese, *shí* (*shih*); Japanese, *ji; toki;* Korean, *si;* Vietnamese, *thời, thi.*

Classification: "Sun" radical (left, four strokes) plus six strokes. Total: ten strokes.

Artists: Formal script, Yu Shinan; semicursive script, Wang Xizhi; cursive script, Wang Xianzhi.

Etymology: "Sun" on the left, plus the sound *shi,* meaning "change" or "travel," on the right.

Seal script: 時

An expressive work inspired by the cursive script ➤

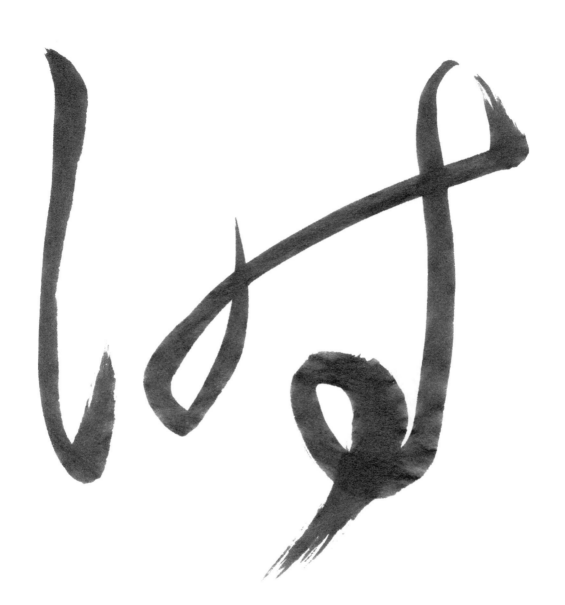

TRANSCEND

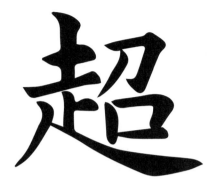 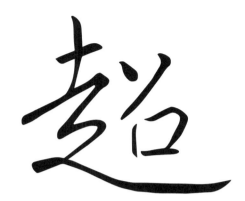

Types: Unabridged, simplified Japanese and Chinese: 超

Other meanings: To jump over, to pass, to excel, to surpass.

Pronunciations: Chinese, *chāo (ch'ao)*; Japanese, *chō; koeru;* Korean, *cho;* Vietnamese, *siêu.*

Classification: "To run" radical (left and bottom, seven strokes) plus five strokes. Total: twelve strokes.

Artists: Formal script, anonymous (*Stone Carved Sutra*); semicursive script, Chu Suiliang; cursive script, Huaisu.

Etymology: "To run" radical on the left and bottom, plus the sound *chao,* meaning "to jump over."

Seal script: 超

 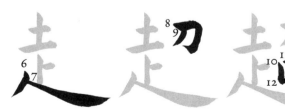

An expressive work inspired by the cursive script ➤

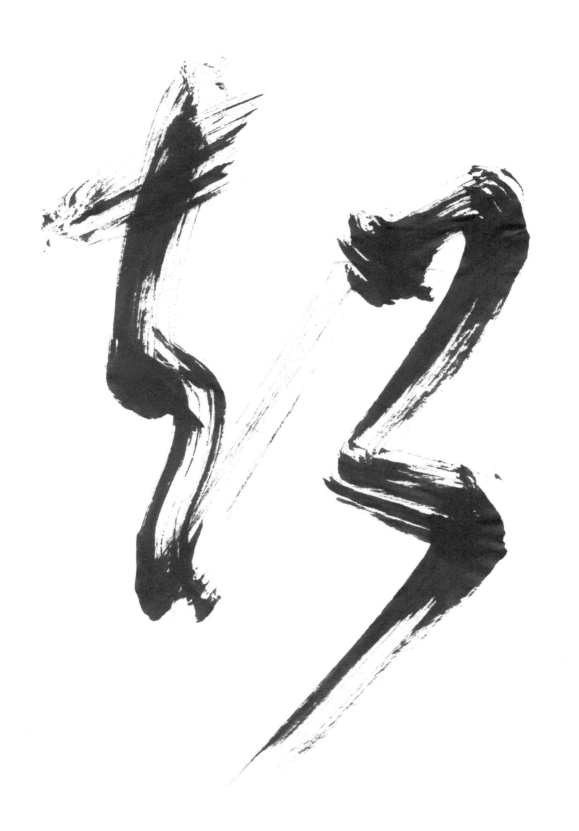

TRANSFORM

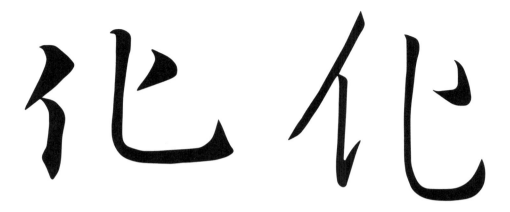

Types: Unabridged, simplified Japanese: 化; simplified Chinese: 化

Other meanings: To change, to teach, disguise.

Pronunciations: Chinese, *huà* (*hua*); Japanese, *ka, ke; bakeru;* Korean, *hwa;* Vietnamese, *hóa.*

Classification: "Ladle" radical (right, two strokes) plus two strokes. Total: four strokes.

Artists: Formal script, Zhi Yong; semicursive script, Wang Xizhi; cursive script, Emperor Tai.

Etymology: Originally a person standing (on the left) and a person standing upside down (on the right), indicating a change of views.

Seal script:

An expressive work inspired by the semicursive script ➤

TRANSMIT

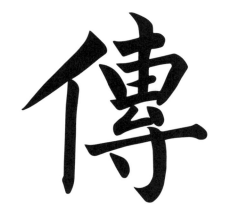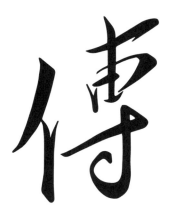

Types: Unabridged: 傳; simplified Japanese: 伝; simplified Chinese: 传

Other meanings: To communicate, to hand, to give.

Pronunciations: Chinese, *chuán* (*ch'uan*); Japanese, *den; tsutaeru;* Korean, *jeon;* Vietnamese, *truyền*.

Classification: "Human" radical (left, two strokes) plus eleven strokes. Total: thirteen strokes.

Artists: Formal script, Liu Gongquan; semicursive script, Wang Zhiwang; cursive script, Sun Guoting.

Etymology: "Human" radical, plus the sound indicator *zhuan,* meaning "to transport," on the right.

Seal script: 傳 傳 傳

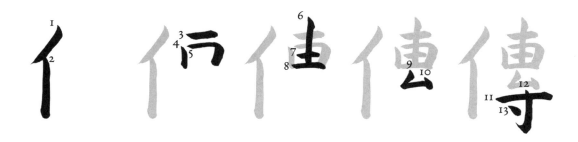

An expressive work inspired by the semicursive script ➤

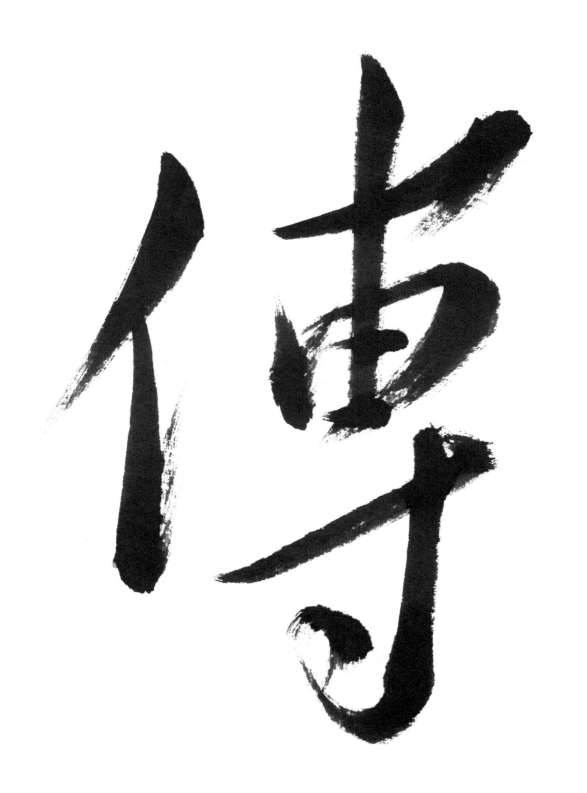

TREE

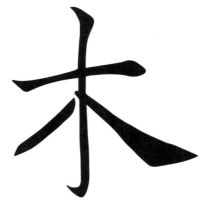
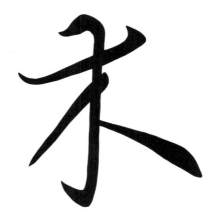
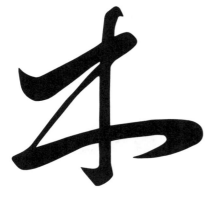

Types: Unabridged, simplified Japanese and Chinese: 木

Other meanings: Wood, wooden.

Pronunciations: Chinese, *mù (mu)*; Japanese, *moku, boku; ki;* Korean, *mok;* Vietnamese, *mộc.*

Classification: "Tree" radical (four strokes). This ideograph is itself a radical.

Artists: Formal script, Chu Suiliang; semicursive script, Zhi Yong; cursive script, Sun Guoting.

Etymology: Originally a pictograph of a tree: a trunk with branches and roots.

Pictograph: 木 木 木

Note: The cursive-script sample begins with the vertical stroke.

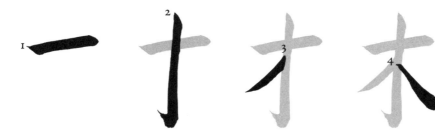

An expressive work inspired by the formal script ➤

TRUE

Types: Unabridged, 實; simplified Japanese, 実; simplified Chinese: 实

Other meanings: Fruit, to bear fruit, harvest, effect, essence, real, truth.

Pronunciations: Chinese, *shí (shih)*; Japanese, *jitsu; mi, minoru, minori;* Korean, *sil;* Vietnamese, *thực.*

Classification: "Roof" radical (top, three strokes) plus eleven strokes. Total: fourteen strokes.

Artists: Formal script, Zhong Yao; semicursive and cursive scripts, Wang Xizhi.

Etymology: The top three strokes mean "roof," which indicates "house." The bottom seven-stroke ideograph means "shell," which indicates "money" or "treasure." The middle symbol in four strokes is the ideograph *zhou* (周), meaning "filled." The original meaning of the ideograph *shī* is "the house is filled with treasures."

Seal script:

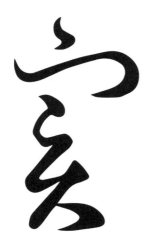

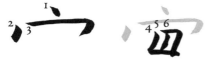

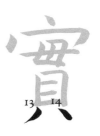

An expressive work inspired by the cursive script ➤

TWO

Types: Unabridged, simplified Japanese and Chinese: 二

Other meanings: Second, dual, again, twice.

Pronunciations: Chinese, *èr (erh)*; Japanese, *ni, ji; futatsu;* Korean, *i;* Vietnamese, *nhị, nhi.*

Classification: "Two" radical (two strokes). This ideograph is itself a radical.

Artists: Formal script, Zhi Yong; semicursive script, Huaisu; cursive script, Wang Xizhi.

Etymology: Originally an ideograph consisting of two horizontal lines, meaning "two."

Seal script: 二 二 二

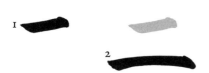

An expressive work inspired by the formal script ➤

UNITY

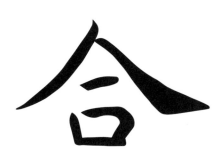 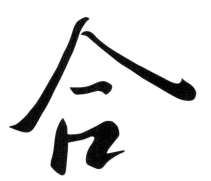

Types: Unabridged, simplified Japanese and Chinese: 合

Other meanings: To fit, to merge, to agree, to coincide.

Pronunciations: Chinese, *hé* (*ke*); Japanese, *gō; au, ai;* Korean, *hap;* Vietnamese, *hợp.*

Classification: "Mouth" radical (bottom, three strokes) plus three strokes. Total: six strokes.

Artists: Formal script, Yu Shinan; semicursive script, Wang Xizhi; cursive script, Zhi Yong.

Etymology: Originally a pictograph that was a combination of "lid" (the top three strokes) with an ideograph indicating the mouth of a container (on the bottom). The original meaning of the pictograph is "to fit."

Seal script:

 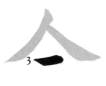 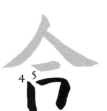

An expressive work inspired by the cursive script, acrylic on canvas ➤

UP

Types: Unabridged, simplified Japanese and Chinese: 上

Other meanings: High, higher, above, to ascend.

Pronunciations: Chinese, *shàng* (*shang*); Japanese, *jō; ue, kami;* Korean, *sang;* Vietnamese, *thượng.*

Classification: "One" radical (bottom, one stroke) plus two strokes. Total: three strokes.

Artists: Formal script, Chu Suiliang; semicursive script, Su Shi; cursive script, Mi Fu.

Etymology: Originally a short line above the base horizontal line.

Seal script: 二 上 上

Note: The stroke order of the semicursive script sample is: 2, 1, 3 (one and three are connected by a ligature).

An expressive work inspired by the cursive script, acrylic on canvas ➤

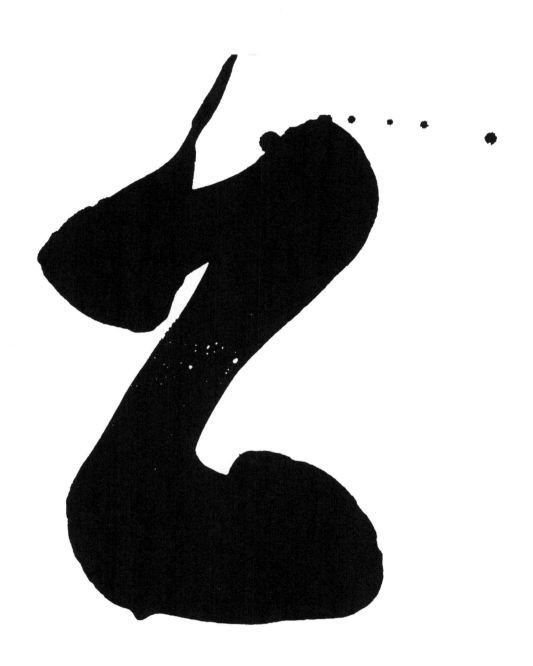

VEGETABLE

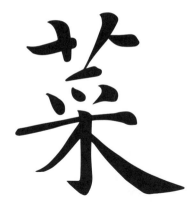

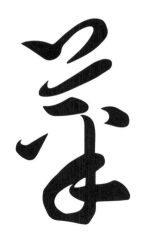

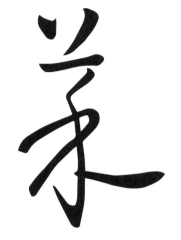

Types: Unabridged: 菜; simplified Japanese and Chinese: 菜

Other meanings: Vegetarian, greens.

Pronunciations: Chinese, *cài* (*ts'ai*); Japanese, *sai; na;* Korean, *chae;* Vietnamese, *thái.*

Classification: "Grass" radical (top, four strokes, though classified under 艸—six strokes) plus eight strokes. Total: twelve strokes.

Artists: Formal script, Zhi Yong; semicursive script, Sun Guoting; cursive script, Huaisu.

Etymology: "Grass" plus the ideograph *cai* (采), meaning "to pick."

Seal script: 菜

 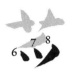

An expressive work inspired by the cursive script, acrylic on canvas ➤

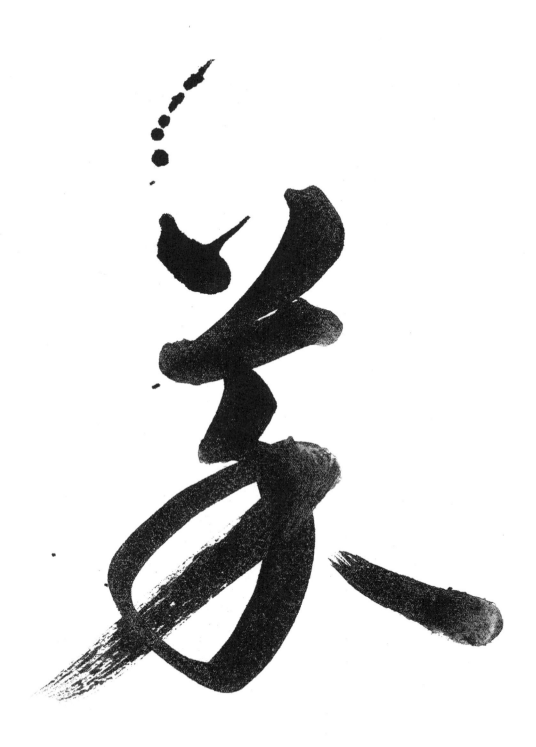

VIRTUE

Types: Unabridged, simplified Chinese: 德; simplified Japanese: 徳

Other meanings: Talent, merit, value.

Pronunciations: Chinese, *dé* (*te*); Japanese, *toku;* Korean, *deok;* Vietnamese, *đức.*

Classification: "Going person" radical (left, three strokes) plus twelve strokes. Total: fifteen strokes.

Artists: Formal script, Yu Shinan; semicursive script, Emperor Tai; cursive script, Wang Xizhi.

Etymology: Originally a combination of the ideographs *ji,* meaning "straight" (top right), and "heart" (bottom right), to mean "virtue." Later the radical on the left, meaning "stepping" or "walking in the path," was added.

Seal script: 𢛳 德 𢛳

Note: The formal- and semicursive-script samples show a simplified formation. See the unabridged type and the stroke order for the standard traditional form.

An expressive work inspired by the cursive script, acrylic on canvas ➤

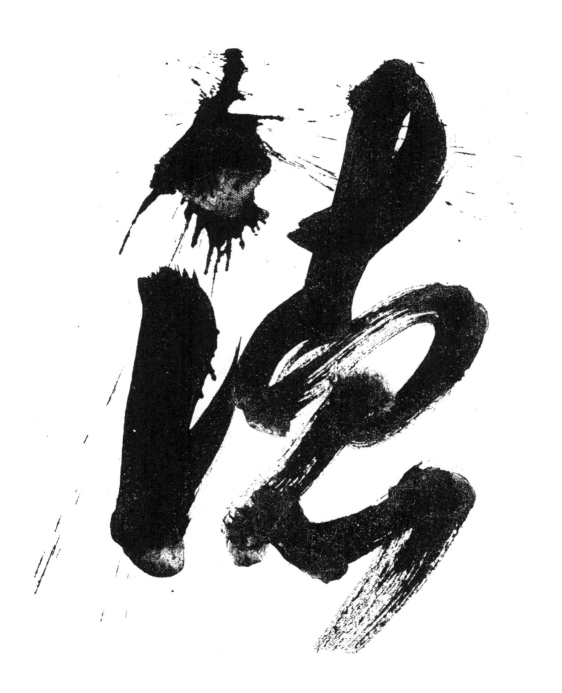

VOICE

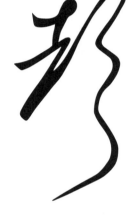

Types: Unabridged: 聲; simplified Japanese and Chinese: 声

Other meanings: Sound, words, reputation, fame.

Pronunciations: Chinese, *shēng* (*sheng*); Japanese, *sei, shō; koe;* Korean, *seong;* Vietnamese, *thanh.*

Classification: "Ear" radical (bottom, six strokes) plus eleven strokes. Total: seventeen strokes.

Artists: Formal script, Chu Suiliang; semicursive script, Mi Fu; cursive script, Huaisu.

Etymology: The pictograph "ear" on the bottom plus "chime" (top left) and "stick" (top right).

Seal script:

Note: The formal-script sample shows an archaic formation. See the unabridged type and the stroke order for the standard traditional form.

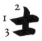 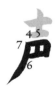 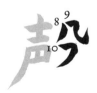

An expressive work inspired by the cursive script, acrylic on canvas ➤

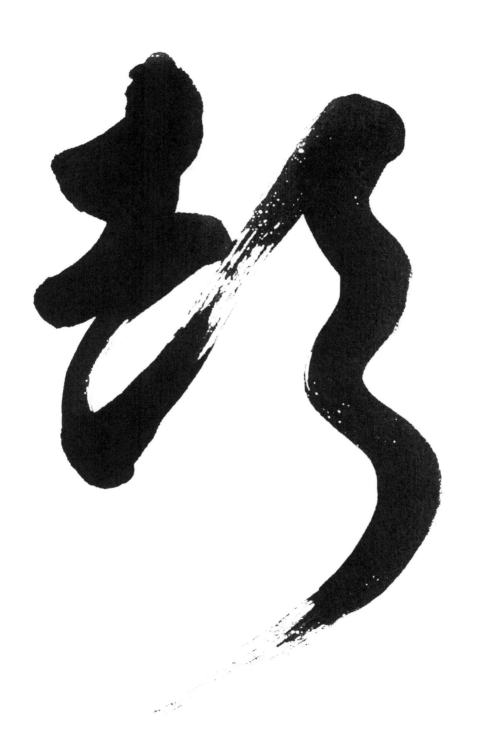

WARRIORSHIP

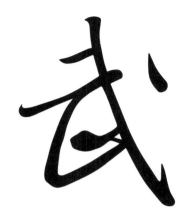
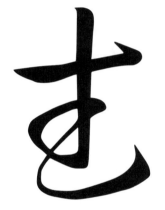

Types: Unabridged, simplified Japanese and Chinese: 武

Other meanings: Military, warrior, courageous, strong.

Pronunciations: Chinese, *wǔ (wu)*; Japanese, *bu; takeshi;* Korean, *mu;* Vietnamese, *vũ, vo.*

Classification: "To stop" radical (bottom left, four strokes) plus four strokes. Total: eight strokes.

Artists: Formal script, Ouyang Xun; semicursive and cursive scripts, Wang Xizhi.

Etymology: The top and right parts represent "spear" or "lance." The bottom left part means "to stop" or "to advance." This ideograph originally meant "to advance a spear (troop)," but later it was interpreted as "to stop a spear (troop)."

Seal script: 武武武

Note: The formal-script sample shows an archaic formation. See the type and stoke order for the standard traditional form.

An expressive work inspired by the cursive script, acrylic on canvas ➤

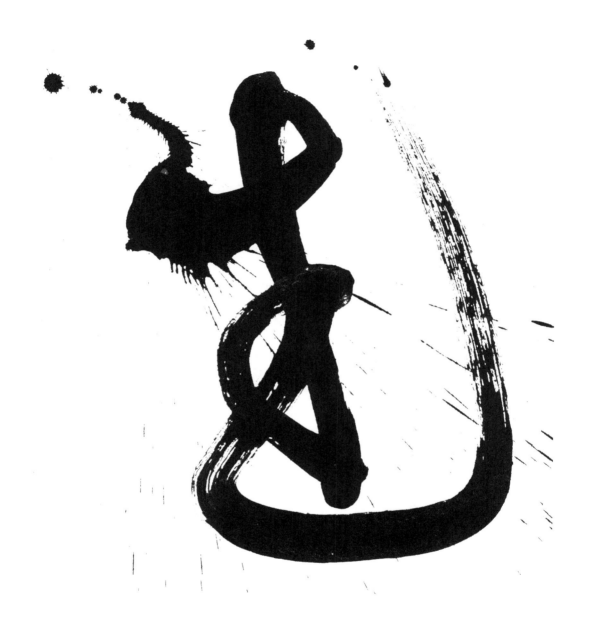

WATER

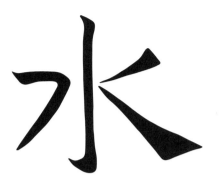 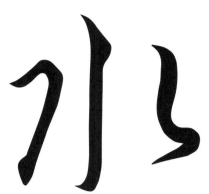

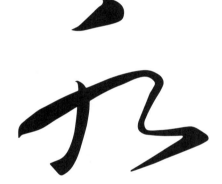

Types: Unabridged, simplified Japanese and Chinese: 水

Other meanings: River, sea.

Pronunciations: Chinese, *shuǐ (shui)*; Japanese, *sui; mizu;* Korean, *su;* Vietnamese, *thủy.*

Classification: "Water" radical (four strokes). This ideograph is itself a radical.

Artists: Formal script, Zhang Gongli; semicursive script, Zhi Yong; cursive script, Huaisu.

Etymology: Originally a pictograph of water drops falling.

Pictograph:

An expressive work inspired by the cursive script, acrylic on canvas ➤

WAY

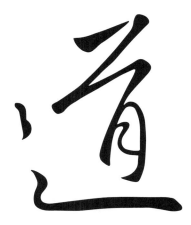

Types: Unabridged, simplified Japanese and Chinese: 道

Other meanings: Path, road, method, principle, to speak, to express, statement, art, enlightenment.

Pronunciations: Chinese, *dào* (*tao*); Japanese, *dō; michi;* Korean, *do;* Vietnamese, *đạo.*

Classification: "Road" radical (left and bottom, often written in three strokes but classified as seven strokes because of its original shape) plus nine strokes. Total: twelve strokes.

Artists: Formal script, Ouyang Xun; semicursive script, Wang Xizhi; cursive script, Huaisu.

Etymology: The radical "road" plus the nine-stroke ideograph *shou,* meaning "head" or "neck" but also used as a sound symbol meaning "long." The ideograph *dao* originally meant "to go a long way."

Seal script:

 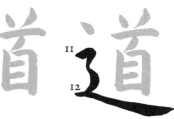

An expressive work inspired by the cursive script, acrylic on canvas ➤

WEST

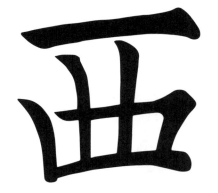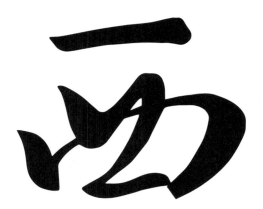

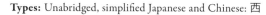

Types: Unabridged, simplified Japanese and Chinese: 西

Other meanings: To go west.

Pronunciations: Chinese, *xī* (*hsi*); Japanese, *sei, sai; nishi;* Korean, *seo;* Vietnamese, *tây.*

Classification: "West" radical 襾 (six strokes). This ideograph is itself a radical.

Artists: Formal script, Ouyang Xun; semicursive script, Chu Sui-liang; cursive script, Wang Xianzhi.

Etymology: Originally a bamboo basket for filtering wine, meaning "to cover" 襾. This symbol is borrowed to mean "west," now commonly written as indicated in the section of types above.

Pictograph: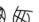

Note: The formal-script sample shows an archaic form. See the unabridged type and the stroke order for the standard traditional form.

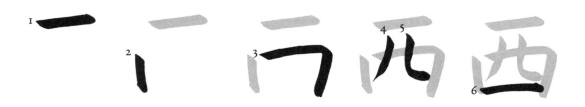

An expressive work inspired by the formal script, acrylic on canvas ➤

WHITE

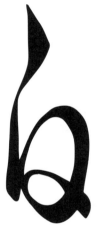

Types: Unabridged, simplified Japanese and Chinese: 白

Other meanings: Pure, bright, clear, innocent, righteous, to say.

Pronunciations: Chinese, *bái* (*pai*); Japanese, *haku, byaku; shiroi, shiro;* Korean, *baek;* Vietnamese, *bạch.*

Classification: "White" radical (five strokes). This ideograph is itself a radical.

Artists: Formal script, Chu Suiliang; semicursive and cursive scripts, Wang Xizhi.

Etymology: A pictograph of a half-moon on the bottom with glowing light on top.

Pictograph: ⏣ ⏣ ⏣

An expressive work inspired by the cursive script, acrylic on canvas ➤

WIND

Types: Unabridged, simplified Japanese: 風; simplified Chinese: 风

Other meanings: Storm, breeze, style.

Pronunciations: Chinese, *fēng* (*feng*); Japanese, *fū; kaze;* Korean, *pung;* Vietnamese, *phong.*

Classification: "Wind" radical (nine strokes). This ideograph is itself a radical.

Artists: Formal script, Ouyang Xun; semicursive script, Su Shi; cursive script, Huaisu.

Etymology: Originally derived from an ideograph meaning "phoenix." The inside symbol, meaning "bird," has been replaced with a symbol meaning "insect."

Seal script:

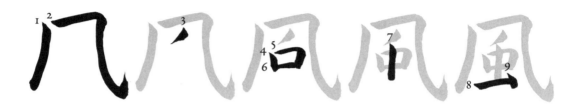

An improvisation inspired by the cursive script, acrylic on canvas ➤

WINTER

Types: Unabridged, simplified Japanese and Chinese: 冬

Other meanings: Wintry.

Pronunciations: Chinese, *dōng* (*tung*); Japanese, *tō; fuyu;* Korean, *dong;* Vietnamese, *đông.*

Classification: "Ice" radical (bottom, two strokes) plus three strokes. Total: five strokes.

Artists: Formal script, Chu Suiliang; semicursive script, Wang Xizhi; cursive script, Wang Ci.

Etymology: "Ice" radical on the bottom plus the sound *chong,* meaning "filled," on top.

Seal script: 𝍑 𝍮 𝍸

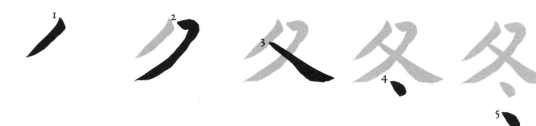

An improvisation inspired by the cursive script, acrylic on canvas ➤

WISDOM

智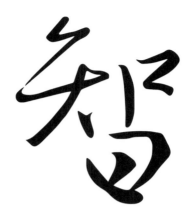

智

Types: Unabridged, simplified Japanese and Chinese: 智

Other meanings: Wise, discernment.

Pronunciations: Chinese, *zhì* (*chih*); Japanese, *chi; satoi;* Korean, *ji;* Vietnamese, *trí.*

Classification: "Sun" radical (bottom, four strokes) plus eight strokes. Total: twelve strokes.

Artists: Formal script, Chu Suiliang; semicursive and cursive scripts, Wang Xizhi.

Etymology: The top section is the ideograph "know/knowledge"—a combination of "mouth" on the right and "arrow" (expressing "continuously") on the left. The bottom section, "sun," was originally "mouth" with no middle horizontal line.

Seal script: 智 智

 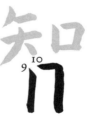 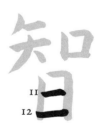

An improvisation inspired by the cursive script, acrylic on canvas ➤

WOMAN

 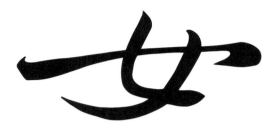

Types: Unabridged, simplified Japanese and Chinese: 女

Other meanings: Female, girl.

Pronunciations: Chinese, *nǚ (nu)*; Japanese, *nyo, jo; onna, me;* Korean, *nyeo, yeo;* Vietnamese, *nǚ*.

Classification: "Woman" radical (three strokes). This ideograph is itself a radical.

Artists: Formal script, Chu Suiliang; semicursive and cursive scripts, Mi Fu.

Etymology: A pictograph of a person kneeling with her arms crossed.

Pictograph: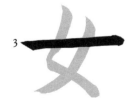

An improvisation inspired by the cursive script, acrylic on canvas ➤

WONDROUS

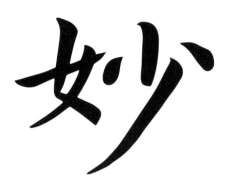
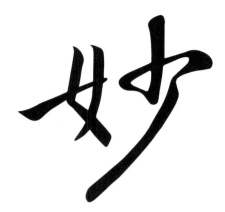

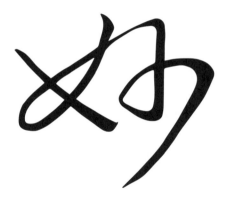

Types: Unabridged, simplified Japanese and Chinese: 妙

Other meanings: Excellent, inconceivable.

Pronunciations: Chinese, *miào (miao)*; Japanese, *myō; tae;* Korean, *myo;* Vietnamese, *diệu.*

Classification: "Woman" radical (left, three strokes) plus four strokes. Total: seven strokes.

Artists: Formal script, Yu Shinan; semicursive script, Ouyang Xun; cursive scripts, Wang Xianzhi.

Etymology: "Female" on the left and "small" or "young" on the right.

Seal script: None. The ideograph was created after the time of seal script.

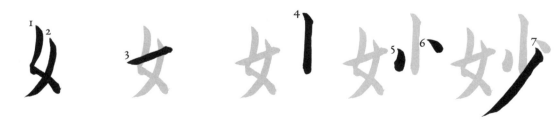

An improvisation inspired by the cursive script, acrylic on canvas ➤

WRITING

Types: Unabridged, simplified Japanese: 書; simplified Chinese: 书

Other meanings: To write, letter, book, calligraphy.

Pronunciations: Chinese, *shū* (*shu*); Japanese, *sho; kaku;* Korean, *seo;* Vietnamese, *thư*.

Classification: "Brush" radical (top, six strokes) plus four strokes. Total: ten strokes.

Artists: Formal script, Ouyang Tong; semicursive script, Wang Xianzhi; cursive script, Wang Xizhi.

Etymology: The pictograph of a brush on top, plus a pictograph of a curved tongue above the mouth, meaning "to say."

Seal script: 書 書 書

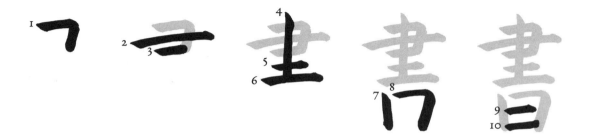

An improvisation inspired by the formal script, acrylic on canvas ➤

YANG

Types: Unabridged, simplified Japanese: 陽; simplified Chinese: 阳

Other meanings: Sun, surface, to appear, clear.

Pronunciations: Chinese, *yáng* (*yang*); Japanese, *yō; hi;* Korean, *yang;* Vietnamese, *dương.*

Classification: "Left village" radical (left, three strokes, classified as eight strokes—阜) plus nine strokes. Total: twelve strokes.

Artists: Formal script, Chu Suiliang; semicursive script, Wang Xizhi; cursive script, Wang Xianzhi.

Etymology: "Left village" radical is translated into English in this way because it appears on the left side of an ideograph. It originally means "plateau." The right side is the sound indicator *yang* (昜), meaning "the sun is shedding light."

Seal script: 㫑 㫑 昜

Note: The formal- and semicursive-script samples show an archaic formation. See the unabridged type and the stroke order for the standard traditional form.

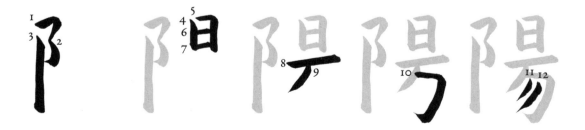

An improvisation inspired by the cursive script, acrylic on canvas ➤

YELLOW

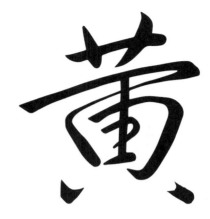
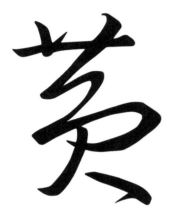

Types: Unabridged: 黃; simplified Japanese and Chinese: 黄

Other meanings: To turn yellow, gold, grains.

Pronunciations: Chinese, *huáng* (*huang*); Japanese, *ō, kō; ki, kiiro;* Korean, *hwang;* Vietnamese, *hoàng.*

Classification: "Yellow" radical (twelve strokes). This ideograph is itself a radical.

Artists: Formal script, Yu Shinan; semicursive script, Wang Xianzhi; cursive script, Wang Xizhi.

Etymology: Originally "fire at the point of an arrow." This was borrowed to mean "yellow."

Seal script: 黃 黄 黃

Note: The formal- and semicursive-script samples show abridged formations. See the unabridged type and the stroke order for the standard traditional form.

An improvisation inspired by the formal script, acrylic on canvas ➤

YIN

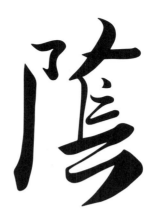

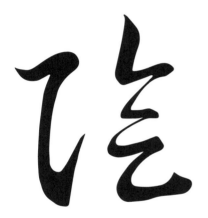

Types: Unabridged, simplified Japanese: 陰; simplified Chinese: 阴

Other meanings: Shadow, shade, passive.

Pronunciations: Chinese, *yīn* (*yin*); Japanese, *in; kage;* Korean, *eum;* Vietnamese, *âm.*

Classification: "Left village" radical (left, three strokes, classified as eight strokes—阜) plus eight strokes. Total: eleven strokes.

Artists: Formal script, Ouyang Xun; semicursive script, Mi Fu; cursive script, Wang Xizhi.

Etymology: "Left village" radical is translated into English in this way because it appears on the left side of an ideograph. The right side of this ideograph is the sound indicator *yin,* meaning "dark."

Seal script: 陰

Note: The formal- and semicursive-script samples show an archaic formation. See the unabridged type and the stroke order for the standard traditional form.

An improvisation inspired by the cursive script, acrylic on canvas ➤

ZEN

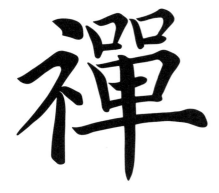 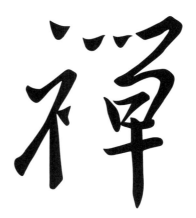

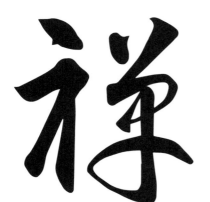

Types: Unabridged: 禪; simplified Japanese and Chinese: 禅

Other meanings: Meditation, an imperial rite for worshipping heaven, to pass on the throne (kingship).

Pronunciations: Chinese, *chán (ch'an)*; Japanese, *zen;* Korean, *seon;* Vietnamese, *thiền.*

Classification: "To show" radical (left, five strokes, sometimes classified in the four-stroke radical 礻) plus twelve strokes. Total: seventeen (or sixteen) strokes.

Artists: Formal script, Ouyang Tong; semicursive script, Wang Xizhi; cursive script, Zhi Yong.

Etymology: "To show" radical, originally meaning "divine message," indicating "spiritual" or "religious." The right side is the sound indicator *shan,* meaning "plateau." Originally meant "a platform where an imperial rite is performed."

Seal script: 禪

Note: The formal-script sample shows a varied formation. See the unabridged type and the stroke order for the standard traditional form.

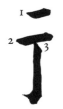

An improvisation inspired by the cursive script, acrylic on canvas ➤

ZEN CIRCLE

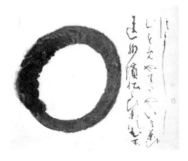

89. A circle by Japanese Zen Master Hakuin.

A circle or an oval was used as a pictograph representing "mouth" or "cut" in early times. It was soon replaced with a rectangle. After that, a circle was never used in ideography until introduction of the Arabic zero.

Zen (Chan) practitioners in China from the Tang Dynasty often drew circles with their hands and fingers in the air. (Some of them may have drawn circles on paper, but I am not aware of any early sample of painted circles in China.) Japanese Zen practitioners, on the other hand, frequently painted circles, called *enso* (literally meaning "circle symbol"). The earliest sample of the Zen circle I am aware of is one by the Zen monk and painter Sesshū (1420–1506).

An *enso* is supposed to represent enlightenment in the Zen tradition. Often, Zen masters would write a poem or a poetic phrase of teaching next to it.

Hakuin (1685–1768) wrote on this painting:

Hamamatsu of En Province
is a tea-growing district.
I want to marry off
my daughter there
to pick fine tea leaves.

He had no daughter, as Zen monks in Japan were supposed to be celibate at that time. He jokingly suggested that his most precious treasure, enlightenment, is open to anyone who has the ability to grasp it. He wrote this tanka poem (in 5, 7, 5, 7, 7 syllables) with a mixture of ideographs and phonetics in cursive style.

An expressive work inspired by Hakuin's Zen circle, acrylic on canvas ➤

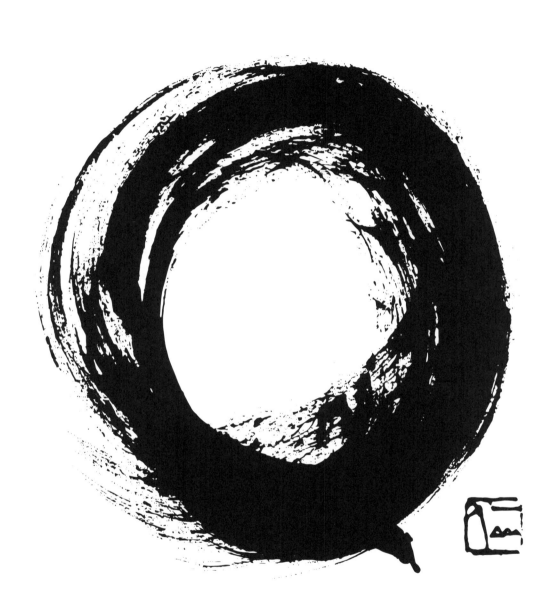

Part Three

INSIDE
CALLIGRAPHY

9 AESTHETICS IN FORMAL SCRIPT

Now that we have viewed and studied classic samples of calligraphy in three styles, I would like to analyze principles of calligraphy as well as points of appreciation in these scripts.

CHARACTER SEQUENCES

Multiple characters are usually placed in vertical columns to be read downward from right to left. Traditionally, horizontal writing started with the character on the right-hand side. Contemporary writing often reads left to right.

POSITIONING

In formal script, each character is placed in an invisible square or sometimes in a slightly tall rectangle. Squares or rectangles of the same size are lined up in columns with the same character spacing. Thus, in official documents or scriptures, all characters are rigidly placed (fig. 90).

UPWARD LINES

Horizontal lines in formal script are drawn from left to right with a slightly upward tilt. The lines may be more or less arched. Vertical lines, on the other hand, are usually drawn fairly straight down (fig. 91).

PARALLELS

Many ideographs contain dual or multiple horizontal and/or vertical lines. These are usually drawn in parallel with subtle or extreme differences in length. The shapes of the lines vary slightly (see fig. 91).

90. The *Heart Sutra,* a portion of a print, Koryo version, Korea. Engraving of the woodblocks for the Buddhist canon in this version was completed in 1251.

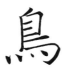

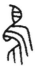

91. A sample of vertical lines and upward horizontal lines drawn in parallel. "Bird" in formal script (top), in comparison with the seal script (bottom).

92. A sample of asymmetric left and right in formal script "emptiness" (top), in comparison with the symmetric formation in seal script (bottom).

93. "Mouth" in formal script.

COMPOSITION

The lengths and angles of lines, as well as the space between lines, determine the composition of each character.

ASYMMETRY

In brushwork, there is a strong tendency to break symmetry in every obvious and subtle way. Each line, horizontal or vertical, is asymmetrical between the beginning and ending. Right- and left-hand lines, as well as top and bottom lines, are all differently shaped (fig. 92).

In the rectangle-shaped ideograph meaning "mouth," for example, the relationships among the four lines are varied. They are expressed with a gap (between the left vertical and the top horizontal strokes), an indentation (at the junction of the left vertical and the bottom horizontal strokes, as well as at the right vertical and the bottom horizontal strokes), and a combined stroke (the top horizontal with the right vertical) (fig. 93).

STRENGTH OF LINES

Sometimes wide, quickly written lines appear to be strong and powerful. However, the real strength of lines comes from the focused attention of the artist.

DETAILS

It is often apparent whether or not the artist has been mindful of every detail of the line he or she has drawn. A work finely composed with careless details does not have as much appeal as one with loose composition but exquisite attention to detail.

GREAT ARTISTS IN FORMAL SCRIPT

Let us take a look at samples of the character "moon" written in formal script by some of the most representative classical artists.

Zhong Yao, of the third century, who established the formal script, is known for his small-scale, thin-line ideographs. His marks are often slightly flat in proportion. His horizontal lines go slightly upward in parallel, while his vertical lines are uniquely slanted (fig. 94).

Wang Xizhi, of the fourth century, demonstrates his tendency to draw each line in a unique manner, varying the directions and widths of lines as well as the values of the white spaces (fig. 95).

Ouyang Xun, of the sixth to seventh centuries, draws each line in a solemn manner. His curved line has fairly even width with sharp beginnings and endings. His horizontal and vertical lines are straight with subtle curves (fig. 96).

Yu Shinan, a contemporary of Xun's, creates a gentle and warm ambiance with minimal changes in the detailed brush direction and pressure (fig. 97).

Chu Suiliang, also a contemporary of Xun's, demonstrates his distinguished style through his thin and highly spirited curvy lines (fig. 98).

Emperor Tai, also a contemporary of Xun's and a patron to his fellow calligraphers, shows contrasts in shapes and widths among his lines (fig. 99).

Yan Zhenqing, of the eighth century, shows a wide range of widths in his brush lines, expressing his bold personality (fig. 100).

These artists, who were all in socially high positions in China, created their own distinguished styles. Their magnificent brush lines and compositions set a standard for later generations. That is why they have been regarded as some of the greatest masters in East Asian calligraphy.

94. Zhong Yao, "moon."

95. Wang Xizhi, "moon."

96. Ouyang Xun, "moon."

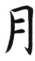

97. Yu Shinan, "moon."

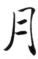

98. Chu Suiliang, "moon."

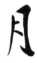

99. Emperor Tai, "moon."

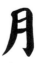

100. Yan Zhenqing, "moon."

10 AESTHETICS IN SEMICURSIVE AND CURSIVE SCRIPTS

FLEXIBILITY

Generally, lines in semicursive script are slightly more curved than those in formal script. Lines in cursive script are even more so.

Compositions in semicursive script are freer than those in formal script and can be off balance. A center line of multiple ideographs in semicursive script may sway to the right or left. These tendencies are amplified in cursive script (fig. 101).

SPATIAL RELATIONSHIP

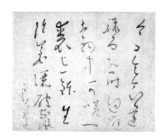

101. A Chinese-style poem by Zen monk Ryokan (1758–1831), cursive script.

In each stroke there is a drawn space, forming a relationship between the drawn spaces of two or more strokes. In addition, there are areas left undrawn. Thus, there is also relationship between the drawn space and blank space.

Here is a sample piece (fig. 101), a poem by Ryokan, a pilgrim, hermit, and beggar, which can be translated:

Today while begging I got caught in a shower.
For some time I found shelter in an old shrine.
Laugh if you like at the one jar and one bowl I own.
Humble and cleansed—my life a broken house.

The empty space around each stroke, between characters, and around characters and columns is vital and dynamic. Ink is added at the beginning of some of the characters, making these characters darker than others, thereby creating a rhythmic flow.

JOURNEY THROUGH TIME

Calligraphy has not only spatial but also temporal elements. Each line is drawn in a predetermined sequence and direc-

tion, from beginning to end. The sequence of strokes in an ideograph is also predetermined. The connections through a ligature show the brush's linear movement from one stroke to another. Viewers may see the calligraphy only as a two-dimensional work of art. However, there is another vital element—time. Viewers follow the brush movement just as they would when watching a motion picture.

THE ULTIMATE MASTERPIECE

On the third day of the third month of the year 353, Wang Xizhi gathered together with forty-one renowned literary figures at Orchid Pavilion in Huiji (Zhejiang) to hold a feast following a Daoist purification rite. Xizhi drafted a preface for the collection of the poems they wrote. Later he wanted to make a finished calligraphic work of the draft text but couldn't brush anything better than his original on-site writing. So he kept the original draft that had additions and corrections scattered here and there (fig. 102).

This piece reveals and immortalizes the spontaneous spurt of poetic creativity and calligraphic ingenuity of Xizhi as a genius of calligraphy. His brush movement is broadly and brilliantly varied, each ideograph being imaginatively shaped.

After his death, hundreds of copies were made, and many were carved on stone. Emperor Tai of the Tang Dynasty, who loved and made an extensive collection of Xizhi's artworks, willed that the original artwork of the "Preface to the Orchard Pavilion Anthology" be buried with him. So what is

available now are reproductions of the work by later calligraphers.

Here is the text as translated by Susan O'Leary and me:

In the ninth year of the Era of Eternal Peace, year of the younger-water ox, at the beginning of late spring, we gather at the Orchid Pavilion, Shan'yin Prefecture, Huiju Region, to conduct a rite of purification.

A group of wise ones has assembled; young and old, all are here. This land has lofty mountains, their jagged peaks rising above dense forests over groves of tall bamboo. Near us is a pure stream with roaring rapids, its waters reflecting both sides of its shores. We channeled its flow, created a small meandering brook to float wine cups. The guests have gathered at both sides of its banks, seated in rows. Although there is no extravagance of music with lute or flute, one poet after another composing and reciting a poem when a wine cup stops in front of one is enough for us to share our deepest feelings.

Today the sky is clear and the air feels pure; a blessing breeze gently blows. Looking up, we see the vastness of the universe; looking down, we know the flourishing of all things. Thus we gaze outward, letting the mind float; we are filled with the complete pleasure of seeing and hearing. This is a day to truly enjoy. For indeed, in reflecting on life, people may embrace a multitude of ways—some speaking intimately with friends in closed rooms, others following their thoughts, wandering freely outside the body.

However different their ways may be—some still, others active—they find joy in life's encounter, momentarily achieving the illusory contentment of self, forgetting old age's certain arrival. When we weary of our accomplishments or our emotions are caught by transient matters, our feelings also change. What pleasure we once rejoiced in quickly becomes memory. Even so, we cannot help but be drawn back to being, fully aware that our short lives are fleeting, and in the end, there is only death.

A sage of old said, "Life and death are a matter of

grave importance." How can this not bring anguish? Whenever we study the words of the ancients, what caused them to be moved, our feelings merge with theirs. We cannot encounter their writings without sorrow, finding then no comfort for our minds. We surely know that to regard life and death as one is vain deception, and to weigh a long-lived life and one cut short as equal is simply false. When those in later times imagine us today, they may well see us as we now imagine the past. How sad! And yet for that reason, we are recording the names and verses of the poets presented in this gathering. Although circumstances vary greatly generation to generation, the feelings that arise in a human life can be similar. Those who read this in later years: may they be touched by these words.

11 THE HEART OF CREATIVITY

GENTLE AND PROFOUND CREATIVITY

The art of calligraphy can be practiced by anyone who is willing to learn to write ideography. Anyone can take up a brush, follow a stroke order, draw lines, and form characters. By reproducing masters' samples, even a beginning student can create a fairly good piece of calligraphy. This art does not require the great creative endeavor of painting or sculpting.

On the other hand, because anyone can practice this, people can easily tell attentively drawn lines from those that were mindlessly drawn. To create a piece that many regard as outstanding requires excellence in theme choice, aesthetics, and skill. Thus, calligraphy is a profoundly creative art.

FIELD OF BRUSH MOVEMENT

The field of brushstrokes is just as you see in the characters written on the paper: each stroke begins with the initial contact of the brush with the paper and ends with the final drawing away of the stroke.

The field of brush movement, on the other hand, is larger. The brush moves through the air, making a large circular motion; touches down; draws a line; takes off and again moves through the air in a curved motion. This airborne movement of the brush affects the shape and quality of each stroke and shows the flow of your energy.

Your flow of energy should not be limited to the field of brush movement. You can draw your energy from a vast field—from the sky, mountains, and oceans. This allows you to be totally relaxed and vastly mindful, which will inevitably affect your brushwork.

AUTHENTICITY

Advanced students of calligraphy are usually given handwritten samples from their masters and are asked to copy those samples as faithfully as possible. These masters are themselves students of earlier masters. And the greater masters, in turn, are students of the great Chinese masters in the classical and postclassical periods, whose works have served as a common standard for calligraphers in China, Taiwan, Hong Kong, Singapore, Malaysia, Vietnam, Korea, and Japan.

Works of those who haven't undergone serious classical study invariably appear to be superficial or even inadequate. In this sense, East Asian calligraphers are classicists. The driving force of calligraphy is the yearning of advanced students to get close to the magnificence of these great masters.

Theoretically speaking, outstanding calligraphy can be created by artists who haven't studied classics. But these may be rare cases. Much of the stylistic exploration was done by a great number of East Asian calligraphers up to now. The more we study their work, the more humbled we become.

PRESENCE OF THE ARTIST

In East Asia, calligraphy is regarded as one of the highest arts, along with poetry and music. Although it requires skills, aesthetics, and creativity, what is most appreciated is beyond these elements of art. Brush lines in calligraphy honestly reveal the artist's personality, level of accomplishment, and presence of heart and mind. This is a higher criterion for appreciating and valuing the work of art than aesthetic and technical excellence alone. This being so, cultivation of profound realization and a wholesome way of life is the ultimate practice of calligraphy. Thus, the presence of the artist is appreciated even when the artist is no longer physically present.

12 CONTEMPORARY ART AND INTERNATIONAL ART

MORE POPULAR THAN EVER

Brushes have gradually been replaced with pens and pencils, and now keyboards, as daily writing tools. Nowadays, brushes are mainly used for sign making, design work, and writing certificates.

The artistic use of brushes in calligraphy, on the other hand, is more popular than ever in Japan. Young pupils learn calligraphy during and after school. Adults study with masters. Innumerable regional, group, and solo exhibitions of calligraphic works are held all the time everywhere. National exhibitions attract a great number of people. The popularity of calligraphy is also prevalent in China, Taiwan, Korea, and other East Asian countries.

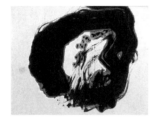

103. Shiryu Morita, ideograph *Circle*. Sumi ink on paper. Circa 1967.

INFLUENCE BETWEEN EAST AND WEST

After the end of World War II in 1945, some Japanese calligraphers began various types of reform in calligraphy. One change they made was to draw a single ideograph in addition to using the traditional way of writing Chinese or Japanese poems and poetic phrases. (Traditionally, poems are written vertically in columns, and poetic phrases in single columns. Calligraphy has also been applied on temple and store signs as well as on monuments.)

Shiryu Morita (1912–1998) used a large brush and created forms that were "liberated from legibility," although he always worked in ideography. The painting-like quality of his work has been widely appreciated in the Western world (fig. 103).

Toko Shinoda, a contemporary of Morita's, moved away from writing ideographs and created paintings consisting of calligraphic lines. Then she created works of noncalligraphic lines (fig. 104).

Works of the U.S. expressionists, including Franz Kline

104. Toko Shinoda, *Verse C*. Print.

(fig. 105), Jackson Pollock, and Robert Motherwell, show an obvious influence of East Asian calligraphy, whether they officially acknowledged it or not. Their large-scale, bold works, which transcended the techniques and aesthetics of calligraphy, in turn impressed, informed, and influenced East Asian calligraphers.

These are a few examples of interactions between artists in the East and West, which can be a fascinating theme to explore further.

CAN WESTERNERS BECOME MASTERS OF EAST ASIAN CALLIGRAPHY?

I have been asked on various occasions whether Westerners can become masters of East Asian calligraphy. I think it depends on how we define a master. In the East Asian sense, a master has to be able to create a fine piece of art upon request, perhaps on the spot. A master should also be able to read other artists' works, including those in cursive script. The job also requires mastery of language and scholarship. (That is, perhaps, why the Chinese sometimes call calligraphers scholars.) In this case, it is difficult, though not impossible, for Westerners to be masters of calligraphy.

Another definition of a master is someone who creates outstanding works of art in ways other people cannot do. In this sense, I see some Western artists as masters of East Asian calligraphy.

Petra Hinterthür, who lives in Hamburg, is a German calligrapher and teacher of qigong (*chi kung*), a Daoist-originated meditation. She studied calligraphy and qigong in Hong Kong in the 1970s. She has also been studying with Japanese calligraphers since then (fig. 106). Calligraphic works in her books on the practice of qigong, including *Lotusblüten Qigong* and *Qigong nach den Fünf Elementen,* show her accomplished brush movements.

Guntram Regen, originally from Canada, is a paper restorer and a long-time calligraphy practitioner in Kassel, Germany. His work *Rain* reflects the free and playful spirit of the artist (fig. 107).

Stephen Addiss is a U.S. composer, calligrapher, and art

105. Franz Kline, *Horizontal Rust,* 1960. Oil on canvas. Courtesy of Cincinnati Art Museum. © 2008 The Franz Kline Estate/Artists' Rights Society (ARS)/New York/ Bridgeman Images.

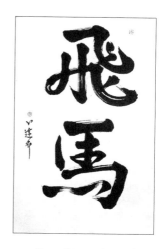

106. Petra Hinterthür, *Flying Horse,* 2011. Sumi ink on paper.

107. Guntram Porps, *Rain,* 2008. Sumi ink on paper.

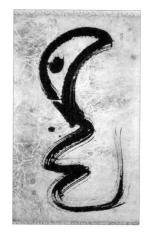

108. Stephen Addiss, *Moon Smoked,* 2010. Sumi ink on paper

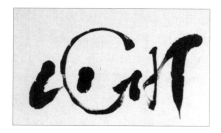

109. Gerow Reece, *Light,* 1983. Sumi ink on paper.

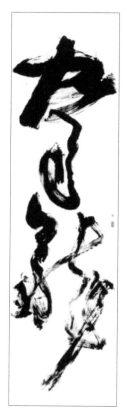

110. Paola Billi, *Dashing Dragon,* 2008. Sumi ink on paper.

historian who teaches at the University of Richmond in Virginia. He has exhibited his ink paintings and calligraphy worldwide. His numerous publications include *The Art of Chinese Calligraphy.* His improvised character in *Moon Smoked,* drawn on paper with a smoky surface, is almost like a picture (fig. 108).

Gerow Reece, a U.S. calligrapher, studied with Shiryu Morita in Kyoto in the 1960s. He teaches traditional East Asian calligraphy in northern California. He has developed a way of writing the Roman alphabet using East Asian brush technique (fig. 109).

Paola Billi, who teaches at FeiMo Contemporary Calligraphy School in Florence and Milan, Italy, has exhibited her calligraphic works internationally. Her work *Dashing Dragon* embodies complexity of brush movement and contrasting dynamics between wet and dry as well as wide and narrow lines that run through space (fig. 110).

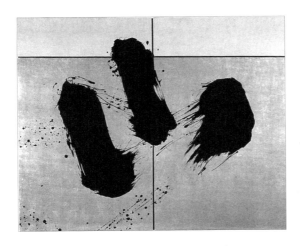

111. Fabienne Verdier, *Mountain,* 2014. Ink, pigments, and varnish on canvas.

112. Fabienne Verdier, *Petite Mater Dolorosa,* 2014. Ink, pigments, atnd varnish on canvas.

Fabienne Verdier, a French artist, studied calligraphy and panting in China from 1983 to 1993, after studying European art. Her autobiography, *Passagére du silence,* describes her tormenting hardship of being a single foreign student in a remote city as well as her painstaking, gradual experience of profound learning from outstanding masters who had survived the Cultural Revolution. She creates large-scale calligraphy and abstract brush paintings on paper and canvas at her studio in a village near Paris. Verdier's works, exhibited worldwide, are masterful, poetic, and imaginative (figs. 111, 112). Her numerous publications include *L'Unique trait de pinceau: Calligraphie, peinture et pensée chinoise;* and books of her solo exhibitions—*Crossing Signs* and *Spirit of Mountain.*

These artists represent a great many outstanding calligraphers emerging outside of East Asia. Today, when East meets West and West meets East, is an exciting time in the history of art.

13 CONTINUOUS PRACTICE

GRINDING INK

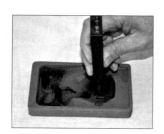

113. Grinding ink.

If you would like to continue your calligraphic experience, get an inkstone (sometimes made of slate) and an ink stick. Here is how you grind ink:

1. Put a small amount of water in the inkwell—the hollow part of the inkstone. Take a look at the writings on the ink stick and determine which end is the top. Hold the ink stick top-side up with a wide side facing you.
2. Using the ink stick, draw some water toward you onto the flat part of the inkstone. Grind the ink stick in a circular or back-and-forth motion (fig. 113). Grinding should not be so harsh it breaks the ink stick or so gentle that it takes too long. Keep the ink stick in a vertical position, periodically turning it around to help it grind evenly without leaning.
3. When you see the water on the inkstone become creamy, push the ink toward the inkwell, get some water, mixed with ink, from the well and repeat the process until the water in the well turns into ink that is thick enough to make your drawn lines visible.

Grinding ink is a calming, contemplative, and enjoyable experience. It will mentally prepare you for drawing characters.

PAPER AND FABRIC ON WHICH TO WRITE

East Asian rice paper is the best material to write on with a brush. Its texture and absorbency vary radically depending on the type and quality of the paper. I strongly suggest experimenting with rice paper of different types and sizes. You may enjoy discovering the unexpected effects of your brush movement. The problem with rice paper is that it is often fragile, is highly absorbent, and wrinkles when the ink is dry. You may

decide to bring your work to a mounter—who may be hard to find. Alternatively, you can try wet-mounting the paper yourself, a skill that takes some time to acquire. (See chapter 15, "Mounting Artwork.")

Western paper, such as thick watercolor or print paper, can also be a solution. Your work will be instantly smooth, flat, and ready to be framed. You can also write on fabric or wood, in which case you need to treat or size the material. Sizing means regulating the size of micro holes in fibers or wood, thus creating adequate absorbency. There are various commercial sizing materials available, including liquids and sprays. Pure soy milk mixed with water also works well.

Canvas can also be used. It is usually primed with gesso, which does not go well with East Asian ink. Acrylic paint, on the other hand, does an excellent job on primed canvas.

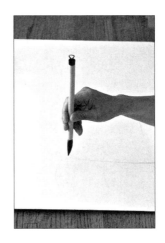

114. A straight and pointed bristle.

KEEPING THE STRANDS TOGETHER

Sometimes the strands of the bristle on your brush get torn, broken, and splayed apart. You can recondition the brush in the way I suggested in the section "Preparing the Brush" in chapter 3, so that you can form a clean dewdrop shape at the beginning of a new stroke. You should recondition the brush whenever you are unable to make a straight and pointed bristle of the brush (fig. 114). If your brush's bristles still fall apart, here are some additional tips for keeping the strands together:

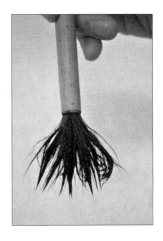

115. A splayed brush.

- Have no more than half of the bristle touch the paper.
- Don't press too hard.
- Before a takeoff, slide the brush on part of the line you have just drawn (for example, at the end of a horizontal stroke). Making your takeoff low helps the strands come together to some extent.
- Make sure you have enough ink on the bristles, as ink has a stickiness that helps hold strands together.

A splayed brush has its own function (fig. 115). Consider keeping some broken lines, as they make your work feel

116. Holding a small brush.

117. Holding a large brush.

118. Holding a giant brush.

natural and alive. You may enjoy the white spaces between thin lines made by a splayed brush—a technique called flying white—for an artistic effect. These spaces are in fact fine white lines.

BRUSH SPEED AND PRESSURE

In studying and reproducing classical masterpieces, moving the brush slowly is an excellent practice. But when you create expressive or improvisational works, feel free to adjust the speed of the brush in any way that suits your feelings. Drawing quickly can help you let go of your planning mind and work spontaneously.

For a disciplined work, applying adequate brush pressure is imperative. Again, for expressive work you can press the brush down hard as long as you do not poke a hole in the paper. There is no limit to brush pressure when you work on canvas, as long as you don't break the brush.

SMALL AND LARGE BRUSHES

When you use a smaller-sized brush, rest the wrist of your primary hand on the table or on the back of the other hand (fig. 116). There are no rules on how to hold a large brush. Grab the handle in any way that is comfortable for you (fig. 117). You may not have the opportunity to use a giant brush, as they are difficult to make or acquire (fig. 118). You may, however, be able to find a medium-large-sized brush—somewhere between the medium and large brushes—in an Asian stationary store (see figs. 117, 118). Using a large or medium-large brush can be an exuberant experience. It is almost impossible to control the brush, as it seems to have a mind of its own, so you will be forced to let go of your desire to control and let the brush move in its own way. Amazing things can happen during interactions with such a brush.

14 ARTIST NAMES AND SEALS

In most cases artist names are given by their teachers in East Asia, but in other cases artists find their own names. There is no rule that you are not supposed to find your own name. Artist names usually consist of two ideographs.

Artist names are carved in seal script on stone. Most painters and calligraphers commission professional carvers to create artistic seals, which are usually carved in an archaic style with some broken outer lines. They are in contrast with perfectly carved business seals.

Seals for artist names are usually in a square shape. Ideographs in relief are common, but engraved ideographs are also used. In addition, calligraphers sometimes stamp a narrow, irregular-shaped seal with their favorite phrases, usually consisting of four ideographs. See fig. 119 for my seals as samples.

On a vertically written work of a poem or a phrase, the artist usually places a signature seal on the lower left-hand side, often following the writing of his or her name. In some cases the artist may choose to place the seal alone, without a signature. For a single-ideograph work or an abstract work, it is all right to place a seal on either the right or the left side, but usually in a low position. You may want to avoid putting a seal in the middle of the unpainted area or in a place where it can distract from the brushwork. You may first want to stamp your seal on a small sheet of paper, then place the paper on different parts of your work to determine the final position of the seal. A well-positioned seal completes the artwork.

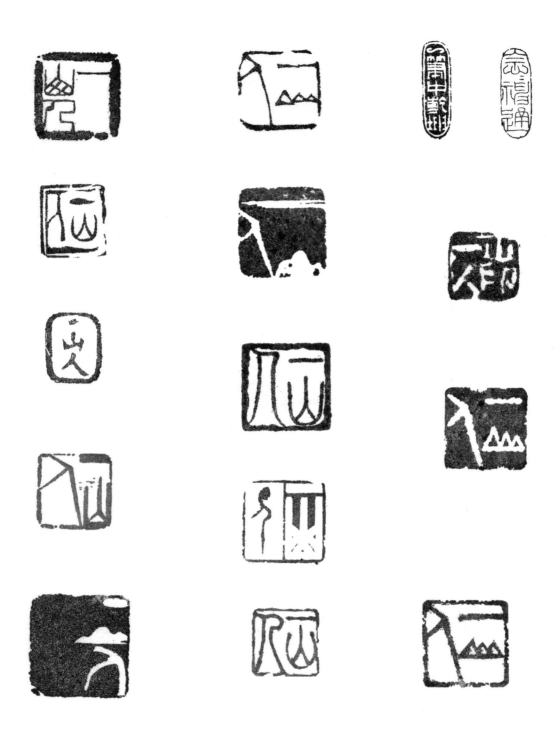

119. Samples of seals. My artist name, "Ichisanjin" 一山人, meaning "One Mountain Person," is carved with different designs in seal script. Two seals on top right contain my favorite phrases: "Miracles of each moment" (right) and "One brush line embodies the universe" (left).

15 MOUNTING ARTWORK

It is standard to present an artwork by mounting it on backing paper for reinforcement and to keep it flat. To do so, your artwork needs to be created on rice paper of good quality. The rice paper backing for it should be of a similar kind. Make sure the ink of the artwork is dry on the artwork. If it is a newly created piece, dry it with a hair drier. Before working on your final piece, experiment with mounting a replaceable work.

There are different ways of wet mounting, but the following procedure, using glue that you yourself will mix, is probably one of the easiest.

What You Need

- Artist-quality wheat powder (available at an art supply store)
- Double boiler or two pots—one small, another medium sized
- Bowl for glue
- Strainer
- Two soft flat mounting brushes, 2–3 inches wide—one for water, another for glue
- Mounting paper (the rice paper for the backing), at least 6 inches longer and wider than the artwork, to provide margins around the artwork
- Fine spray bottle or mister
- Mounting surface: a wooden board or tabletop twice as wide as the mounting paper
- Soft cloth

120. Misting the back of the artwork.

Preparation

Mix wheat powder with water in a double boiler and cook it until it starts to congeal to a consistency similar to that of cream of wheat. Strain the glue.

First, experiment with the strength of the glue on a small sample of practice artwork and backing paper. The glue should

121. Laying the artwork with a flat brush.

122. Applying glue to the mounting paper with another flat brush.

123. Laying the mounting paper on the back of the artwork.

124. Pressing down the mounting paper on the back of the artwork.

125. Cutting the artwork out with a knife.

be strong enough to keep the margins of the backing paper held to the mounting surface once the backing paper is placed on the artwork. Ideally, when the backing paper mounted on the artwork is dry, you should be able to separate it from the mounting surface by lifting it. When you are done experimenting, clean the mounting board thoroughly.

Mounting

Place the artwork facedown to one side of the mounting board. Spray water sparsely on the back of the artwork with a spray bottle or mister to get the paper to relax (fig. 120). Go over the back of the artwork with a clean soft brush to lay it flat (fig. 121).

Lay the backing paper down next to the artwork and apply glue to it with a brush (fig. 122). The movement should be quick from the center toward the corners and edges. Strokes should go all the way to the edges of the paper.

Use the following procedure to lay the glued side of the mounting paper against the back of the artwork, allowing a three-inch margin all around (fig. 123). Beginning at one side of the mounting paper, gently lay it against the artwork, pushing it down with a hand or a brush, swiftly and lightly extending it across the artwork.

Working from the center out with a soft brush or cloth, push out any bubbles that may have gotten caught between the two pieces of paper (fig. 124). This is to eliminate bubbles and creases that may affect the way the artwork will look.

Let the mounted artwork dry in position for at least twenty-four hours. The artwork should just peel off the surface of the mounting board. Sometimes if the glue is too thick, the overlapping edge of the mounting paper may be persistently glued to the mounting board surface. In that case, cut the artwork out with a knife (fig. 125). Once your artwork has been removed, soak the remaining edges of the mounting paper off the mounting board. When you are done, clean the mounting board thoroughly.

16 STUDYING ONLINE

Much of the study of East Asian calligraphy can be conducted through the Internet. Even if you don't know any East Asian language, you can identify ideographs and find information about them as well as learn about classical samples. Note that websites often change rapidly and more-advanced programs are introduced. The following steps reflect what was available during the production of this book.

FINDING AN IDEOGRAPH FROM A MEANING

Go to www.translate.google.com. Insert an English equivalent of the ideograph you are looking for in the left window and select *English* from the choices above. Then select *Chinese* (simplified or traditional) or *Japanese* from among the choices above the right window. You will find one or more ideographs in the translation window in the order of frequent usage. Choose a likely ideograph and copy it.

Another way is to go to www.saiga-jp.com/kanji_dictio nary.htm and type in the window *English Word* an English equivalent of the ideograph you are looking for and click *Search*. Choose a likely ideograph and copy it. Or go to www .zhongwen.com. Under *Dictionary* click *English-Chinese*. Type the English word in the *English* window and press the *go* button.

LEARNING ABOUT AN UNKNOWN IDEOGRAPH

If you have only a printed or written version of an ideograph, go to www.nciku.com, click the pen icon at the right side of the window near the top, draw the unknown ideograph with your mouse or track pad on the left side of the window that opens, then select from the right side of the window an ideograph similar to what you have drawn, and copy it to use in the next step.

STUDYING AN IDEOGRAPH

You will find many aspects of the character you've chosen at the following website: www.wiktionary.org. Paste the ideograph you have copied in the search window at the lower left. Click the arrow to the far right. You will find much information about the ideograph, including its meanings, pronunciations, etymology, radical, and at times, stroke order.

STROKE ORDER

If you don't find the stroke order of your chosen ideograph at Wiktionary, go to www.kakijun.jp. Paste the ideograph in the blank window on the left top of the screen and click a button on the right of the window. You will shortly see the ideograph being drawn in its stroke order in a blank box.

CLASSICAL SAMPLES OF AN IDEOGRAPH

To see classical samples of an ideograph, go to www.shufazidian.com. Paste your ideograph on the left top window. Choose a style in the middle window by selecting one of the following Chinese words: 楷书 (formal script), 行书 (semicursive script), 草书 (cursive script), or 篆书 (seal script). Click the search button on the right. You will see classical samples with the artist's name, often following the dynasty name, and preceding the name of the work. To find the English spelling of the artist's name, and so forth, copy the Chinese characters below the sample work, go to www.translate.google.com and paste the characters in the box on the left. Select "Chinese" from the choices on top. The romanized spelling of the characters will appear below the left window.

TUTORIALS

Go to www.youtube.com. Type "Chinese calligraphy tutorial," "Japanese calligraphy tutorial," or "Korean calligraphy tutorial" in the search window. Select and play a video.

17 A BREAKTHROUGH
WITH THE BRUSH

AN EFFECTIVE WAY OF STUDYING

Keep re-creating samples of the ancient masterpieces shown in part 2. Do not try to draw one character to the point of perfection before moving on to another. Do not worry about shortcomings and problems in your brushwork. Instead, keep studying a variety of characters in different styles. This will help you get used to brush movements in general, which will, in turn, have a positive effect on the way you draw lines in the characters you were studying earlier.

Observe the shape and direction of each stroke. Then observe the spatial relationship among strokes. Determine the invisible vertical centerline of each character, then draw the character around the center line.

Start your exercise with a faithful reproduction of classical samples in order to develop discipline. Then interpret them and create expressive works inspired by the samples. Interpretative and expressive works help you develop artistic freedom and bring forth sudden and unexpected breakthroughs. Both discipline and freedom are essential to your creative process. Alternate a disciplined study and a free way of working. Both are helpful for moving forward.

The practice of drawing a few lines a day, or even a week, will help your progress. Studying with a teacher in your region would be ideal.

DRAWING A CIRCLE

The circle you draw with a brush reflects the state of your body and mind at that very moment. Unlike ideographs that are loaded with meanings, a circle is an open and clean slate free of meanings. You observe what you have just drawn, listen to the unheard voice, and learn much about the deep part of your consciousness. Also, you can draw a circle just the way

you would like it to be—kind, thoughtful, joyous, bold, free, or wild. What you draw can be how you are and what you are. In the Zen tradition, a circle—called *enso* in Japanese—is an expression of the completeness of each moment, or enlightenment. You can also write a message, such as "Wake up!" to go with it.

A cardiologist friend, Steve Crisman, who has been drawing circles every night for more than ten years, says, "It's a wonderful way to relax before going to bed. A circle can be a reflection of the past, a prediction of the future, and being in the present moment." Drawing a circle every day is an easy, enjoyable, and illuminating practice.

ACCEPTING IMPERFECTIONS

The brush is a marvelously expressive tool. It has its own life and may appear to act against your will. Your lines may not look perfect. Don't worry. Lines drawn by anyone, including a master, will never be perfect. "Perfect" means that the result is exactly what you intended. But the brush never draws the same line twice. All you can do is strengthen your skills and keep your expectations open.

To learn is to notice and reduce problems. Don't hope to arrive at a state where you have no problems. There will always be problems, for beginners and masters alike. Everyone's goal should be to reduce problems, not eliminate them. The brush teaches you how to live with imperfections and, furthermore, realize that they are an essential part of beauty.

Our learning curve does not go straight up. It goes up and down, fast and slow. You may sometimes feel you are getting worse. But you don't need to be frustrated or blame yourself. Getting worse is necessary to the process of getting better. Instead of becoming frustrated, celebrate when you notice that you are getting worse.

MEDITATION IN MOTION

In East Asia, calligraphy has always been closely related to meditation. When you grind ink, you calm your body and

mind. When you lay down paper, when you hold the brush, and when you load it with ink and draw, enjoy doing so in a meditative manner. Drawing a line is itself a miracle.

Chattering away or listening to background music is not recommended. Put your thinking and planning mind to rest and bring forth the depth of your consciousness. Only then will you enter the realm of the sacred practice of calligraphy.

APPLYING THE PRACTICE TO EVERYDAY LIFE

The practice of calligraphy teaches us that anyone can be creative. Whether you are a beginner or an advanced calligrapher, you can expand your creativity and enjoy making artwork. You can apply your creativity in your daily activity whether you are a student, a teacher, a parent, a scientist, or an artist.

I have taught calligraphy for forty-five years. I have shared my love of brushwork with painters and calligraphers from other traditions as well as with people of all occupations. From these experiences I know that you have the ability to find a practical application of the practice of brushwork in your occupation.

My cardiologist friend whom I mentioned earlier keeps brushes, ink, and paper at his office and does calligraphy between heart surgeries. A professor of history posts his practice pieces on the door to his office so his students and colleagues can take them home for their enjoyment. A sumi painter warms up with calligraphic exercises before she paints on a large sheet of paper.

By doing brushwork, you learn to be slow, relaxed, and focused all at the same time. You experience each moment fully and appreciate imperfection. You experience meditation in motion and intimacy with a deeper part of yourself. You come to the point where you keep noticing breakthroughs and miracles in your life.

Appendix 1:

LIST OF RADICALS

All ideographs are categorized by classifying indicators called radicals. Some radicals are independent ideographs, but they can also be used as an element of other ideographs with related meanings. Other radicals are used only as a part of ideographs.

Many dictionaries of ideographs are organized by radicals. In each category, related ideographs are arranged in the order of the number of additional strokes. These dictionaries also have a list of ideographs according to the numbers of entire strokes, regardless of radicals.

The list of radicals presented here applies to the unabridged system as well as the simplified Japanese system. Radicals that are unique to the simplified Chinese system are not included here. Some radicals have two or more forms (see fig. 75). Radicals with no English translations, placed at the end of a numbered-stroke section, are referred to their basic forms by arrows.

ONE STROKE

一	one
乚	carving knife
丿	diagonal
丶	dot
亅	hook
丨	rod
乙	second

TWO STROKES

冂	borders
凵	bowl
厂	cliff
厶	cocoon
十	cross
冖	crown
卜	divine
八	eight
入	to enter
人 亻	human
冫	ice
匕	ladle

儿	long legs
亠	lid
又	right hand
卩	seal
匚	to shield
力	strength
刀 刂	sword
几	table
二	two
勹	wrap

THREE STROKES

匸	basket
大	big
口	box
弓	bow
子	child
廾	clasp
巾	cloth
尸	corpse
弋	dart
夕	dusk

彳	going person
寸	inch
尢 尣 兀	lame
小	little
廴	march
山	mountain
口	mouth
彐 彑	pig's head
川 巛	river
宀	roof
士	scholar
己	self
广	shelter
干	shield
幺	slender
夂	slow
土	soil
屮	sprout
彡	streaks
夂	summer
女	woman
工	work
忄	→ 心

扌	→ 手
氵	→ 水
犭	→ 犬
艹	→ 艸
辶	→ 辵
⻏	→ 邑
阝	→ 阜

FOUR STROKES

旡 无		already
斤		axe
歹 歺		bad
支		branch
气		breath
氏		clan
爪 爫		claw
比		to compare
牛 牜		cow
爻		crisscross
毋		do not (imperative)
戶		door
父		father
火 灬		fire
毛		fur
手 扌		hand
心 忄 㣺		heart
戈		halberd
殳		to kill
攴 攵		to knock
文		literature
月		moon
爿		plank
曰		to say
斗		scoop
方		square
止		to stop
日		sun
木		tree
欠		to yawn
水 氵 氺		water
片		slice
牙		tooth
犬 犭		dog
⻂		→ 示
耂		→ 老

辶	→ 辵
⺲	→ 网

FIVE STROKES

矢		arrow
癶		back
穴		cave
玄		dark
皿		dish
目 ⺳		eye
玉 王		jewel
生		to produce
田		rice field
禾		rice plant
疋 ⺪		roll of cloth
示		to show
疒		sick
皮		skin
矛		spear
立		standing
石		stone
甘		sweet
瓦		tile
内		track
用		use
白		white
⺳		→ 网
衤		→ 衣

SIX STROKES

竹		bamboo
血		blood
聿		brush
虫		bug
衣 衤		clothing
色		color
舛		discord
缶		earthenware
耳		ear
羽		feather
肉 月		flesh
行		to go
艸 ⺾ 艹		grass
瓜		melon
臼		mortar

网 ⺲ ⺳	net
老 耂	old
耒	plow
至	reach
米	rice
自	self
羊 ⺶	sheep
舟	ship
艮	stubborn
糸	thread
虍	tiger
舌	tongue
西 西	west
而	yet

SEVEN STROKES

豆		bean
辛		bitter
身		body
豸		cat
酉		chief
镸		dancing feet
足 ⻊		foot
角		horn
里		mile
臣		official
豕		pig
赤		red
邑		right village
辵 辶 辶		road
走		to run
見		to see
釆		separate
貝		small shell
言		speech
辰		time
谷		valley
車		wheel
臼		→ 臼
麦		→ 麥

EIGHT STROKES

門	gate
青 青	green
阜 ⻏	left village

長	long
金	metal
非	not
隹	old bird
雨	rain
隶	secondary
飠	→ 食
齊	→ 齊

NINE STROKES

頁	big shell / page
食 飠	to eat
面	face
飛	to fly
香	fragrant
首	head
韭	leak
韋	leather
革	revolution
音	sound
風	wind

TEN STROKES

骨	bone
鬥	fight

鬼	ghost
髟	hair
馬	horse
高	tall
鬲	tripod bowl
鬯	wine
竜	→ 龍

ELEVEN STROKES

麥 麦	barley
鳥	bird
鹿	deer
魚	fish
麻	hemp
鹵	salt
龜	turtle
黃	→ 黃
黑	→ 黑

TWELVE STROKES

黑	black
黍	millet
黹	sewn pattern
黃	yellow
齒	→齒

THIRTEEN STROKES

鼓	drum
黽	frog
鼠	rat
鼎	tripod

FOURTEEN STROKES

齊 齐	even
鼻	nose

FIFTEEN STROKES

齒	front teeth

SIXTEEN STROKES

龍	dragon
龜	turtle

SEVENTEEN STROKES

龠	flute

Appendix 2:

LIST OF COMPOUNDS

"Compound" here means two or more ideographs combined to form a word, term, or phrase. A combination unique to Japanese is indicated with an asterisk. The numbers following the English headings represent pages where the ideographs are found.

above in the heaven	138, 298	天上	Avalokiteshvara	196, 252	觀音	
above in the sky	298, 104	上空	baby bird	70, 54	子鳥	
Aikido	296, 62, 310	合氣道*	baby cow	70, 84	子牛	
air travel	124, 36	飛行	bamboo brush	46, 66	竹筆	
air	104, 62	空氣	bamboo sound	46, 304	竹聲	
all things	274, 90	萬法	basement	98, 92	地下	
ancient buddha	38, 44	古佛	beautiful color	50, 80	美色	
ancient flavor	38, 80	古色	beautiful custom	50, 316	美風	
ancient legend	38, 288	古傳	beautiful voice	50, 304	美聲	
ancient old person	38, 200	古老	beautiful woman	50, 144	美人	
ancient person	38, 144	古人	beautiful woman	50, 322	美女	
ancient poem	38, 212	古詩	beautiful writing	50, 154	美文	
ancient style	38, 316	古風	beloved horse	162, 142	愛馬	
ancient teaching	38, 270	古教	big bird	52, 54	大鳥	
ancient time	38, 282	古時	big brush	52, 66	大筆	
ancient times	276, 38	千古	big dragon	52, 94	大龍	
ancient way	38, 310	古道	big ocean	52, 198	大海	
ancient writing	38, 326	古書	big rain	52, 222	大雨	
appointed meeting	114, 168	面會	big sound	52, 252	大音	
ashamed	224, 114	赤面	big stone	52, 260	大石	
aspiration for the way	310, 136	道心	big talk	52, 182	大口	
at one time	202, 282	一時	big tree	52, 290	大木	
atmosphere	52, 62	大氣	big wind	52, 316	大風	
autumn atmosphere	40, 62	秋氣	bird chirping	54, 304	鳥聲	
autumn bamboo	40, 46	秋竹	bird flying	54, 124	鳥飛	
autumn cloud	40, 78	秋雲	bird going	54, 36	鳥行	
autumn color	40, 80	秋色	black cow	56, 84	黑牛	
autumn light	40, 158	秋光	black dragon	56, 94	黑龍	
autumn moon	40, 178	秋月	Black Sea	56, 198	黑海	
autumn night	40, 184	秋夜	blank paper	314, 206	白紙	
autumn rain	40, 222	秋雨	blowing wind	36, 316	行風	
autumn sky	40, 138	秋天	blue sky	58, 138	青天	
autumn wind	40, 316	秋風	blue sky	58, 104	青空	

east wind	100, 316	東風	flowers for tea ceremony	268, 122	茶花	
eastern land	100, 98	東地	flying bird	124, 54	飛鳥	
eastern mountain	100, 180	東山	flying cloud	124, 78	飛雲	
eastern sea	100, 198	東海	flying dragon	124, 94	飛龍	
eastern sky	100, 138	東天	flying fish	124, 118	飛魚	
education	270, 194	教育	flying rain	124, 222	飛雨	
eight hundred	102, 146	八百	flying white	124, 314	飛白	
eight o'clock	102, 282	八時	flying wind	124, 316	飛風	
eight thousand	102, 276	八千	forty	128, 272	四十	
eighteen	272, 102	十八	forty thousand	128, 274	四萬	
eighty thousand	102, 274	八萬	four hundred	128, 146	四百	
eighty	102, 272	八十	four o'clock	128, 282	四時	
eleven	272, 202	十一	four thousand	128, 276	四千	
eleven o'clock	272, 202, 282	十一時	fourteen	272, 128	十四	
emperor	138, 70	天子	fragrant air	130, 62	香氣	
empty and serene	104, 236	空寂	fresh rain	220, 222	清雨	
empty space	104, 314	空白	fresh wind	220, 316	清風	
empty stroke	104, 66	空筆	geisha girl in training	86, 70	舞子*	
enlightened mind	108, 136	悟心	gentle face	208, 114	和面	
enlightenment song	108, 244	悟歌*	giant man	52, 164	大男	
entire life	202, 156	一生	giant woman	52, 322	大女	
entire surface	202, 114	一面	go north	188, 298	北上	
equator	224, 310	赤道	go beyond the			
erotic love	80, 162	色愛	present moment	284, 192	超今	
erotic pleasure	162, 106	愛樂	go south	254, 36	南行	
erotic pleasure	80, 106	色樂	going away person	36, 144	行人	
erotic thought	80, 136	色心	going beyond Buddha	284, 44	超佛	
eternal bliss	110, 106	永樂	going spring	36, 258	行春	
excessive eating	52, 166	大食	gold	330, 172	黄金	
excursion	36, 106	行樂	golden autumn	172, 40	金秋	
facing south	254, 114	南面	golden light	172, 158	金光	
female	322, 70	女子	good brush	298, 66	上筆	
fifteen	272, 120	十五	grammar	154, 90	文法	
fifty	120, 272	五十	grass and trees	132, 290	草木	
fifty thousand	120, 274	五萬	grass color	132, 80	草色	
final writing	220, 326	清書	great awakening	52, 42	大覺	
first day	202, 264	一日	great buddha	52, 44	大佛	
first month	202, 178	一月	great compassion	52, 82	大慈	
fish shadow	118, 240	魚影	great delusion	52, 88	大迷	
fish swimming	118, 36	魚行	great earth	52, 98	大地	
five elements	120, 36	五行	great enlightenment	52, 108	大悟	
five hundred	120, 146	五百	great fire	52, 116	大火	
five o'clock	120, 282	五時	great heart	52, 136	大心	
five thousand	120, 276	五千	great house	52, 140	大家	
flood	52, 308	大水	great light	52, 158	大光	
flower grass	122, 132	花草	great love	52, 162	大愛	
flower tree	122, 290	花木	great merit	52, 170	大功	
flowers and birds	122, 54	花鳥	great person	52, 68	大機	
flowers and fruit	122, 292	花實	great sky	52, 104	大空	

great teaching	52, 90	大法
great way	52, 310	大道
great wisdom	52, 320	大智
greatly virtuous person	52, 302	大德
green bamboo	58, 46	青竹
green dragon	58, 94	青龍
green grass	58, 132	青草
green vegetables	58, 300	青菜
grownup person	52, 144	大人
handsome man	50, 164	美男
harmonious and enjoyable	208, 106	和樂
harmonious atmosphere	208, 62	和氣
harmonious heart	208, 136	和心
harmonious interaction	208, 296	和合
harmony (in music)	208, 252	和音
Heart Sutra	136, 266	心經
heaven and earth	138, 98	天地
heavenly being	138, 144	天人
heavenly dragon	138, 94	天龍
heavenly moon	138, 178	天月
heavenly sky	138, 104	天空
heavy snowfall	52, 248	大雪
Himalaya	248, 180	雪山
homage to	254, 190	南無
houses	144, 140	人家
human and		
heavenly beings	144, 138	人天
human figure	144, 240	人影
human voice	144, 304	人聲
humanity	144, 310	人道
hundreds of thousands	146, 276	百千
ignorant	190, 320	無智
illuminating light	148, 158	照光
illuminating sun	148, 264	照日
in one breath	202, 62	一氣
in the air	104, 174	空中
in the family	140, 174	家中
in the soil	250, 174	土中
in water	308, 174	水中
India	312, 138	西天
ink calligraphy	150, 326	墨書
ink color	150, 80	墨色
inside the ground	98, 174	地中
inside the mind	136, 174	心中
inside the mouth	182, 174	口中
inside the ocean	198, 174	海中
invisible virtue	332, 302	陰德
jade seal	152, 234	玉印
Japanese style	208, 316	和風

kind heart	200, 136	老心
landscape	316, 158	風光
Laozi	200, 70	老子
large assembly	52, 168	大會
large fish	52, 118	大魚
large mountain	52, 180	大山
large river	52, 228	大川
lawful	296, 90	合法
life energy	156, 62	生氣
light of compassion	82, 158	慈光
literary person	154, 144	文人
literary writing	154, 66	文筆
live fish	156, 118	生魚
live-in student	326, 156	書生*
lost child	88, 70	迷子
long past	158, 38	光古
lost person	88, 144	迷人
lotus flower	160, 122	蓮花
loud voice	52, 304	大聲
love and compassion	82, 162	慈愛
lover	162, 144	愛人
loving heart	162, 136	愛心
luminous cloud	158, 78	光雲
luminous jade	158, 152	光玉
luminous sky	158, 138	光天
male servant	92, 164	下男
male	164, 70	男子
man and woman	164, 322	男女
many forms	146, 132	百草
many teachings	146, 270	百教
martial art	306, 310	武道
mask	286, 114	化面
metal statue of Buddha	172, 44	金佛
method of mindfulness	176, 90	念法
method of visualization	196, 90	觀法
midautumn	174, 40	中秋
middle of the river	228, 174	川中
milky way	138, 228	天川
mind dharma	136, 90	心法
mind ground	136, 98	心地
mind moon	136, 178	心月
mind movement	136, 36	心行
mind spirit	136, 62	心氣
mind thought	136, 176	心念
mindfulness practice	176, 36	念行
moment by moment	176, 176	念念
monk	78, 308	雲水
monochrome	202, 80	一色
month and day	178, 264	月日

poetic heart	212, 136	詩心	river surface	228, 114	川面	
poetry and prose	212, 154	詩文	river water	228, 308	川水	
popularity	144, 62	人氣	river wind	228, 316	川風	
practice dharma	36, 90	行法	same format	202, 230	一定	
practice mindfulness	36, 176	行念	scriptural school	270, 140	教家	
practice of seeing	196, 36	觀行	sea bird	198, 54	海鳥	
practice of the precept	216, 36	戒行	sea of cloud	78, 198	雲海	
practice of the way	214, 310	修道	sea surface	198, 114	海面	
practice teaching	36, 286	行化	seaweed	198, 132	海草	
practice the way	36, 310	行道	second month	294, 178	二月	
practice virtue	36, 302	行德	semicursive and cursive	36, 132	行草	
practice/training	214, 36	修行	semicursive script	36, 326	行書	
practicing buddha	36, 44	行佛	serene autumn	236, 40	寂秋	
practitioner of the way	310, 144	道人	serene light	236 158	寂光	
precept scripture	216, 266	戒經	serene mind	236, 136	寂心	
precept teaching	216, 270	戒教	serene night	236, 184	寂夜	
present and past	192, 38	今古	set menu	230, 166	定食	
profound and wondrous	218, 324	玄妙	seven o'clock	238, 282	七時	
profound dharma	218, 90	玄法	Seven Original Buddhas	238, 44	七佛	
puppet play	154, 106	文樂*	seven thousand	238, 276	七千	
pure joy	220, 106	清樂	seventeen	272, 238	十七	
qigong	62, 170	氣功	seventh day	238, 264	七日	
radiant light	158, 76	光明	seventh month	238, 178	七月	
rain cloud	222, 78	雨雲	seventy	238, 272	七十	
rainwater	222, 308	雨水	seventy thousand	238, 274	七萬	
rain wind	222, 316	雨風	sewage	92, 308	下水	
rainy atmosphere	222, 62	雨氣	shade of a mountain	180, 332	山陰	
rainy day	222, 264	雨日	shadow of a cloud	78, 240	雲影	
rainy night	222, 184	雨夜	shadow of the sunlight	264, 240	日影	
rainy season	210, 222	梅雨*	shadows of flowers	122, 240	花影	
rainy sky	222, 138	雨天	shout	62, 296	氣合*	
rainy time	222, 282	雨時	silently recite a sutra	176, 266	念經	
raising a child	70, 194	子育	sincere heart	224, 136	赤心	
reading the sutra	60, 266	轉經	sing and dance	244, 86	歌舞	
recent time	192, 282	今時	singing heart	244, 136	歌心	
reciting a sutra	36, 266	行經	singing voice	244, 304	歌聲	
red and white	224, 314	赤白	six o'clock	246, 282	六時	
red color	224, 80	赤色	six paths	246, 310	六道	
red flower	224, 122	赤花	six thousand	246, 276	六千	
red light	224, 158	赤光	sixteen	272, 246	十六	
regretful	190, 176	無念*	sixth day	246, 264	六日	
regulating the river	134, 228	治川	sixth month	246, 178	六月	
regulating the stream	134, 308	治水	sixty	246, 272	六十	
respectful heart	226, 136	敬心	sixty thousand	246, 274	六萬	
respectfully say	226, 314	敬白	sky	138, 104	天空	
respecting heaven	226, 138	敬天	slow going	84, 36	牛行	
river fish	228, 118	川魚	snack	256, 166	間食*	
river sound	228, 252	川音	snow cloud	248, 78	雪雲	
river stone	228, 260	川石	snow dance	248, 86	雪舞	

Appendix 3:

LIST OF TECHNICAL TERMS

ENGLISH TRANSLATION	IDEOGRAPHS	CHINESE SOUND	JAPANESE SOUND
abstract work	抽象	chōu xiàng	chūshō
	墨象		bokushō
art	藝術	yi shù	geijutsu
basic dot	側	cè	soku
	右點	yòu diǎn	uten
bent vertical stroke	左短豎	zuǒ duǎn shù	satanju
bent vertical-to-horizontal stroke	龍尾鉤	lóng wěigōu	ryūbikō
big brush	大筆	dà bǐ	ōfude
bristle	筆鋒	bǐ fēng	hippō
broken stroke	破墨	pò bǐ	haboku
brush movement	運筆	yùn bǐ	umpitsu
brush shaft	筆管	bǐ guǎn	hikkan
brush tip	筆尖	bǐ jiān	hissen
	筆先	bǐ xiān	hissen
calligrapher	書法家	shū fǎ jiā	
	書家	shū jiā	shoka
calligraphic style	書風	shū fēng	shofū
	書體	shū tǐ	shotai
calligraphy	書法	shū fǎ	
	書道	shū dào	shodō
calligraphy work	書品	shū pǐn	shohin
	作品	zuò pǐn	sakuhin
chipped carving	破側	pò cè	hasoku
	破邊	pò biān	hahen
classical work	古典	gǔ diǎn	koten
clerical script	隸書	lì shū	reisho
column	行	háng	gyō
combined stroke, horizontal and vertical	橫折	héng zhé	ōsetsu
composition	結構	jié gòu	kekkō
contemporary calligraphy	現代書	xiàn dài shū	gendaisho

copying	臨寫	lín xiě	
	臨帖	lín tiě	
	臨書		rinsho
core brush line	骨法	gǔ fǎ	koppō
cursive script	草書	cǎo shū	sōsho
diagonal rightward up and diagonal leftward down stroke	橫折撇	héng zhé piě	ōsettetsu
diagonal stroke leftward down	撇	piě	hetsu
	啄	zhuó	taku
diagonal stroke rightward down	捺	nà	na
	磔	zhé	taku
diagonal stroke rightward up	挑	tiāo	chō
dot	點	diǎn	ten
dry brush	渴筆	kě bǐ	kappitsu
empty stroke	空筆	kōng bǐ	kūhitsu
engraving	陰刻	yīn kè	inkoku
entering	入筆	rù bǐ	nyūhitsu
etymology	語源	yǔ yuán	gogen
exhibition	展覽會	zhǎn lǎn huì	tenrankai
expressive work	隨意	suí yì	zuii
	創作	chuàng zuò	sōsaku
falling (fourth) tones	去聲		kyoshō
	第四聲	dì sì shēng	daishishō
flat mounting brush	刷毛	shuā máo	hake
flying white	飛白	fēi bǎi	hihaku
formal script	楷書	kǎi shū	kaisho
four tones	四聲		shishō
giant brush	巨筆	jù bǐ	kyohitsu
hanging scroll	掛軸	guà zhóu	kakejiku
horizontal stroke	橫畫	héng huà	ōkaku
ideograph	漢字	hàn zì	kanji
ideographic stroke	筆畫	bǐ huà	hikkaku
ideography	表意文字	biǎo yì wén zì	hyōi moji
ink	墨	mò	sumi
ink stick	固形墨	gù xíng mò	kokeizumi
inkstone	硯	yàn	suzuri

interpretation of the energy	勢臨	shì lín	seirin
interpretation of the spirit	意臨	yì lín	irin
leftward-down dot	左點	zuǒ diǎn	saten
light tone	輕聲	qīng shēng	keishō
line	線	xiàn	sen
liquid ink	墨汁	mò zhī	bokjū
lower even (second) tone	陽平	yáng píng	yōhyō
	陽 聲	yang shēng	yōshō
	第二聲	dì èr shēng	dainishō
master	名書家	míng shū jiā	meishoka
masterpiece	名作	míng zuò	meisaku
	名品	míng pǐn	meihin
Ming Dynasty	明朝	míng cháo	minchō
mounting	裱	biǎo	
	裏打		urauchi
number of strokes	畫數	huàshǔ	kakusū
paper	紙	zhǐ	kami
paperweight	文鎮	wén zhèn	bunchin
phonetic	音標文字	yīn biāo wén zì	ompyō moji
phonetic symbols (Japanese)	假名	jiǎ míng	kana
pictograph	象形	xiàng xíng	shōkei
pingyin	泙音	píng yīn	hŏ'on
printing type	活字	huózì	katsuji
pronunciation	發音	fā yīn	hatsuon
radical	部首	bù shǒu	bushu
relief carving	陽刻	yang kè	yōkoku
rice paper	宣紙	xuān zhǐ	
	和紙	hé zhī	washi
rising (third) tone	上聲	shàng shēng	jōshō
	第三聲	dì sān shēng	daisanshō
Sage of Calligraphy	書聖	shū shèng	shosei
scroll	卷軸	juàn zhóu	makijiku
scroll making	裱	biǎo	
seal	印章	yìn zhāng	inshō
	蓋章	gài zhāng	
	印	yìn	in

seal carving	篆刻	zhuàn kè	tenkoku
seal ink	印泥	yìn ní	indei
seal script	篆書	zhuàn shū	tensho
	籀書	zhòu shū	
semicursive script	行書	xíng shū	gyōsho
shade	濃淡	nóng dàn	nōtan
short horizontal stroke	短畫		tankaku
signature	落款	luò kuǎn	rakkan
simplified Chinese script	簡體	jiǎn tǐ	kantai
simplified Japanese script	當用漢字		tōyō kanji
small, thin formal script	細楷	xì kǎi	saikai
small brush	小筆	xiǎo bǐ	kofude
Song Dynasty	宋朝	sòng chào	sōchō
sound indicator	象聲詞	xiàng shēng cí	
	音符	yīn fú	ompu
space	空間	kōng jiān	kūkan
splashes	飛沫	fēi mò	himatsu
standing dot	向上點	xiàng shàng diǎn	kōjōten
stone rubbing	拓本	tà běn	takuhon
	拓片	tà piān	
stroke energy	筆勢	bǐ shì	hissei
stroke order	筆順	bǐ shun	hitsujun
unabbreviated Chinese script	繁體	fán tǐ	hantai
unabbreviated Japanese script	舊漢字		kyū kanji
undermat	下敷	xià fù	shitajiki
unpainted part	餘白	yú bái	yohaku
upper even (first) tone	陰平	yīn píng	impyō
	陰聲		inshō
	第一聲	dì yī shēng	dai'isshō
vertical stroke	垂露	chuí lù	suiro
vertical stroke with a hook	豎畫	shù huà	jukaku
	縱畫		jūkaku
write or paint	染筆		sempitsu
	揮毫	hī háo	kigō
writing model	手本	shǒu běn	tehon

Appendix 4:

LIST OF ANCIENT CHINESE ARTISTS

In this section, I present brief biographical descriptions of Chinese calligraphers whose works appear in Part Two, "Master Samples and Study." The numbers indicate pages where their works are found. Abbreviations:

 f = formal script
 sc = semicursive script
 c = cursive script

Cai Xiang (蔡襄): 1012–1067, Song Dynasty. From Xianyou (Fujian). Served as a minister of finance in the central government. Known for his scholarship and virtue. A masterful calligrapher in all scripts. 268sc.

Chu Suiliang (褚遂良): 596?–658, Sui to Tang dynasties. Known for his unique style of formal script. A close retainer of Emperor Tai's, the second ruler of the Tang Dynasty. Gaozong, the third emperor, gave Suiliang the title of Lord of Henan. Opposed the ascension of Empress Zetian Wu and was exiled to Yue (present-day Vietnam), where he died. 42f, 48f, 54f, 58f, 64f, 76f, 78f, 84sc, 88f, 90f, 96f, 104f, 106f, 108f, 114f, 122f, 142f, 142sc, 150f, 150sc, 154sc, 160f, 184f, 210f, 214f, 218sc, 230f, 232f, 244sc, 248f, 252f, 254sc, 258f, 260f, 262f, 272f, 274f, 276f, 284sc, 290f, 298f, 304f, 312sc, 314f, 318f, 320f, 322f, 328f.

Deng Wenyuan (鄧文元): 1259?–1329, Southern Song Dynasty. From the Mian Region (Sichuan). A government official. Known for his adaptation of Jin and Tang dynasties' calligraphy. 216c.

Dong Qichang (董其昌): 1555–1636, Ming Dynasty. Known for his skilled landscape painting and gentle, authentic style of calligraphy. A high official in the imperial court in the capital city of Nanjing. 42sc, 74sc, 166c, 224c, 234sc.

Du Yan (杜衍): 978–1057, Northern Song Dynasty. An uncorrupted and highly respected government official, he was promoted to prime minister in 1044.

Known for his poetry and calligraphy in formal, semicursive, and cursive scripts. Regarded as a national treasure in *History of Song*. 210c.

Emperor Tai of Tang (唐太宗): 599?–649. Taizong. Second emperor of the Tang Dynasty; reigned 626–649. Supported Xuanzang's translation of the Buddhist Canon from Sanskrit into Chinese. Being served by great calligraphers—including Ouyang Xun and Chu Suiliang—he created a golden age of calligraphy. An admirer and collector of Wang Xizhi's calligraphy, he himself was an outstanding calligrapher, initiating the inscription of monuments in semicursive instead of the traditional clerical or formal style for official occasions. 62sc, 80c, 92sc, 122sc, 152sc, 176c, 188sc, 208sc, 228c, 230c, 262sc, 286c, 302sc.

Huaisu (懷素): Ca. 737–ca. 799, Tang Dynasty. A Buddhist monk. As he was poor; he planted a banana tree and practiced calligraphy on its leaves. He also practiced on a lacquered board until he wore a hole in it. He was inspired by the shapes of clouds and created a crazy cursive-style script. 40c, 54c, 60c, 68c, 72c, 78c, 90c, 98c, 124c, 126c, 132c, 150c, 152c, 158c, 160c, 174c, 180c, 186c, 194c, 204c, 212sc, 212c, 218c, 244c, 252c, 274c, 276c, 278c, 284c, 294sc, 300c, 304c, 308c, 310c, 316c.

Huang Tingjian (黄庭堅): 1045–1105, Southern Song Dynasty. From the Hong Region (Jiangxi). Recognized by Su Shi (Su Dongpo) for his poetic talent in his twenties and became known as a poet.

Later he became a government official but suffered from being transferred a number of times and died in poverty. Called himself Old Man Shangu. Both his poetry and his calligraphy inspired later generations. 44c, 184sc, 236f.

Lady Wei (衛夫人): 272–349, Western Jin to Eastern Jin dynasties. Wife of Lord Li Ju. Studied calligraphy following the style of Zhong Yao. It is said that Wang Xizhi studied with her when he was young. 66f.

Li Yong (李邕): 678–747, Tang Dynasty. From the Yang Region (Jiangsu). A government official who was often transferred for his extravagant lifestyle; was eventually executed. Known for his sharp calligraphic style after Wang Xizhi. 64sc.

Liu Gongquan (柳公權): 778–865, Tang Dynasty. Government official. Renowned for his powerful and elegant style. His advice to his emperor—"Brush movements come from your heart. If your heart is upright, your calligraphy is upright"—has been remembered in later generations. 82c, 130f, 288f.

Mi Fu (米芾): 1051–1107, Northern Song Dynasty. From Xiangyang (Hebei). For his painting and calligraphy skill, he served as the art advisor to Emperor Hui (r. 1101–1126), who was, himself, an excellent artist and art collector. Mi Fu admired Wang Xizhi and his son Wang Xianzhi and was known for his faithful copying of their works. 50sc, 60sc, 66sc, 70c, 106sc, 128sc, 132sc, 134sc, 156c, 166sc, 168sc, 182c, 206sc, 210sc, 214c, 224sc, 232c, 234c, 270sc, 298c, 304sc, 322sc, 322c, 332sc.

Ouyang Tong (歐陽通): ?–691, Tang Dynasty. The fourth son of Ouyang Xun. Raised by his mother, as his father passed away when he was young. Studied his father's calligraphy and developed his own stern style. Killed for opposing the appointment of Wu Chengsi as crown prince. 50f, 60f, 74f, 200f, 224f, 256f, 326f, 334f.

Ouyang Xun (歐陽詢): 557–641, Chen, Sui, and Tang dynasties. From the Tan Region (Hunan). As an instructor of the Imperial Academy of Art, he taught calligraphy to high officials together with Chu Suiliang. Instead of the traditional way of putting ideographs in imaginary squares, he put his marks in slightly tall rectangles. His calligraphy mainly consisted of dignified, sharp, and straight lines. He is known as the foremost calligrapher in formal script. 52f, 70f, 80f, 84f, 92f, 100f, 110f, 126f, 138f, 148sc, 154f, 158f, 166f, 174f, 176f, 178f, 180f, 188f, 196sc, 198f, 208f, 240f, 250f, 254c, 270f, 306f, 310f, 312f, 316f, 324sc, 332f.

Su Shi (蘇軾): 1036?–1101, Northern Song Dynasty. Also known as Su Dongpo. From Mei Region (Sichuan). A renowned poet and high government official, often transferred. Also imprisoned and exiled because of his political struggles. Lay student of Zen master Zhaojue Changzong. Later studied Zen with Foyin Liaoyuan. He did not follow the mainstream trend of conforming to Wang Xizhi's style. Instead advocated the Yan Zhenqing style, creating his own fresh approach. 36sc, 46sc, 86sc, 118c, 154c, 240c, 258sc, 298sc, 316sc.

Sun Guoting (孫過庭): Ca. 648–ca. 691, Tang Dynasty. From Wu Prefecture (Jiangsu). A government official. Known for his accurate copying of Wang Xizhi and his son Wang Xianzhi. Known as author of *Shupu*, a celebrated critical essay on calligraphy. 50c, 58c, 66c, 74c, 84c, 86c, 88c, 100c, 106c, 116c, 126sc, 148c, 168c, 170c, 200c, 206c, 242c, 258c, 272c, 288c, 290c, 300sc.

Wang Ci (王慈): 451–491, Song to Qi dynasties in the Southern and Northern dynasties period. An early calligrapher as well as a government official. 318c.

Wang Duo (王鐸): 1592–1652, Ming to Qing dynasties. From Mengjin (Henan). A landscape painter. As a calligrapher, he merged the styles of Zhong Yao, Wang Xizhi, Wang Xianzhi, and Yan Zhenqing, establishing his own style of continuously flowing cursive script. He served as a government official at the Ming court and then at the Qing court. 38c, 56c, 94sc, 94c, 122c, 130c, 138c, 162c, 198c, 222c, 270c.

Wang Meng (王蒙): 1308–1385, Yuan Dynasty. From Hu Region (Zhejiang). Escaped from a revolt and lived on Mount Huanghe and called himself

Huanghe. Renowned for his landscape painting. 268f.

Wang Shouren (王守仁): 1472–1528?, Ming Dynasty. Also known as Wang Yangming. A high government official as well as a poet and renowned Confucian scholar and thinker. His calligraphic style was finely solemn. 116sc.

Wang Xianzhi (王献之): 344–388?, Eastern Jin Dynasty. From Huiji (Zhejiang). The seventh and youngest son of Wang Xizhi. All members of Xizhi's family studied calligraphy with him, but Xianzhi proved the most gifted when young. A government official serving as a general and later as an imperial secretary. Xianzhi was nearly as good as his father and surpassed him in sweeping strokes. Known for his relaxed spirit and flavorful style. Regarded as Small Wang of the two Wangs, both of whom have inspired calligraphers of all later generations. 42c, 62c, 112sc, 136c, 146c, 178sc, 192f, 192sc, 194sc, 204sc, 282sc, 312c, 324c, 326sc, 328c, 330sc.

Wang Xingman (王行滿): Circa seventh century, Tang Dynasty. Served Emperor Gao, who was on the throne 649–683. Further biography unknown. 36f.

Wang Xizhi (王羲之): Ca. 303–ca. 361, Western Jin to Eastern Jin dynasties. From Langxie (Shandong). Excelled in calligraphy when young; first recognized for his unprecedented artistry in clerical script. Served in the government and received the title of a general but retired early and enjoyed his artistic life. Renowned for his mastery in all scripts, strong presence in brush lines, and imaginative and elegant composition. Set standards, particularly in semicursive script. While he was still alive, those who owned his calligraphic works treasured them, and some forged his works. While none of his original works have survived in complete forms, several written copies and a number of prints from stone carvings remain. "Orchid Pavilion Preface," written in Huiji (Zhejiang) in 353, is one of his most celebrated pieces. The most influential master in the art, he is regarded as the Sage of Calligraphy. 36c, 38sc, 40sc, 44sc, 46sc, 48c, 52sc, 52c, 56sc, 64c, 68sc, 70sc, 76sc, 76c, 78sc, 82sc, 88sc, 90sc, 92c, 96sc, 98sc, 100sc, 102c,

104sc, 108sc, 108c, 110sc, 114sc, 118sc, 120sc, 124sc, 130sc, 134c, 136sc, 138sc, 140sc, 142c, 144sc, 144c, 146sc, 156sc, 162sc, 174sc, 176sc, 178c, 180sc, 184c, 186sc, 188c, 190sc, 190c, 192c, 196c, 198sc, 200sc, 202sc, 202c, 204f, 208c, 220c, 222sc, 226sc, 226c, 230sc, 232sc, 236sc, 238sc, 238c, 240sc, 246sc, 246c, 248sc, 250sc, 250c, 252sc, 256sc, 256c, 260sc, 260c, 262c, 264sc, 264c, 266c, 272sc, 274sc, 278sc, 280f, 280c, 282sc, 286sc, 292sc, 292c, 294c, 296sc, 302c, 306sc, 306c, 310sc, 314sc, 314c, 318sc, 320sc, 320c, 326sc, 328sc, 330c, 332sc, 334sc.

Wang Xun (王珣): 349–400, Eastern Jin Dynasty. Born as a member of the Wang clan in Langxie (Shandong) as a latecomer but a contemporary of Wang Xizhi's and Wang Xianzhi's. Served Emperor Xiaowu. Known for his relaxed and slender style of calligraphy. 128c.

Wang Zhiwang (王之望): Circa tenth century, Five Dynasties period. 288sc.

Xu Youzhen (徐有貞): 1407–1472, Ming Dynasty. From Xian Prefecture (Jiangsu). Lost his official position because of a revolt. Known for his landscape painting. 268c.

Xue Yao (薛曜): Circa seventh to eighth centuries, Tang Dynasty. A government official serving Empress Zetian Wu, who was on the throne 690–705. Followed the calligraphic style of Chu Suiliang. 112f, 242sc.

Yan Zhenqing (顏眞卿): 709–785, Tang Dynasty. From the capital city of Chang'an (Shanxi). A government official known for his incomparable loyalty. Was appointed tutor to the crown prince at age seventy-two. He was dispatched as an envoy to negotiate with the revolt leader Li Xilie but was captured and killed by him. Self-taught calligrapher who wrote more inscriptions for monuments than any other calligrapher in history. Instead of following the main trend of elegant use of the brush, he initiated a style of expansive presence of the artist. Regarded as one of the geniuses of East Asian calligraphy. 44f, 46f, 48sc, 58sc, 148f, 170sc, 172sc, 202f, 214sc, 218f, 220sc, 234f, 248c, 266f.

Yao Shou (姚綬): 1423–1495, Ming Dynasty. From Jiashan (Zhejiang). A government official who excelled in calligraphy and painting. His inspirations included the works of Zhao Mengtiao of Southern Song Dynasty. 140c.

Yin Lingming (殷令名): Circa sixth–seventh centuries, Tang Dynasty. From Chen County (Henan). Further biography unknown. 162f.

Yu Ji (虞集): 1272–1348, Southern Song to Yuan dynasties. From Renshou (Sichuan). A scholar and poet. Particularly recognized for his mastery of the ancient clerical script. 72f.

Yu Shinan (虞世南): 558–638, Chen to Tang dynasties. From Yue Province (Zhejiang). Studied calligraphy with the monk Zhi Yong. As an art advisor to Emperor Tai, Shinan helped spark his enthusiasm for Wang Xizhi's work. Tai loved Shinan and listed his five outstanding qualities as virtuous deeds, loyalty, extensive learning, literary ability, and letter writing. His inscriptions for imperial monuments are known for their gentle and noble quality. After death, he was buried next to the emperor. 38f, 40f, 62f, 86f, 94f, 102f, 114c, 120f, 120c, 124f, 128f, 134f, 144f, 146f, 152f, 156f, 170f, 172f, 186f, 194f, 196f, 212f, 220f, 222f, 238f, 246f, 254f, 264f, 278f, 282f, 296f, 302f, 324f, 330f.

Zhang Gongli (張公禮): Sixth century. An army general of Sui Dynasty. His Longzang Monastery monument was carved in 586. His formal script with a flavor of clerical script has influenced later calligraphers. 132f, 308f.

Zhang Ruitu (張瑞圖): 1570–1639?, Ming Dynasty. From Quan Province (Fujian). Once a cabinet member. Developed an eccentric style in calligraphy. Also a painter. 160sc.

Zhang Xu (張旭): Circa eighth century, Tang Dynasty. From Wu Region (Jiangsu). A government official. Drank a lot of wine with the poet Li Bai, the calligrapher Yan Zhenqing, and other literary figures in the capital city of Chang'an. Engaged in such eccentric behaviors as doing calligraphy while shouting, splashing ink on his head, and standing up-side down while painting. Known as Sage of Cursive Script for his bizarre style. 104c.

Zhao Mengtiao (趙孟頫): 1254–1322, Southern Song to Yuan dynasties. From Hu Region (Zhejiang). A high government official. Resolved to maintain the orthodox calligraphy of the Jin and Tang dynasties. Also created a fresh style of painting. 54sc, 72sc, 96c, 164sc, 216f, 216sc, 266sc, 280sc.

Zhi Guo (智果): Circa sixth century, Chen to Sui dyanasties. A Buddhist monk from Huiji (Zhejiang), who studied with Zhi Yong. 242f.

Zhi Yong (智永): Circa sixth century, Chen to Sui dyanasties. A Buddhist monk from Huiji (Zhejiang). Abbot of Yongxin Monastery in Wuxing (Zhejiang). Endeavored to master the Wang Xizhi style and excelled in cursive script. Created eight hundred copies of one thousand ideographs in formal and cursive scripts, where he wrote both scripts side by side and donated the copies to temples east of the Zhe River (Zhejiang). The text was originally created by Zhou Xingsi of the Liang Dynasty of the sixth century. As there is no repeated ideograph in the text, it has been regarded as a suitable calligraphy study book. After Zhi Yong, a number of masters, including Ouyang Xun, Chu Suiliang, Sun Guoting, and Huaisu, made their versions of "One Thousand Ideographs." 68f, 80sc, 82f, 98f, 102sc, 110c, 112c, 116f, 118f, 136f, 140f, 158sc, 164f, 164c, 168f, 172c, 182f, 182sc, 206f, 226f, 228f, 228sc, 236c, 244f, 276sc, 286f, 290sc, 294f, 296c, 300f, 308sc, 334c.

Zhong Yao (鐘繇): 151–230, Later Han to Wei dynasties. From the Changge area (Henan). Became a lord in Later Han and then served the first three emperors of the Wei Dynasty in northern China as a key government official for establishing the nation. In a society where the clerical script had been exclusively used for centuries, Zhong Yao created formal script, which thereafter became the all-time standard in East Asian calligraphy. His brushwork in small-scale ideographs is regarded as ingenuous and noble. Writings by him are known only through carved inscriptions, some of which were copied by Wang Xizhi. 190f, 292f.

RECOMMENDED SUPPLIES AND TUTORIAL VIDEO

I recommend products from Yasutomo and Company, South San Francisco, California. You may find these products at your local art supply store. Or go to www.yasutomo.com.

PAPER

Regular computer paper works well for practice, as I suggested in chapter 3, "Shall We Begin?"

For inexpensive hanshi rice paper (9½" x 13"), I recommend Yasutomo 6E (100 sheets) or 6A (500 sheets).

Check with your local art supply stores for high-quality rice paper.

BRUSH

A medium-sized brush: Yasutomo CA4 (bristle, ⅜" x 1⅞") works well for regular practice.

For larger brushes: Yasutomo BSL1 and BSL2. For smaller brushes, Yasutomo CA1 to CA3.

INK

For black liquid ink, Yasutomo KF2 (2 oz.) or KF12 is good.

FELT

Black or dark-color felt may be purchased at your local fabric store.

TUTORIAL VIDEO

A video of the author executing samples of the ideograms shown in this book can be found at www.shambhala.com/heartofthebrush

Selected Bibliography

ENGLISH

Addiss, Stephen. *The Art of Chinese Calligraphy.* Philadelphia: Running Press, 2005.

———. *77 Dances: Japanese Calligraphy by Poets, Monks, and Scholars, 1568–1868.* Boston and London: Weatherhill, 2006.

Chin, Tsung, and Wendan Li, eds. *East Asian Calligraphy Education.* Potomac, MD: University Press of Maryland, 2004.

Choy, Rita Mei-Wah. *Read and Write Chinese: A Simplified Guide to the Chinese Character.* San Francisco: China West Books, 1990.

Davey, H. E. *Brush Meditation: A Japanese Way to Mind and Body Harmony.* Berkeley: Stone Bridge Press, 1999.

Ecke, Tseng Yu-ho. *Chinese Calligraphy.* Philadelphia: Philadelphia Museum of Art, 1971.

Fazzioli, Edoardo. *Chinese Calligraphy: From Pictograph to Ideogram; The History of 214 Essential Chinese/Japanese Characters.* Milan: Arnoldo Mondadori Editore, 1986.

Go, Ping-gam. *Understanding Chinese Characters by Their Ancestral Forms.* San Francisco: Simplex Publications, 1988.

Harada, Shodo. *Moon by the Window: The Calligraphy and Zen Insights of Shodo Harada.* Edited by Tim Jundo Williams and Jane Shotaku Lago. Translated by Priscilla Daichi Storandt. Boston: Wisdom Publications, 2011.

Lai, T. C. *Chinese Calligraphy: An Introduction.* Kowloon, Hong Kong: Swinton Book Company, 1974.

Peng, Tan Huay. *Chinese Radicals.* Peng's Chinese Treasury, vol. 1. Singapore: Times Books International, 1953.

Sato, Christine Flint. *Sumi Workbook.* Osaka: Kaifusha, 2014.

Sato, Shozo. *Shodo: The Quiet Art of Japanese Zen Calligraphy.* North Clarendon, VT: Tuttle Publishing, 2013.

Yee, Chiang. *Chinese Calligraphy: An Introduction to Its Aesthetic and Technique.* Cambridge, MA: Harvard University Press, 1976.

CHINESE

中国书 法大字典编辑組「中国書法大字典」世界图书出版公司北京公司　1992

启功　曽湘文　黄文学　刘晓渡「书法大字海三卷」　海南出版社出版发行　1999

JAPANESE

飯島太千雄編　「王羲之大字典」　東京美術　1980

飯島春敬編　「書道辞典普及版」　東京堂出版　1995

小川環樹　西田太一郎　赤塚忠　「新字源」角川書店　1968

高田竹山監修　法書会編集部「五體字類」西東書房　1916

天石東村　「書の教室楷書」　日本放送出版協会　1975

服部大超　若尾俊平　「草字宛」　柏書房　1976

藤原鶴来編　「新書道字典」　二玄社　1985

水野恵　「古漢字典」光村推古書院　1984

Photography Credits

Joshi Radin: figs. 1, 2.
Christine Haggarty: figs. 42–47, 113–118.
Ryokan Memorial Museum, Niigata Prefecture, Japan: fig. 101.
Nicole Hatley: figs. 120–125.
Mitsue Nagase: author photo, p. 390.

Acknowledgments

Ancient Chinese masters whose works I show in this book have shaped my understanding of calligraphy. The art of my teacher Kodo Fukada as well as my senior colleagues Shiryu Morita, Yuichi Inoue, and Gaboku Ogawa have inspired me for six decades.

My gratitude goes to Wouter Schopman, who has supported my brushwork for many years. Thanks to many of those who have invited me to conduct brush workshops in Europe and North America for a number of years, including Dr. Angela Jannsen, Dr. Norbert Jannsen, Petra Müller, Lona Rothe-Jokisch, Liz Uribe, Mario Uribe, Joan Halifax Roshi, Chozen Bays Roshi, Hogen Bays Roshi, Richard Baker Roshi, Gaelyn Godwin Roshi, Dr. Friederike Boissevain, Liza Mathews, Sarah Cox, David Cox, Susan Perry Sensei, and Dr. Ron Rubin.

This book has benefited from advice by Dr. Szevone Chin, Dr. Steve Crisman, Nigel Black, Seano Whitecloud, Mark Ballard, and Kuofang Chiang. Thanks to Kichung Lizee, Rev. Dongho, Tae Shi Lee, and Sunghee Gallo for providing Korean pronunciation of ideographs and to Rev. Quang Huyen and Phuong Ertley for Vietnamese pronunciation. My appreciation goes to those who contributed their illustrated works: Petra Hinterthür, Guntram Porps, Dr. Stephen Addiss, Gerow Reece, Paola Billi, and Fabienne Verdier. I thank Joshi Radin, the Ryokan Memorial Museum, Nicole Hatley, and Mitsue Nagase for their photography. Dr. Susan O'Leary, Roberta Werdinger, and Diane Abt have given me invaluable editorial advice. Eri Suzuki helped me in my office. Thanks to Karuna Tanahashi for creating the tutorial video. I deeply appreciate the dedicated and tireless work of my associate editor, Christine Haggarty.

It is always wonderful to work with the staff at Shambhala Publications. Thanks to Hazel Bercholz, Lance Hidy, and Lora Zorian for their excellent design. My appreciations go to Nikko Odiseos, Jonathan Green, and Ben Gleason. Dave O'Neal has guided me through the production, including copyediting. Thank you also to Victoria Shoemaker for representing me.

About the Author

Kazuaki Tanahashi, born in 1933, was classically trained in calligraphy by Kodo Fukada in Aichi, Japan. In 1960 he had his first exhibition of brushwork in Nagoya. In 1964 and 1965 he taught calligraphic painting at the Ontario College of Art and Design in Canada and at the University of Hawaii. He has been living in the United States since 1977. He has presented solo exhibitions of his brushwork worldwide and has taught numerous workshops in Europe and North America, including seven international calligraphy conferences. His publications include *Brush Mind; Penetrating Laughter: Hakuin's Zen and Art; Moon in a Dewdrop; Treasury of the True Dharma Eye: Zen Master Dogen's Shobo Genzo;* and *The Heart Sutra: A Comprehensive Guide to the Classic of Mahayana Buddhism.* He is a Fellow of the World Academy of Art and Science.

For more information: www.brushmind.net.